# JOYCE KOZLOFF

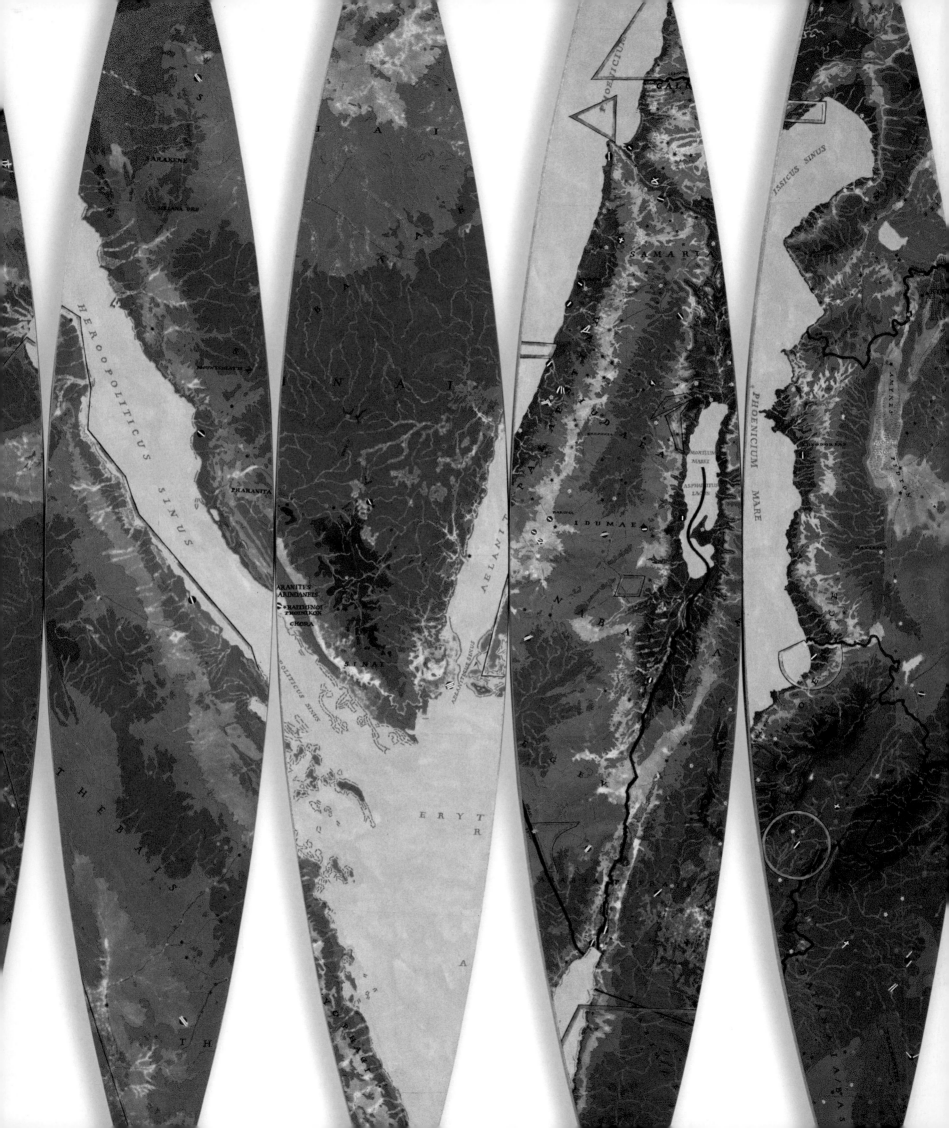

# JOYCE KOZLOFF
# CO+ORDINATES

Nancy Princenthal and Phillip Earenfight
Edited by Phillip Earenfight

## THE TROUT GALLERY

Dickinson College, Carlisle, Pennsylvania
Distributed by D.A.P., Distributed Art Publishers, Inc., New York

This publication was produced in part through the generous support
of the Helen E. Trout Memorial Fund and the Ruth Trout Endowment
at Dickinson College

Published by The Trout Gallery, Dickinson College, Carlisle,
Pennsylvania, 17013

Distributed by D.A.P., Distributed Art Publishers, Inc., New York, 10013

First published 2008 by The Trout Gallery, Dickinson College
Editor: Phillip Earenfight
Layout and Composition: John Bernstein Design, Inc.
Print Production Management: The Actualizers
Printed in Canada by Hemlock Printers Ltd., Vancouver, B.C.

Library of Congress Cataloging-in-Publication Data

Princenthal, Nancy.
     Joyce Kozloff : co+ordinates / Nancy Princenthal and Phillip
     Earenfight; edited by Phillip Earenfight.

               p.     cm.

Includes bibliographical references and index.
ISBN 978-0-9768488-8-2 (hardcover : alk. paper)

1. Kozloff, Joyce.  2. Maps in art—Exhibitions.  3. Cartography in art—
Exhibitions.  I. Earenfight, Phillip.  II. Trout Gallery.  III. Title.

N6537.K657A4 2008
709.2--dc22                              2008035622

Printed in Canada

Cover detail:  Joyce Kozloff, *Dark and Light Continents*, 2002.
     Acrylic, collage on canvas, 96 x 192 in. (see plate 21)
Frontispiece detail:  Joyce Kozloff, *Spheres of Influence*, 2001.
     Acrylic, collage on canvas, 96 x 192 in. (see plate 22)

Joyce Kozloff is represented by DC Moore Gallery, New York

# CONTENTS

Introduction 7

Acknowledgments 8

I · Essays 11

*Joyce Kozloff: Border Crossings*
Nancy Princenthal 12
*Joyce Kozloff: Mappae mundi*
Phillip Earenfight 24
*Questions for Joyce Kozloff*
Phillip Earenfight with the artist 44

II · Plates 59

1. Knowledge 60
2. *La Conquista* 67
3. *Targets* 68
4. Boys' Art 74
5. Celestial+Terrestrial 80
6. *Rocking the Cradle* 84
7. American History 86
8. Voyages 94
9. Tondi 102
PLATE NOTES 112

III · Reference

Selected Biography 114
Selected Bibliography 120
Index of Works by the Artist 129
Notes on Contributors 131

# INTRODUCTION

We locate ourselves through coordinates—a pair of crossing streets, where two rivers join, intersecting lines of latitude and longitude. The sight of a map leads us to identify recognizable coordinates and trace them until we find our home or places we've been. Upon locating ourselves we proclaim our association with this site or that, affirming our position and identity. This process of orientation and self-identification is reassuring. We find comfort in knowing where and who we are—and are not. Maps are mirrors in which we look for ourselves; they reveal how strong our sense of identity is associated with location and place relative to others.

Co+Ordinates, cartographic works by Joyce Kozloff, considers such issues of place, location, and identity. In this selection of paintings and works on paper, Kozloff examines relationships of power, gender, and global politics through the imagery of maps and cartography. Her paintings, some of which cover spherical surfaces and globes, include and at times combine features from maps of the ancient world, the Age of Discovery, and the digital era to examine issues of identity and territorial conquest and act as metaphors for people, culture, body, and mind.

Co+Ordinates brings together works from the late 1990s to the present and represents an important aspect of Kozloff's extensive career. These works exhibit Kozloff's attention to color and ornament, which point to the artist's fundamental role in the Pattern and Decoration Movement of the 1970s, while their scope and communicative power point to her work on numerous public art commissions in the 1980s and 1990s. Themes of power, gender, travel, and a sense of place run through all of her works and are especially strong in this selection.

Co+Ordinates features nine different projects by Kozloff: Knowledge, *La Conquista*, *Targets*, Boys' Art, Celestial+Terrestrial, *Rocking the Cradle*, American History, Voyages, and Tondi. Some of the projects are single works, such as *Targets* or *Rocking the Cradle,* that illustrate a highly focused idea; both of these works represent regions that have been attacked by the U.S. military. Others, such as Boys' Art and American History, are series of works on paper based on the themes of territorial expansion, imperialism, and gender. In Knowledge, Kozloff focuses on error-filled maps from the Age of Discovery to reveal human fallibility, whereas in Voyages she looks at the poetics of travel through a series of monumental woodblock prints, painted carnival masks, and cut-paper collages. In Celestial+Terrestrial and Tondi, the artist works on shaped canvases to examine the consequences of power and territorial expansion on and above Earth. In all of these works we see glimpses of ourselves: comic, blind, arrogant, optimistic, tragic.

The Co+Ordinates exhibition and book are conceived as distinct but complementary experiences. While the book cannot fully capture the power and effect of the exhibition, it contextualizes the works presented. The opening essay by art critic Nancy Princenthal examines how Kozoff's paintings operate both as image and text, to be experienced like one's surroundings and read closely like letters on a page. Phillip Earenfight provides an historical analysis, situating Kozloff's cartographic work within the broader history of mapping imagery as well as within the artist's career. The essays are followed by an interview with the artist in which she discusses various aspects of the works presented in Co+Ordinates and her earlier work in the Pattern and Decoration Movement in addition to her public art projects. The subsequent plate section includes many of the works in each of the nine projects or series, highlighting works featured in the exhibition as well as others that were not part of the show.

Co+Ordinates is an important presentation and analysis of Joyce Kozloff's cartographic work. Her paintings and works on paper compel us to evaluate our position and reevaluate our coordinates.

Phillip Earenfight
Director, The Trout Gallery

Kozloff, *Targets* (detail), 2000.

Acrylic on canvas on wood, 108 in. diam.

Courtesy DC Moore Gallery, New York

# DIRECTOR'S ACKNOWLEDGMENTS

Co+Ordinates is the result of the dedication, professionalism, fine skills, and countless hours of work by many gifted individuals. I am profoundly grateful for their tireless effort and support, and am pleased to recognize their contributions to this project.

Foremost, I thank Joyce Kozloff for giving of herself through her work and through her time in bringing this project to life. In addition to all that an artist must do to prepare for a solo exhibition, Joyce also reviewed numerous drafts of this book, correcting errors and sharpening all aspects of its content and production, and challenging me to be the best curator and editor possible. Through the exhibition and pages of this book, I hope that I have done justice to her work and conveyed a glimpse of the artist that I have had the sincere pleasure to work with over the past few years.

I wish to thank the lenders who supported this exhibition. Without their generous cooperation and willingness to make their collections available, Co+Ordinates would not have been possible. Among the lenders to the exhibition, I extend special thanks to everyone at DC Moore, in particular Bridget Moore and Heidi Lange, who made available a number of key works and helped with all aspects of the project.

I am honored to have my name appear on the same title page with Nancy Princenthal, and thank her for the insightful essay on Joyce's recent paintings. John Bernstein deserves praise and thanks for designing and producing this handsome book and for enduring the hundreds of e-mails from Joyce and me. Kathleen Parvin, Stephanie Keifer, and Mary Gladue sharpened and strengthened the text in countless ways. The errors that remain are mine alone. I thank Elisa Leshowitz and Todd Bradway at D.A.P., Distributed Art Publishers, in New York, for bringing this book to the national and international market.

At Dickinson College, President William Durden, Provost Neil Weissman, and members of the Department of Art and Art History have shaped an academic environment that supports creativity and scholarship. At The Trout Gallery, I am grateful to my colleagues James Bowman, Stephanie Keifer, Rosalie Lehman, Wendy Pires, Dorothy Reed, Catherine Sacco, and Satzuki Swisher. Promotional materials for the exhibition were designed by Pat Pohlman and Kim Nichols.

I thank the Friends of The Trout Gallery and its board members for providing valuable assistance to the museum and its activities. Funding for Co+Ordinates was provided by the Ruth Trout Endowment and the Helen E. Trout Memorial Fund.

As with all of my projects, I owe special thanks to Nancy Siegel for her unending support and encouragement while pursuing her own demanding schedule of research and writing.

Given the nature of exhibitions and publication projects, many individuals will be of assistance who are as yet unknown to me. Let me take this opportunity to thank you all for your efforts.

Phillip Earenfight
Director, The Trout Gallery

# ARTIST'S ACKNOWLEDGMENTS

I would like to thank the many people who helped me create these artworks: my former studio assistants Jihyon Jon, Julia Randall, Solange Roberdeau, and Addison Walz; Daniel Bozhkov and the Skowhegan School of Painting and Sculpture, Skowhegan, ME; Judith Solodkin and Rodney Doyle at SOLO Impression, NY; Paul Mullowney and interns Nichol Markowitz and Roxanne McGovern at the Hui No'eau Visual Arts Center, Makawao, Maui, HI; Sarah Amos and the Vermont Studio Center Press, Johnson, VT; Lori Waxman and D.A.P., Distributed Art Publishers, Inc., NY; carpenters Morris Shuman, Brooklyn, David Ferry, New York, and Antonio and Alessandra Potena, Rome. The installation in Venice would not have been possible without the hard work of my friends Debra Werblud and Mark Solomon, Antonietta Grandesso and Roberto Marascalchi at Thetis, and Michela Rizzo and Chiara Valsecchi at Galleria Michela Rizzo. I was given the gift of time, for which I am deeply grateful, by the Camargo Foundation, Cassis, France; the Lucas Artists Program, Montalvo Arts Center, Saratoga, CA; the Bogliasco Foundation, Liguria Study Center, Bogliasco, Italy; and the American Academy in Rome. Bridget Moore, Heidi Lange, Mark Valenti, Kate Pollack, and Sandra Paci at DC Moore Gallery, NY, were helpful and supportive as always, a great backup team. It is especially enjoyable to collaborate with the gifted, patient book designer John Bernstein. I was delighted and moved by Nancy Princenthal's sensitive essay about my art. Phillip Earenfight worked so far beyond what anyone could rightly expect of a curator, on all aspects of the exhibition and catalog, that I will never be able to express my respect and gratitude! And a lifetime of thanks to my husband, Max Kozloff, and my parents, Leonard and Adele Blumberg, who met at Dickinson College in 1932.

Joyce Kozloff
New York City, NY

ESSAYS

# JOYCE KOZLOFF: BORDER CROSSINGS

Nancy Princenthal

A perilously full cup, Joyce Kozloff's work brims with visual detail and narrative information. Much of it is sorrowful or angry, though not infrequently it is funny, even raucous. Kozloff, a world traveler and political activist of formidable energy, presents in her art impossible choices between reading and looking, thinking and feeling. Her husband, the photographer Max Kozloff, said in a joint interview that he sees a gift for hyperbole and dissonance in Joyce's work.[1] The two agree that she also has a gift for humor. But above all, it is her bountiful generosity that has characterized Kozloff's career.

A founding member of the feminist collective Heresies in the 1970s and, in the same years, of the Pattern and Decoration Movement—which worked against the separation of decorative and fine art, of pleasure and principle—Kozloff has embraced applied arts, women's work, and the visual arts of world cultures. Architecture, literature, food, and sex have played important roles in her work, as has the fine art of old masters. The media in which she has worked include ceramic tiles, textiles, mosaics, and fresco. She has traveled to study the craft traditions of Ecuador, Egypt, India, Islamic Spain, Mexico, Morocco, and Vietnam. After a long period of commitment to public art, she returned in the late 1990s to studio practice, painting on canvas in particular.

For more than fifteen years, cartography has been Kozloff's predominant point of reference. Her use of maps began in earnest in the early 1990s, though the first map appeared in a 1987 work, *Riding Roughshod through the Heavens* [fig. 1]. One of thirty-two watercolors in a series fusing pornography and ornament, the piece includes a cosmological chart by Albrecht Dürer. "When I was young," Kozloff says, "I found a great and inexhaustible subject: the history of the applied arts. I keep inventing approaches to it, and mapping has proven to be a fruitful device for contextualizing these investigations....With the maps, I can create wide-angle macrocosmic aerial views of landmasses, plus micro-cosmic zoom shots of bird's-eye mini worlds. Like decoration, maps are neither exclusively figurative nor abstract."[2]

Though cartography is generally associated with reliable measurements and objective representation,

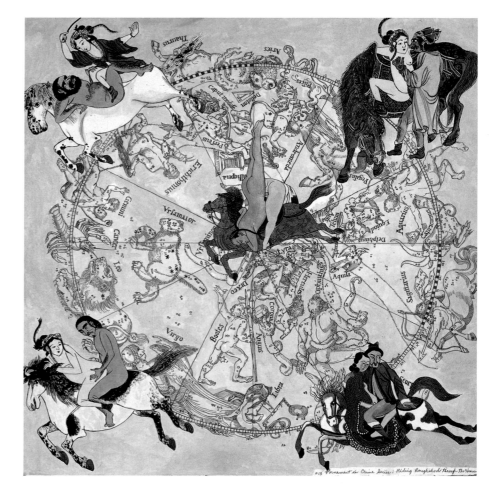

it is the instability of maps that interests Kozloff. Maps are variable not just to the degree that boundaries change with geopolitics (quickly), or that topography changes in time (slowly, although human intervention has accelerated that pace), but also in the sense that space and time are inextricably bound together, and were long before Einstein. Dava Sobel makes the point in her graceful little book *Longitude,* which is about the search for a reliable means of marking positions at sea: that to know where one is, in the Age of Discovery (an era that serves as a touchstone for Kozloff's current work) as well as in the twenty-first century, one must know what time it is.[3]

Of course, the earth can be mapped in any number of ways: divided by nation, tribe, religion, or

1. Kozloff, *Pornament Is Crime #13: Riding Roughshod through the Heavens,* 1987.
Watercolor on paper, 22¼ x 22¼ in.
Collection Max Kozloff

Previous page, Kozloff, *Knowledge #41, China, 1470* (detail), 1998.
Fresco on panel, 8 x 10 in.
Collection Mr. and Mrs. Judson P. Reis

2. Kozloff, *Knowledge #73: 1st Century A.D.*, 1999.
Watercolor, plaster, rope, cardboard, porcelain, 9¼ in. diam.
Collection Nicholas Pentecost

3. Kozloff, *Knowledge #74: 1561*, 2000.
Watercolor, gesso, cardboard, porcelain, 9⅛ in. diam.
Private collection

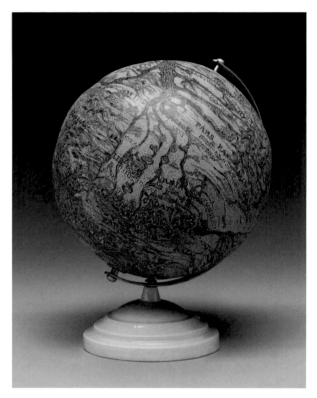

language; by natural boundaries (mountain ranges, rivers) and natural resources; by geometry; by chance; and, most commonly, by conquest and fiat. No world map lasts long. In *Songlines*, a book Kozloff admires a great deal (and from which she has incorporated fragments in recent work), Bruce Chatwin notes that in the creation story of Australia's Aborigines, the land was sung into being as it was walked and can be understood and maintained only in the same way, by repeated, peripatetic singing.[4] Kozloff is fundamentally sympathetic to the restless pastoral ethic—the nomadism—that Chatwin celebrates and that finds lyrical expression in a very different book which also has been instrumental to Kozloff, Italo Calvino's *Invisible Cities*.[5] In the parables of Calvino's book, a mythologized Marco Polo describes cities organized around patterns of memory and desire: for youth, immortality, beauty, and love, and—to satisfy his royal interlocutor—for the promise that a doomed empire might resist its fate. "Only in Marco Polo's accounts," the prologue says, was Kublai Khan able to discern, "through the walls and towers destined to crumble, the tracery of a pattern so subtle it could escape the termites' gnawing." This vain hope, which shapes the infinity of cities outlined or anticipated in Kublai Khan's many atlases, also runs through Kozloff's proliferating body of maps as a matter of both emotional truth and cautionary history.

If literary connections to Kozloff's current work can be made on the strength of her own inclination,

they also reflect the dual nature of maps, which are read like books but also looked at like pictures. Maps reach forward (to map something is to plan it) and backward (they show what has been discovered, learned, calibrated). They schematize information—simplifying it for clarity—and elaborate on it. Historically, they have often been extraordinarily rich in information and also in visual adornment, reflecting their political and economic importance, as well as the expense invested in the voyages of exploration from which they derive. Charting routes to sources of trading goods of all kinds, from textiles, foodstuffs, spices, and minerals to miscellaneous rarities, maps are themselves a kind of treasure. At once real and abstract, as Kozloff notes, maps have been a source, a metaphor, and an organizing strategy for artists ranging from Jasper Johns to Alfredo Jaar and Peter Fend.

But while Fend and Jaar have seized upon widely accepted world map projections as contestable expressions of First World arrogance, and have undertaken to correct them, Kozloff is especially drawn to flagrantly wrong maps in which the history of such acts of cartographic hubris can be traced, mappae mundi—maps of the entire known world—in particular. She favors heavily figured and utterly fanciful ones (the world shaped like a heart) and old globes. During a residency in Rome (1999–2000), Kozloff made an extended series of globes called, with some irony, "Knowledge." The sources they incorporate reflect desire as much as fact. And the visual opulence these pieces sustain suggests the place

that old globes have had in the culture of Italy, a seafaring land whose palaces often had celestial as well as terrestrial globes. Using a fresco-based process, also influenced by local historical resources, Kozloff in most examples of Knowledge applied plaster to standard commercial globes and then painted on them in watercolor when the plaster was dry, not wet as in traditional fresco. Their finished surfaces are suggestive of damask or stained glass or spice: the colors of those goods brought back from the trade routes they trace.

The globes' origins, often named in their titles, are as various as their palettes. *Knowledge #73: 1st Century A.D.* [fig. 2] is a desert-colored sphere based on the Tabula Peutingeriana in which information, presented on a long horizontal scroll in the Roman original, circles the Earth both right side up and upside down. *Knowledge #78: 1154* pictures what was known of the world one thousand years later [pl. 10]. Based on a world map created by the Arab cartographer al-Idrisi for King Roger II of Sicily, which orients south at the top and is written in Arabic, it is a jewel-toned ball illuminated by golden points of light, the land masses a rich leathery brown, the sea a deep navy blue. Reflecting information current four hundred years later, the jade-green *Knowledge #74: 1561* [fig. 3], which incorporates a map of Italy and southern Germany, is articulated throughout with flowing rivers that suggest blood vessels and are punctuated by node-like cities. In *Knowledge #77*, which draws upon Giacomo Maggiolo's Genovese Mappa Mundi (1564), Italy is easily recognizable, as are the other countries bordering the Mediterranean, but the continents of the southern hemisphere are given only rudimentary representation, and fanciful tents, rulers seated before them, substitute for land masses—as in others of the Knowledge series, information dwindles with distance from home [figs. 4, 5].

During the same residency, Kozloff constructed a hybrid painting/sculpture that remains one of her most imposing, and acclaimed, works to date. *Targets* (2000) is a walk-in globe, nine feet in diameter, made of canvas over a wood-paneled frame [figs. 6, 7]. From the outside its wooden supports, which trace broad lines of longitude and latitude, make the structure roughly—and unintentionally, Kozloff says—resemble a bathysphere or an early spaceship or perhaps a giant hand grenade. Inside, individually painted panels represent every country bombed by the United States since 1945, among them Afghanistan, China, Colombia, the Congo, Cuba, El Salvador (in the so-called War on Drugs), Guatemala, Iraq, Korea, Libya, Vietnam, and Yugoslavia. Kozloff worked from maps produced by the U.S. Department of Commerce's National Oceanic and Atmospheric Administration, including Tactical Pilotage Charts and Operational Navigation Charts. Both were

4. Kozloff, *Knowledge #77: 1564*, 1999.
Watercolor, acrylic, gesso, cardboard, porcelain, 9⅛ in. diam.
Collection Judy Fiskin

5. Kozloff, *Knowledge #77: 1564* (detail)

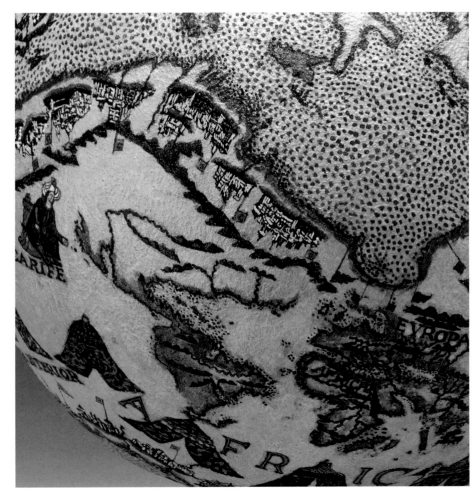

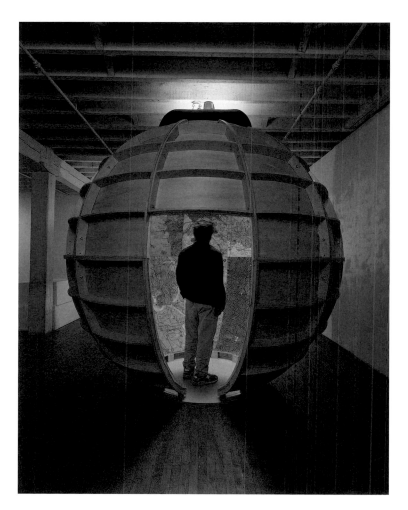

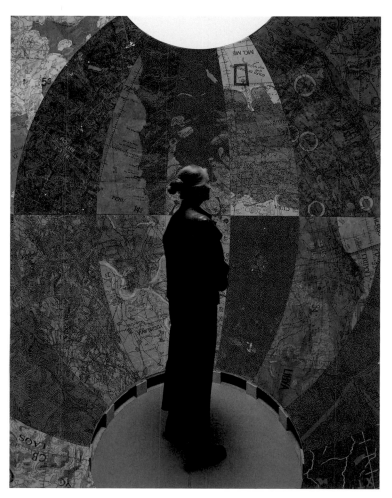

6. Kozloff, *Targets*, 2000.

Acrylic on canvas on wood,
108 in. diam.

Courtesy DC Moore Gallery,
New York

7. Kozloff, *Targets* (detail)

created to assist civilian as well as military pilots; analogously, aerial bombardment does not, as a rule, discriminate well between civilian and military targets. On the other hand, increasingly precise maps protect pilots two ways: flying at ever-safer altitudes, they are spared the firsthand experience of killing. Kozloff's *Targets*, too, plots violence without picturing victims— and is no less chilling for the omission. This world turned inside out captures something of the physical consequence of aerial warfare, in which buildings and bodies are ravaged and exposed. But that horror runs deep beneath the deliberately numbing tidiness and bloodlessness of *Targets*, emphasized by the light- and air-admitting oculus at its apex. Modeled (again, with local inspiration) on the Roman Pantheon, this opening conflates rational order with carnage in a way that only intensifies the viewer's sense of being caught inside a world devoid of safety or escape. "If…the history of the world is the history of struggle, then mapmakers are among its chief chroniclers," Robert Storr has written, in a phrase that well serves Kozloff's recent work.[6]

*Targets* preceded by a single year the events of September 11 and their sequel. The first body of work

that Kozloff made in the wake of 9/11, and one of her most heartrending, is a series of twenty-four drawings called Boys' Art (2002). She had just returned to Italy for a residency when the World Trade Center was attacked; the resources she had with her included military maps from the Han Dynasty to the second half of the twentieth century. When back home in New York, she turned to a trove of drawings her adult son had made as a child, shrinking them in a photocopier to 25 percent of their original size and adding them to materials she had utilized in her weeks in Italy. The collaged drawings of Boys' Art mix languages—including Arabic, English, French, and Spanish—and span the globe from Nagasaki to Havana. Imagery is borrowed from Goya, Hokusai, Manet, and Henry Darger [fig. 8]. The Bayeux Tapestry appears, and so does Laurent de Brunhoff's Babar. But the most potent juxtapositions are those Kozloff makes between innocence and armed combat. In Kozloff's portrayal, war is not politics by other means —it is childhood without end, a transformation of the generally harmless aggressions of small boys into something virulent and grotesque. As do Kim Jones's war maps, which revisit his experience in Vietnam in childlike diagrams of military emplacements, Kozloff's

15

Boys' Art looks at war through the eyes of a boy and finds it an incomprehensible charade played by adults who refuse to grow up.

No less insidiously ferocious is American History, a series of collaged drawings that followed in 2004 [fig. 9]. All are organized around the outtakes from an edition of sepia ink etchings, printed at the Vermont Studio Center Press, for a book in which the Boys' Art drawings were reproduced. Based on a c. 1700 watercolor map of a fort in Mont-Dauphin, France, these delicate, slightly misprinted images are a perfect foil for the almost comically manic violence of the small drawings in which they are buried. So densely layered and compressed that one almost needs a magnifying glass to read them—each is only 11⅛ by 16½ inches—the American History collages force the viewer into a kind of intimacy that is achieved only with regret, not simply on ethical grounds but also for the sheer nastiness of what one sees (hacked bodies, rivers of gore). As Kozloff did in Boys' Art, she combines reproductions of historical works with original drawings and, once again, children's war games, here in the form of print ads and packaging material for the anachronistic (that is, non-video) strategy game *Warhammer*. Other material ranges from scraps of sheet music to crusader maps of Jerusalem (for a drawing titled *Twenty-First-Century Crusades*) and a map from the *New York Times* showing all the countries that have been subject to

8. Kozloff, *Boys' Art #2: Nagasaki* (detail), 2002.

Graphite, collage, colored pencil on paper, 12 x 18 in.

Collection Ellen Saltonstall and Robert Kushner

9. Kozloff, *Sing-along American History: Cowboys and Indians* (detail), 2004.

Etching, collage, watercolor, colored pencil on paper, 11⅛ x 16¼ in.

Courtesy DC Moore Gallery, New York

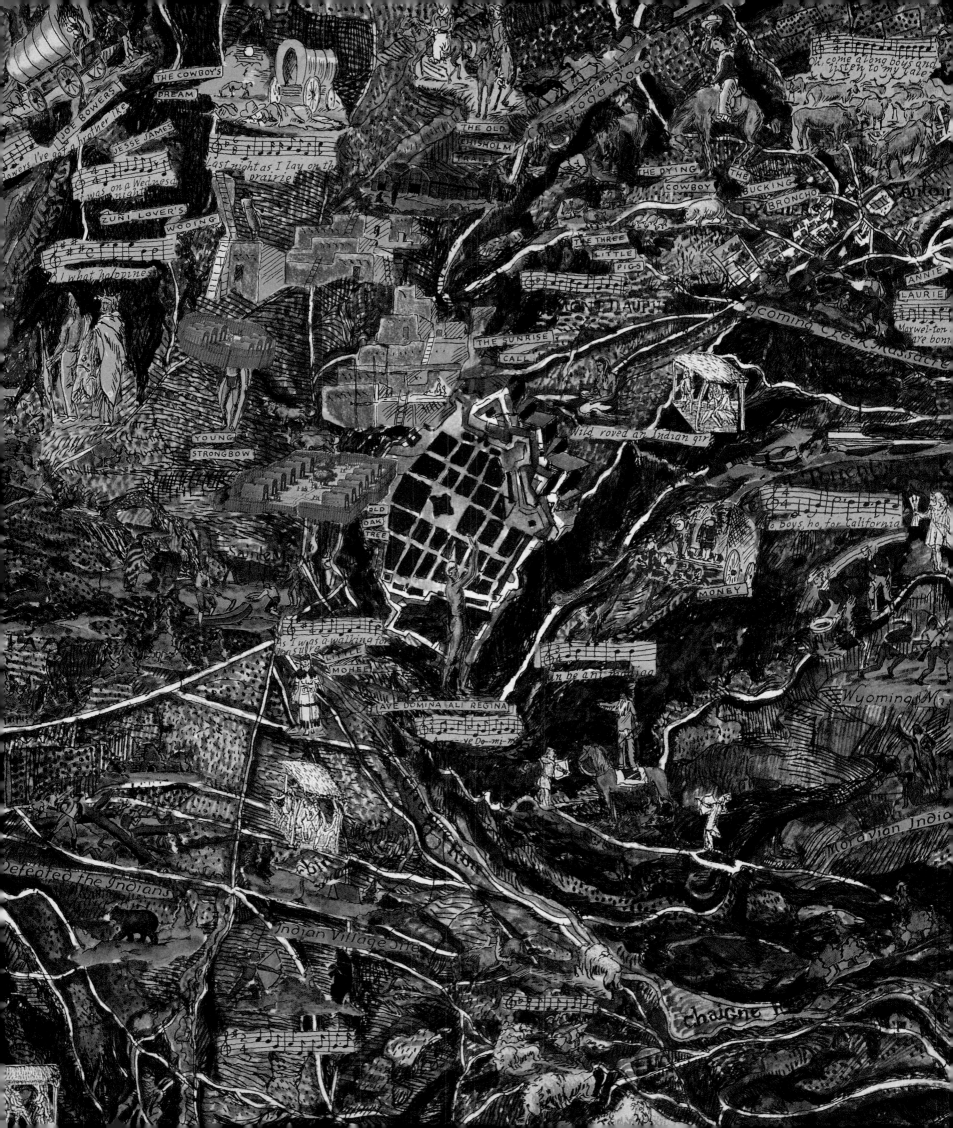

terrorist attacks (*Going Global*). The series begins with *Age of Discovery*—always to be understood as set between scare quotes in Kozloff's work—and proceeds through *Popular Uprisings* (including the American Revolution but also that of the Indians against colonists, and on through the Chiapas uprising in Mexico in 1994; the action is hardly limited to the fifty states). *War and Race* plays out against a vivid magenta ground. *Nuking the Japs* is enlivened with little lozenges borrowed from Japanese maps; a Buddha figure sits imperturbably at the center of the recurring French fort. The series includes *Sing-along American History: White Bread*, with bars of music, and, inevitably, *Cowboys and Indians*. In Kozloff's hands, clichés are squeezed until the blood runs.

Back in Italy—Venice, this time—in 2004, Kozloff turned to a form of common kitsch for a series of works called *Voyages*, in which the imagery is painted and collaged on cheap carnival masks manufactured for tourists. The Venetian carnival goes back to 1268, not long before Venice developed into a major maritime power, a magnet for world travelers in much the same way that it is today. In a book subtitled *The Revolutionary Power of Women's Laughter,* Jo Anna Isaak notes that the medieval and Renaissance carnival, with its potent streak of social disruption and frank insubordination, was, in significant part, the province of women. Isaak draws upon Mikhail Bakhtin, in whose characterization "carnival celebrates temporary liberation from the prevailing truth of the established order; it marks the suspension of all hierarchical rank, privileges, norms, and prohibitions." Isaak goes on to say that the subsequent history Bakhtin

traces "is the history of the near-eradication of a potent form of social revolt, kept alive primarily by small groups of women."[7]

To a lifelong feminist like Kozloff, this connection is especially relevant. But the appeal of the traditional carnival also involves, for a modern observer, its irreducible unknowability. In an essay about Kozloff's Voyages, Lucy Lippard wrote, "Carnival itself is a kind of travel into mysterious realms of possibility."[8] Of course, it is no small part of the power associated with masks that they offer the wearer the benefits of concealment—and a link to the accessories, if not the practice, of crime. On the other hand, and just as important, are the connections in tribal cultures between masks and spiritual authority, whether beneficent or terrifying.

Trade and tourism, elegant disguise, culturally tolerated disruption, and lurking danger all animate the imagery of the painted and collaged Voyages masks. Again, the scale is small, and, even more insistently than the American History drawings, the work invites an intimate relationship—here, it is literally face to face, as the masks are meant to be installed at eye level; one can imagine an even closer relationship, as a player in the masquerade. The paintings begin in each case with maps of islands, most real, a few mythical. The first association is with Venice, an island city-state, but the choice also suggests the insularity and inscrutability to others that masks confer. Some of the mapped faces are evil and alien looking, others benevolent. *Lemnos* is painted a serene, sunny blue, delicately gridded with fishnet [fig. 10]. A storm of wind and battle roils the brow of *Sumatra with G.I. Joes,* and patches of camouflage appear like war paint on its cheeks [fig. 11]. *Terra incognita Nova Guinea* is dense with buildings, ghastly and deathlike. *Galapagos Islands* glows with fleshy warmth [fig. 12]. Lettered

10. Kozloff, *Voyages #5: Lemnos*, 2004.

Watercolor, acrylic, cast paper, 8⅜ x 5⅜ x 4 in.

Collection William and Norma Roth

11. Kozloff, *Voyages #37: Sumatra with G.I. Joes*, 2006.

Watercolor, acrylic, collage, cast paper, 8¼ x 6¼ x 3½ in.

Collection William and Norma Roth

10

11

12

beneath the mouth of the grim-faced *lava* is, again, the singularly resonant word "Incognita." In Venice, the *Voyages* masks were hung in front of windows, permitting sunlight to stream through their eyes, as part of an ambitious installation in 2006 at Thetis, an exhibition space in the old Arsenale, that is now devoted to the study of hydraulics and water issues in the Venetian lagoon [fig. 13].

Voyages also includes (among other components) a suite of eighteen prints published by HuiPress in Makawao, Maui [fig. 14]. The subject is again islands, in this case the Hawaiian islands of Maui and Kaho'olawe, the latter a sacred site formerly used as a bombing range by the U.S. military. Suspended like banners from the ceiling at the Arsenale, these large prints (each measures 84 by 36 inches), printed on Japanese paper from woodblocks and further worked with watercolor, are superficially festive and, especially those of Kaho'olawe, fundamentally grim. The maps of the blasted island are augmented with small black-and-white etchings based on aerial charts—they seem ghostly, like X rays of planned detonations; the land itself generally appears barren and burnt. The Maui prints are brighter, often enlivened with warm shades of green, orange, and gold. All are surrounded by big,

rolling, abstracted waves in the manner of Japanese textiles. They provide the kind of interference pattern typical of Kozloff's work, in which currents of optical pleasure run across seas of trouble.

Another recent print project, this one published by SOLO Impression, is a pair of color lithographs—*Now, Voyager* and *Now, Voyager II* (2007); tondi based on celestial charts (c. 1660) overlaid with routes of space satellites marked in glitter [figs. 15, 16]. The sky, Kozloff believes—and her political convictions warrant attention—is the new space of warfare as well as intelligence gathering; unquestionably, satellites are revising the geography of the known, conquerable world. Even the number of dimensions in that world, Kozloff notes, is changing. As an active organizer of groups for political discussion and social protest, a role that requires vigilant intelligence and also a certain capacity for dreamy abstraction (call it optimism), she lately has found her interest focused on wars of the future and on the possible colonization of space. If the idea that space is our last active frontier is at least as old as Sputnik, it remains true that its frontiers are uncharted—which allows us to create maps no less fanciful than those drawn before the earth had been circumnavigated.

12. Kozloff, *Voyages #55: Galapagos Islands,* 2006.

Watercolor, acrylic, cast paper, 8¼ x 6¼ x 3½ in.

Collection William and Norma Roth

13. Kozloff, *Voyages + Targets,* 2006.

Thetis, S.p.A., Arsenale, Venice

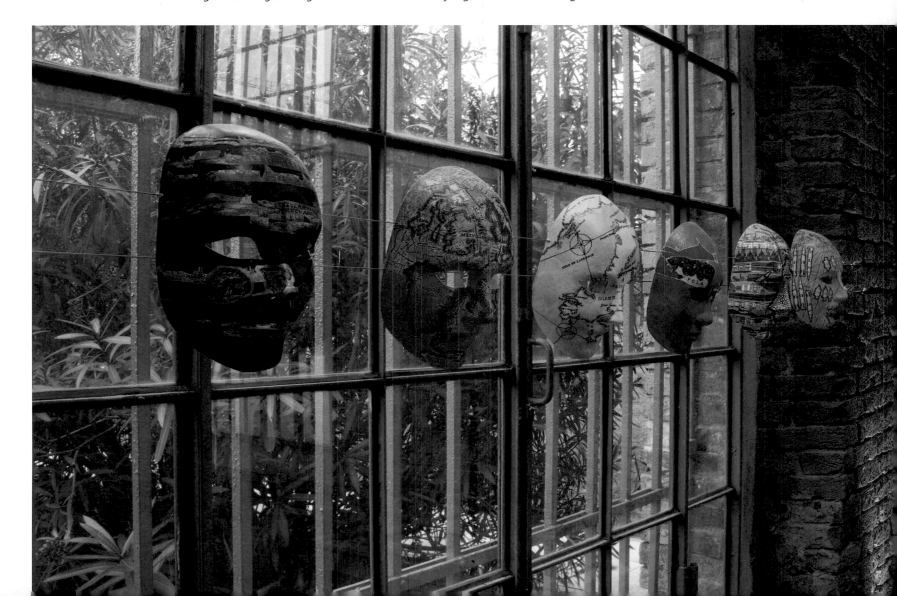

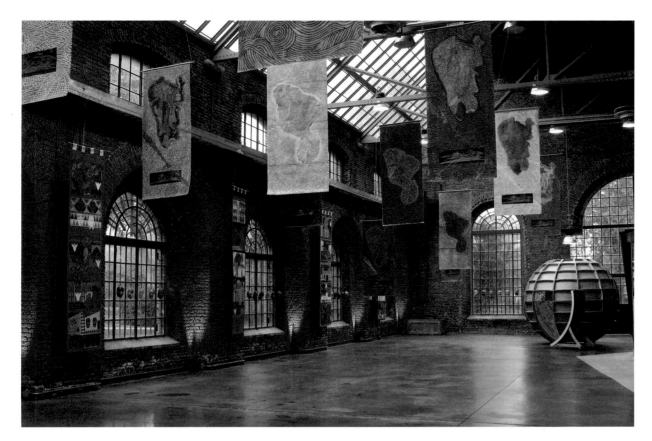

14. Kozloff,
*Voyages+Targets*, 2006.
Thetis, S.p.A., Arsenale, Venice

15. Kozloff,
*Now, Voyager*, 2007.
Lithograph with glitter,
31½ x 31½ in.
Courtesy SOLO Impression,
New York

16. Kozloff,
*Now, Voyager II*, 2007.
Lithograph with glitter,
31½ x 31½ in.
Courtesy SOLO Impression,
New York

Among this new series of tondi and mappae mundi are two circular canvases (2007) based on Baroque star charts, drawn in a millennia-old language of mythological figuration. In *the days and hours and moments of our lives* [pl. 42], the celestial atmosphere is depicted in deep, rich shades of reds and blues; in *the moments and hours and days of our lives,* the same template is rendered with white colored pencil on a spectral blue [fig. 17]. Also focused on atmospheric conditions is *Dark and Light Continents* (2002), a mostly black-and-white, 12-gore global projection that indicates, with circles of earthbound illumination that are sad echoes of astral light, those areas of the earth with the greatest light pollution—hence, the most obstructed view of stars [fig. 18]. Across the whole, constellations are sprinkled like pixie dust. Made for the Co+Ordinates exhibition is *Revolver,* a rotating tondo that Kozloff conceives as a replacement of the lost painting by Ambrogio Lorenzetti, thought possibly to be a map of Siena, that once hung in that city's town hall. Kozloff's slowly turning celestial map imagines the grotesque possibility of actual star wars; like her revolving globes, it invokes not only Earth's ceaseless rotation but also, she says, the endless, deathly interventions of mankind.

In a recent essay, the cultural observer Boris Groys notes that political theorizing is always oriented to the future. "Every ideological vision," he writes,

"is…a promised vision." By contrast, Groys continues, in a formulation that neatly inverts conventional understanding of the relationship between art and politics, "all ideologically motivated art necessarily breaks with this politics of deferral, because art is always made here and now.…The substitution of the ideological vision by the artwork is the substitution of the sacred time of infinite hope by the profane time of archives and historical memory."[9] But Groys also writes that contemporary artists' appropriation of work by other, earlier practitioners "brings the whole order of historical memory into disarray."[10] Disordering the progression of history is an ongoing project for Kozloff, and a link to many of her peers. But few are able to graft the insistently physical presence of visual objects onto the essentially visionary outlook of political engagement with the clarity, determination, and sheer grace that Kozloff sustains throughout her work.

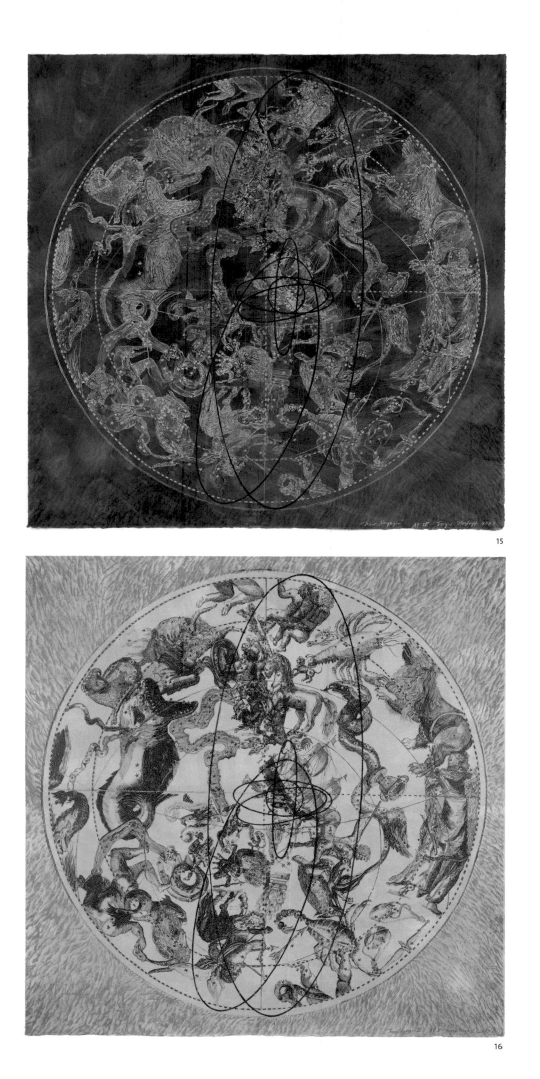

15

16

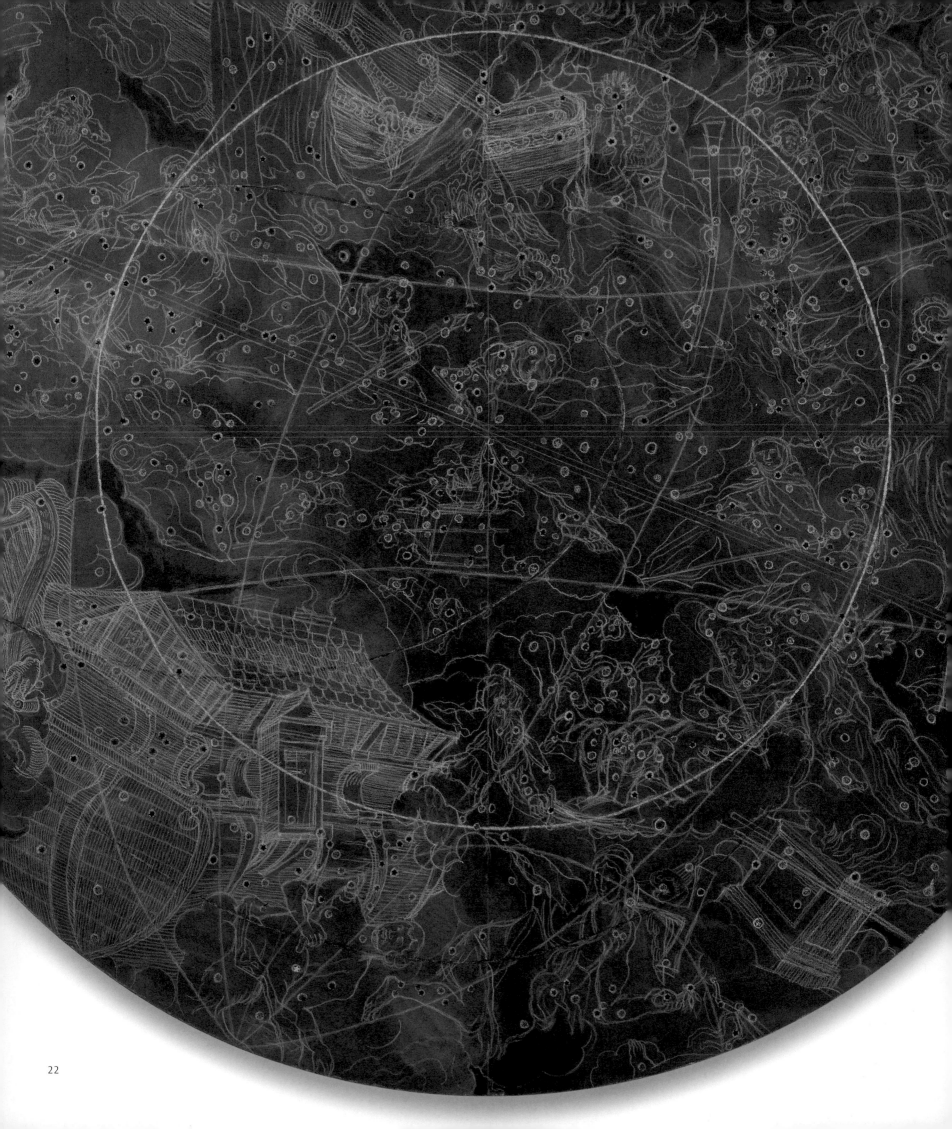

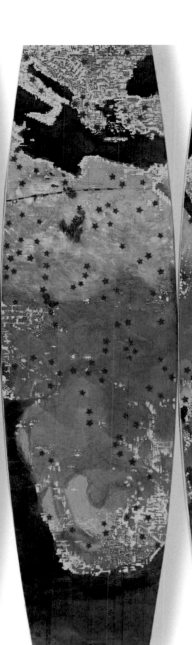

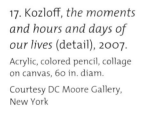

17. Kozloff, *the moments and hours and days of our lives* (detail), 2007.

Acrylic, colored pencil, collage on canvas, 60 in. diam.

Courtesy DC Moore Gallery, New York

18. Kozloff, *Dark and Light Continents* (detail), 2002.

Acrylic and collage on canvas, 96 x 192 in.

Courtesy DC Moore Gallery, New York

## NOTES

1. Moira Roth, "Conversation with Joyce and Max Kozloff," *Crossed Purposes: Joyce & Max Kozloff* (Youngstown, Ohio: The Butler Institute of American Art, 1998), 10.

2. Moira Roth, "Conversation with Joyce Kozloff," in ibid., 32.

3. Dava Sobel, *Longitude: The True Story of a Lone Genius Who Solved the Greatest Scientific Problem of His Time* (New York: Walker, 1995).

4. Bruce Chatwin, *Songlines* (London: Picador, 1987).

5. Italo Calvino, *Invisible Cities*, trans. William Weaver (London: Vintage, 1974) of *Le città invisibili* (Turin: Einaudi, 1972).

6. Robert Storr, "The Map Room: A Visitor's Guide," *Mapping* (New York: Museum of Modern Art, 1994), 10.

7. Jo Anna Isaak, *Feminism & Contemporary Art: The Revolutionary Power of Women's Laughter* (London and New York: Routledge, 1996), 16–17.

8. Lucy Lippard, "Joyce Kozloff: Global Plotting," *Joyce Kozloff: Voyages* (New York: DC Moore Gallery, 2007).

9. Boris Groys, *Art Power* (Cambridge and London: MIT Press, 2008), 8.

10. Ibid., 39.

# JOYCE KOZLOFF: MAPPAE MUNDI

Phillip Earenfight

In 1345 council members of the Republic of Siena commissioned Ambrogio Lorenzetti to paint a revolving map of the world to decorate a council chamber in the city hall (the Sala del Mappamondo) [fig. 20].[1] Although the painted map is long lost, the surviving fresco decorations on the chamber's west wall bear evidence of where it once hung. According to documents, the map represented Siena at the center, so that the republic's territorial possessions revolved around it as the map turned. Such a conceit was based on theological maps which positioned Jerusalem at the center of the earth [fig. 19].

Although striking in its own right, the rotating mappa mundi was one part of a series of decorations that represented vast battle scenes, seized castles, newly acquired territories, and finely dressed knights, all of which served to develop Siena's wealth and power [fig. 21].[2] Ambrogio's rotating map and the frescoes in the Sala del Mappamondo are about property, pride, and power. The decorations were conceived by men, painted by men, represent men, and made to inspire and be viewed by men. They are—to borrow the title of one of Joyce Kozloff's collage series—Boys' Art. Indeed, the intersection of maps, power, warfare, and gender has not gone unnoticed by historians:

> cartography has until very recently been an almost exclusively male activity; at the same time, most cultures construe nature as inherently female, so that making and using maps sustains one of the most fundamental social divides.... The making and using of maps can therefore be understood as expressions of power—of the technological, social, economic, political, military, and cultural ability to exert authority over the world and to modify it.[3]

Since the 1990s, Joyce Kozloff has turned to maps from all ages and regions, including those that inspired Ambrogio, as sources for her paintings, where they serve as metaphors for knowledge and power. As documents, maps—old and new—are often future oriented and suggest potential, be the ends good or tragic. Kozloff's painted maps are a collage of the cautionary, humorous, poetic, and critical. Her works combine a strong use of pattern and decoration with historical imagery infused with irony, blunt criticism, and tragedy.

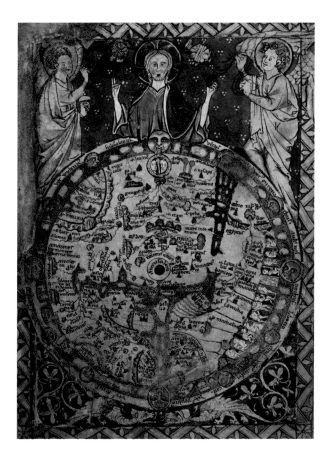

19. Mappa mundi from a Psalter, c. 1265. British Library, London, Add. MS 28681, Fol. 9
HIP/Art Resource, New York

In 1999 Kozloff arrived in Rome as a fellow at the American Academy to continue work on Knowledge, a series of mappae mundi she initiated the year before.[4] Over the course of the decade, she had been making works based on world maps and cartography as a means to explore issues of control, the poetics of travel, the limits of rational thought, and the insatiable hunger of imperialism. Once settled in the Eternal City, Kozloff continued working on Knowledge, which featured map-based images of all parts of the world, from antiquity to the Age of Discovery and the Enlightenment.

At first, Knowledge was a series of individual maps, each painted on a small fresco panel, which highlighted the culturally specific nature of all maps and the errors of early mapping. In *Knowledge #6: The New World, 1546*, Kozloff worked from a map based on a limited understanding of the lands that lay

20. West wall of the Sala del Mappamondo, Palazzo Pubblico, Siena
Scala/Art Resource, New York

21. North and east walls of the Sala del Mappamondo, Palazzo Pubblico, Siena
Scala/Art Resource, New York

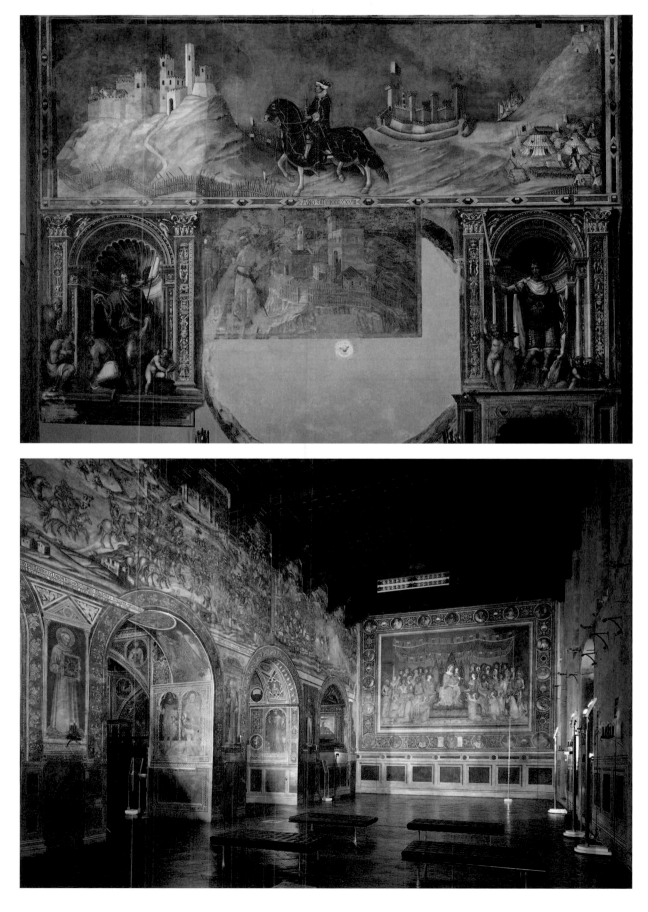

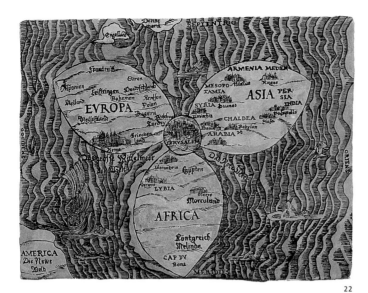

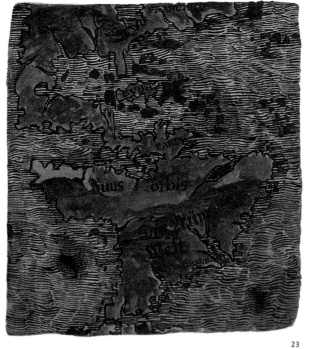

22. Kozloff, *Knowledge #49: The World, 1581*, 1999.

Fresco on panel, 8 x 10 in.

Collection Laurance S. Rockefeller Outpatient Pavilion, Memorial Sloan-Kettering Cancer Center, New York

23. Kozloff, *Knowledge #6: The New World, 1546*, 1998.

Fresco on panel, 8 x 7 in.

Collection Thomas and Jean Pedersen

22

23

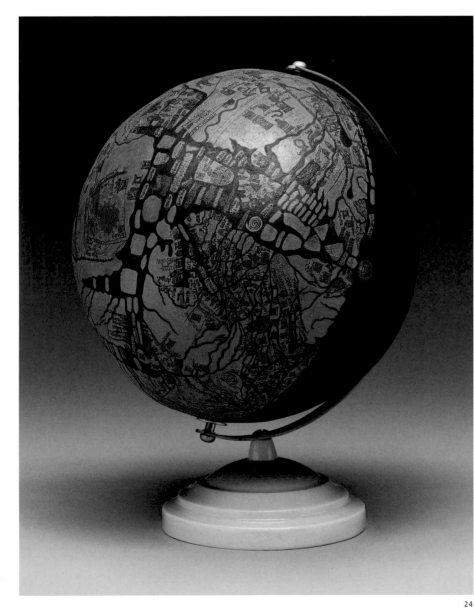

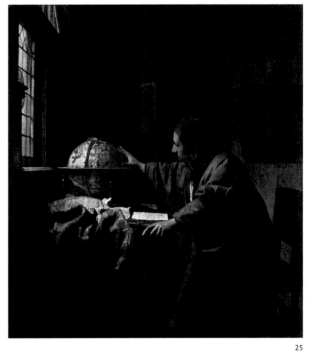

25

24

24. Kozloff, *Knowledge #75: 1290*, 1999.

Watercolor, acrylic, plaster, rope, cardboard, porcelain, 10⅛ in. diam.

Courtesy DC Moore Gallery, New York

25. Jan Vermeer, *The Astronomer*, 1668.

Oil on canvas, 19⅜ x 17¾ in.

Musée du Louvre, Paris; Réunion des Musées Nationaux/ Art Resource, New York

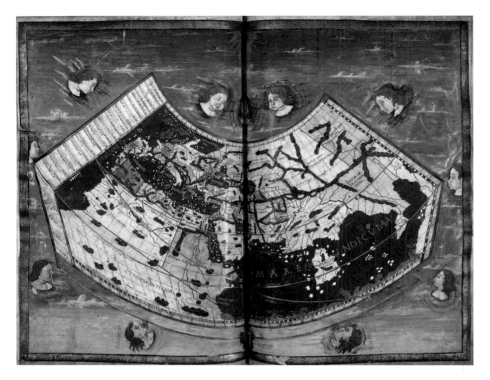

26. Claudius Ptolemaeus (Ptolemy), *Planisphere from Cosmography*, fifteenth-century copy. Biblioteca Vaticano, Vatican City, Cod. Lat. 463, fol. 75v–76r

Alinari/Art Resource, New York

27. Kozloff, *Targets*, 2000.

Acrylic on canvas over wood, 108 in. diam.

Courtesy DC Moore Gallery, New York

between Europe and China [fig. 23]. In 1546 the map represented a considerable body of information about the New World. However, by extracting the map from its context and transforming it into a contemporary fresco, Kozloff makes obvious the now humorous gap in the cartographer's understanding of the world, which today serves as a metaphor for intellectual fallibility. Along similar lines, *Knowledge #49: The World, 1581*, presents Africa, Asia, and Europe in the form of a flower, centered—like Lorenzetti's sources—on the city of Jerusalem [fig. 22]. While the flower served the original cartographer's aim of organizing the world according to a symbol of life, Kozloff's fresco of the map underscores the degree to which this map, and by extension all maps, reveals the cartographer's worldview. As frescoes, Kozloff's paintings appear as fragments from an ancient archaeological site or as though pried from the wall of the Sala del Mappamondo. Their permanence belies the fleeting nature of her original sources and the "knowledge" on which they are based.

After arriving in Rome, Kozloff continued working on the Knowledge series but shifted from flat fresco panels to globes, which she plastered or gessoed and painted in watercolor and acrylic. For these works Kozloff projected flat maps onto the spherical surface, reversing the problem of distortion that plagues all makers of flat mappae mundi. For *Knowledge #75: 1290* [fig. 24], Kozloff incorporates aspects of the Hereford Map, which presents the world as it was known to artists such as Ambrogio Lorenzetti. But in this worldview, Kozloff has painted half of the sphere dark, as if in shadow. By showing the cartographer's known

world in light, Kozloff describes a worldview lacking any grasp beyond its borders, unaware of the darkness on the other side. Through historic maps such as the one used here, Kozloff implies that we are all blind to the limitations of our knowledge.

Implicit in many of Kozloff's mappae mundi is the power of knowledge, however imperfect, suggested by the mapping enterprise. During the Age of Exploration, a favorite period for Kozloff, maps were not simply expressions of a worldview; they were tools made in the service of resource acquisition and in the competition and conflict that followed. Maps led to a sense of the world and its inhabitants as something to be known, experienced, changed, possessed. Rooted in prior documentation but oriented for future use, maps often convey a sense of optimism and potential [fig. 25]. Yet, as a repository of information, the resulting power derived from maps, like all power, has been distributed disproportionately and used to exercise authority over the land and the people the maps measure and plot.[5] The moment ancient cartographers such as Ptolemy realized that their known world was but a small segment of a larger sphere [fig. 26], the remaining surface of the sphere—like the dark side of Kozloff's globe—begged the curious to explore it. In the hands of controlling minds, such knowledge was eventually harnessed to serve the ambitions of those in the light— at the center—at the expense of those in the dark—on the margins.

While working on the globes for Knowledge, Kozloff embarked on one of her most overtly political works to date—*Targets* [figs. 27, 28]. Desiring to make a larger, inhabitable globe, Kozloff began working on a

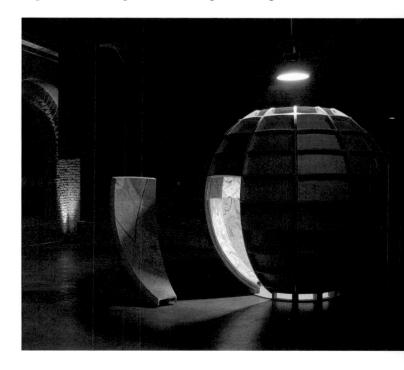

three-dimensional painting/sculpture nine feet in diameter. From the outside, one sees that the "painting" is made of twenty-four wedge-shaped, curved plywood panels that come together to form a sphere, their joints forming the latitudes and longitudes. But as is the case with so many buildings in Italy, the simple, unassuming exterior gives way to a richly decorated interior space. A person enters the sphere through a portal made by drawing back one of the wedges. Inside, the viewer encounters a world of colors, patterns, and text, each segment oriented in contrasting directions. The "equator" formed by the joining of the upper and lower wedges provides an artificial horizon in an otherwise disorienting space. A quick tally of the maps reveals that each of the segments represents a country bombed by the United States since 1945. Unlike the maps from Knowledge, which are playful and at times curious in their inaccuracies, the maps in *Targets* are coldly clinical, precise. In these maps one sees through the eyes of a pilot, miles above identifiable life. Despite the impulse to recoil, the all-encompassing sphere provides nowhere to retreat. The echo of the viewer's voice from inside, amplified by the shape of the globe, intensifies the disorienting experience. Only the oculus offers a momentary respite. But in the context of aerial bombing, looking up is hardly comforting.

Over the course of the last two centuries, many artists have represented the miseries of war by focusing on the reality of civilian casualties. Even so, while Callot, Goya, Manet, and Picasso graphically depicted the fallen and mutilated, thereby sparing the darker side of viewers' imaginations, Kozloff's rich colors and sharp abstraction do not limit the horror—we are left

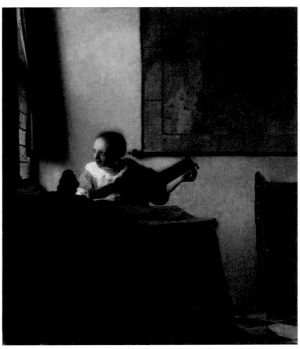

28. Kozloff, *Targets* (detail)

29. Jan Vermeer, *Woman with a Lute*, c. 1660.

Oil on canvas, 20¼ x 18 in.

The Metropolitan Museum of Art, New York; Bequest of Collis P. Huntington, 1900 (25.110.24); The Metropolitan Museum of Art/Art Resource, New York

30. Kozloff,
*Buffalo Dance,* 1973.
Acrylic on canvas, 79 x 67 in.
Brooklyn Museum, Brooklyn

31. Kozloff,
*Hidden Chambers,* 1976.
Acrylic on canvas, 78 x 120 in.
Collection Harvey and Françoise
Rambach

to picture what happens at the civilian level. The maps and the information on which her paintings are based are the means to unimaginable ends. Knowledge and *Targets* consider the power of information through the metaphor of cartography, to argue for a world in which maps serve peaceful ends.

Although Kozloff's perspective alternates from the comic to the tragic in Knowledge and *Targets,* both projects demonstrate the artist's brilliant use of color and pattern. In this, Kozloff upholds a longstanding tradition among cartographers, that maps be both informative and visually stunning. This practice was certainly in mind when the Sienese commissioned Lorenzetti to create the revolving mappa mundi for the town hall. Likewise, during the Age of Exploration, maps and globes were treasured as much for their information as for their design and decoration. As Vermeer portrays in the *Woman with a Lute* [fig. 29], a map could be a wall decoration while subtly identifying citizens by their land, their expanding nation, the means to their wealth, and their place in a growing global economy. Maps can be both beautiful *and* powerful. Although sometimes little more than lines and text captions, what separates the mundane map from the truly spectacular one is how the cartographer has used pattern and color to improve a map's legibility and to make it visually striking. In all of her map-based paintings, Kozloff indulges in this aspect of the cartographer's art. This is true in *Targets* and Knowledge, where she frequently departs from the original schemes and invents powerful color combinations.

While maps have been at the center of Kozloff's work for the past fifteen years, her interest in pattern and color dates back to the early 1970s, when she began to direct her style away from the influences of the hard-edged Minimalism then practiced in most art schools [fig. 30], becoming one of the central figures in the Pattern and Decoration Movement.[6] The artist reflects: "My reaction to minimal art was that you got it too fast, and you missed what I like about art, which is the slow take. So I try to hold people's attention by giving them a lot of things to look at. I give them scale jumps, and in some pieces, changes of materials, surfaces, textures, and imagery."[7] Her rejection of purely flat intersecting planes and her move toward tightly integrated repeating patterns were inspired in part by a growing interest in traditional textiles, mosaics, and tile work, such as those she saw during two months spent in the Southwest (1972) and three she spent in Mexico (1973). As Kozloff began to make studies of these designs and incorporate them into finished paintings and prints, her work questioned the art world's rigidly enforced primacy of academic abstraction and conceptual art over pattern and decoration. Kozloff's incorporation of these decorative patterns expressed her interests in social, political, and feminist issues. Kozloff was drawn to the patterns and decorations in part because they were made by "anonymous" artisans and women, a feature that fused and reinforced her social and aesthetic concerns. Decoration challenged the male-dominated hierarchies of contemporary abstraction. "Pattern painting was a reaction against the

30

31

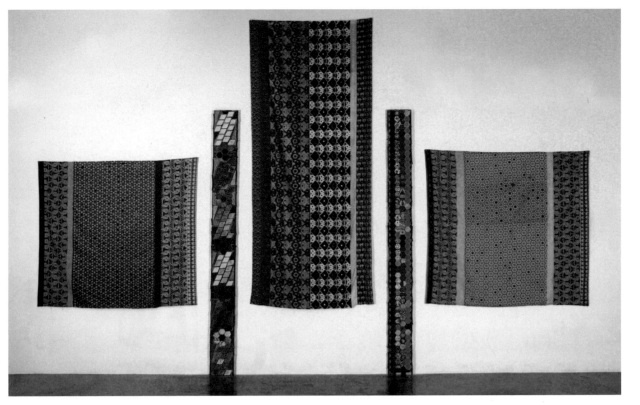

Reassembled for *Claiming Space: The American Feminist Originators* (2007), Katzen Center, American University Museum, Washington, DC

I · MAPPAE MUNDI

pieties of modernist thinking," Kozloff notes, "and I saw the politics of art as connected with larger political issues."[8]

Over the course of the early 1970s, Kozloff's travels to Italy, Mexico, Morocco, Spain, and Turkey brought her into contact with architecture rich in decorative features that quickly found their way into her paintings, which became for the artist "a private metaphor for travel, paralleling the experience of walking through a bazaar or the streets of an unfamiliar city."[9] Kozloff was not alone in her attraction to patterns and decoration found outside the canon of Western art. Painters such as Robert Kushner, Valerie Jaudon, Robert Zakanitch, Tony Robbin, Miriam Schapiro, and Kim MacConnel, as well as artist/critic Amy Goldin, were interested in similar issues. In 1975 Kozloff cofounded the Pattern and Decoration Movement in New York, which acted as a loose forum for considering and giving voice to the artists' social and artistic concerns.[10] Viewers seized on those qualities in the works traditionally associated with feminine practices (quiltlike, decorative) and praised or criticized them accordingly [fig. 31].[11] Kozloff remarked, "I always need to emphasize the political content of my work, as it has been missed or misread. My sensuous textures seem to blind viewers to the art's critical and deconstructive content."[12] Kozloff's works from this period are faithful to their sources, which she cites as crucial to her aesthetic and social aims, but critics expecting a greater degree of transformation found

this trait objectionable. Kozloff notes, "It's always seemed very important to me to acknowledge the sources, and that's one of the reasons I don't transform them to the point where they're not recognizable."[13] Nevertheless, in her recent works the sources carry a more readily identifiable point, and the juxtapositions are more overt and more quickly decoded. While critics continue to debate the place of the Pattern and Decoration Movement in late twentieth-century art, Kozloff's earlier, ornamental art serves as a source from which she draws her current projects. This is not to reduce the Pattern and Decoration Movement to a means toward other ends, but rather it recognizes that the force of Kozloff's current work is unimaginable without her having participated in it.[14]

Kozloff's interest in pattern and decoration during the 1970s led to installations, beginning with *An Interior Decorated* [fig. 32].[15] The project involved her conscious shift from painting on large independent canvases to producing tiles and fabrics that were to be integrated into a specific setting. This shift to an architectural scale was inspired by the public and sacred buildings she had seen in Mexico and Morocco earlier in the decade. As Kozloff reflects, "I looked at [my paintings]...and couldn't figure out what they were *for*.... At that point I decided to move onto the walls and to decorate a room—that is, an environment in which the ornament would be literal and physically palpable."[16] *An Interior Decorated* represented for Kozloff a "personal anthology of the decorative arts."[17]

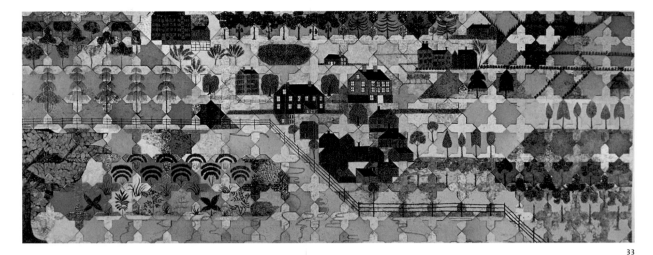

33. Kozloff, *New England Decorative Arts*, 1985.

Ceramic tile, 96 x 996 in.

Harvard Square Subway Station, Cambridge, Massachusetts

34. Kozloff, *New England Decorative Arts* (detail)

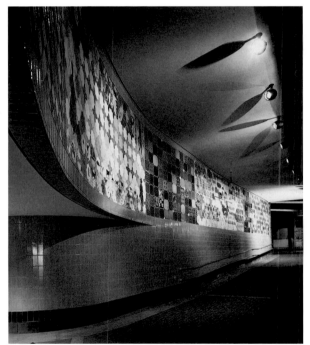

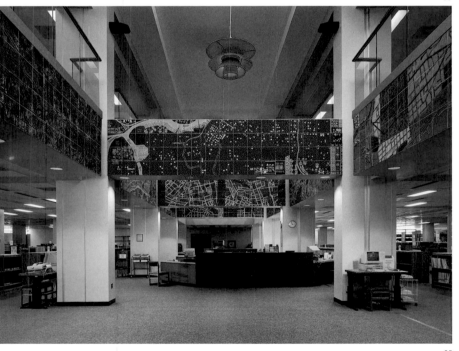

34

35

35. Kozloff, *Around the World on the 44th Parallel*, 1995.

Twelve ceramic tile murals, each 48 x 204 in.

Memorial Library, Mankato State University, Mankato, Minnesota

36. Kozloff, *Around the World on the 44th Parallel* (detail)

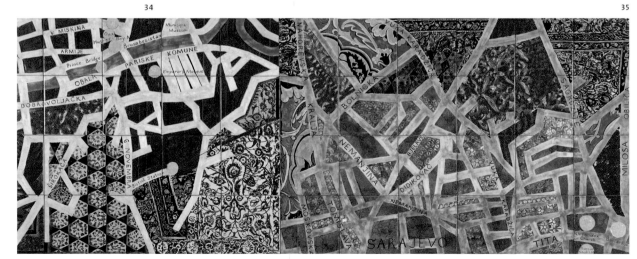

36

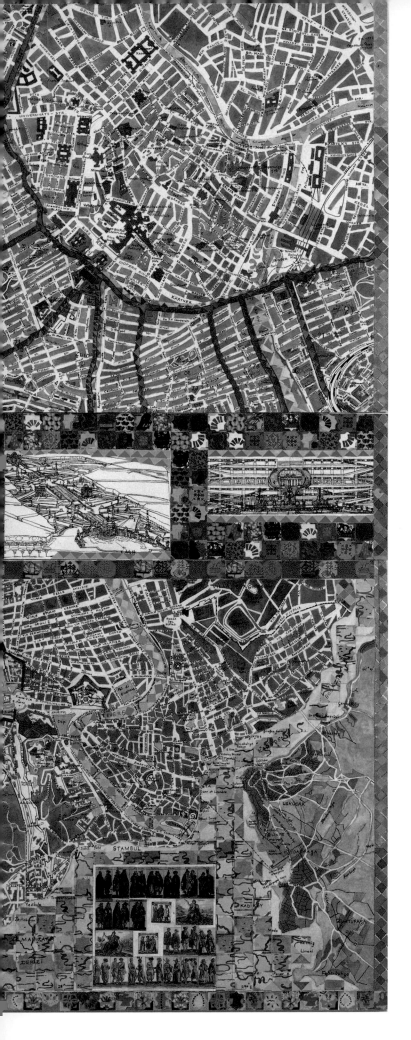

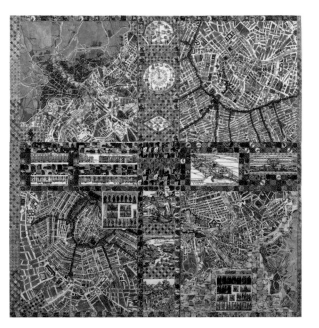

37–38. Kozloff,
*Imperial Cities*, 1994.

Watercolor, lithographs, collage
on paper, 55 x 55 in.

Collection Patricia Conway

It remains a pivotal work in her early career, and elements of it can be seen in a number of her later mapping projects.[18]

As she was completing work on *An Interior Decorated*, Kozloff received the first in a series of public art commissions, most of which were large-scale tile and mosaic installations in architectural spaces.[19] The projects, which would dominate her work for the next two decades, involved creating mural decorations for transportation centers, public buildings, and corporate headquarters that would speak to a broad audience and cover large, irregularly shaped spaces. Like the earlier canvases, her public art projects often combine various historic and contemporary sources and references [figs. 33, 34]. Unlike her strictly studio work, which was governed entirely by her interests, working on public art projects involved collaboration among a number of constituents, including the patron, architects, community boards, art agencies, and the public.

Because such projects led Kozloff to work extensively in different cities, researching their histories and their transportation systems, it is no surprise that maps, historic and contemporary, should find their way into the iconography of the projects and, because of their strong two-dimensional patterns, into her artistic vocabulary. In 1991 Kozloff joined a group of artists, architects, and urban planners to work on Riverside South, a development project in New York. Although the group's visionary social and environmental plans went unrealized, Kozloff made some discoveries of her own. "As I worked with old diagrams of that area of the city, adding new ideas for the future, I realized that in my own work, maps could become a device for layering multiple readings."[20] Two years later Kozloff was able to use maps in a public commission

for the Memorial Library at Mankato State University. *Around the World on the 44th Parallel* (1995) consists of twelve ceramic tile murals that incorporate maps and other topographic and decorative references to various cities located on the same latitude as Mankato, Minnesota [figs. 35, 36]. One of the cities represented is Sarajevo, which was under military attack while Kozloff was working on the project. Interwoven in the city's map are decorative patterns from a number of Sarajevo's mosques, ones that were subsequently destroyed during the war in the Balkans. Six years later Kozloff returned to maps of the former Yugoslavia for *Targets*.

After more than fifteen years working on public art commissions, Kozloff grew disillusioned with politics during the Culture Wars of the 1990s and returned primarily to private work. As Kozloff explains, "I refuse to censor myself. That's why I pulled back from public art, a field that has become increasingly restricted. These days, administrators are nervous because controversy continually arises over a wide array of issues. Proposals are closely examined and artists directed toward safe content."[21] As she withdrew from public art commissions, she returned to the studio with a wealth of experience and newfound inspiration in map-based imagery.

In cartography Kozloff found images and metaphors that were as complex, layered, and multivalent as her patterns and decorations. And this new source suited her commitment to global issues and politics: "[Maps] have become a versatile structure for my long-term passions: history, culture, decorative and popular arts. By overlapping systems of information, I intuitively make connections which emerge in a literal and conceptual collage."[22] Among the contemporary artists who have used maps and mapping in their work, Kozloff's sensitivity to color and pattern as well as to methods of working with large-scale decorative projects enable her to capitalize on the demands presented by the overwhelming volume of visual information embedded in any given map source.[23]

Kozloff began her independent map-based works in the early 1990s. Among them is *Imperial Cities* (1994), which splices and interweaves sections of Amsterdam, Istanbul, Rome, and Vienna alongside images appropriated from the margins of old maps, specifically representations of conquered territories and peoples [figs. 37, 38]. *Imperial Cities* is among the first of her works to consider global politics and territorial conquest through the metaphor of cartography.[24] By combining the four maps, Kozloff underscores common denominators among the cities, suggesting that as imperial capitals they shared certain physical features in their shape and in the minds of those that shaped them. The collage is remarkably intricate and intense, and these qualities point to a fundamental aspect of Kozloff's artistic tendencies. As far back as 1975, Jeff Perrone, a decorative artist and early supporter of the Pattern and Decoration Movement, astutely noted that Kozloff's basic aesthetic is rooted in collage: "[T]he formal characteristics of the work…take on greater resonance because they have been decontextualized and then layered—not merely juxtaposed."[25]

Kozloff followed with a series on colonialism with works entitled *The Spanish Were Here, The French Were Here,* and *The British Were Here* (1995).[26] In these collages, the interweaving of map, pattern, and cutout is at its most dense and rich. For each collage, Kozloff integrates references to each nation's respective colonies (Havana, Cholula, and Quito; Quebec, Port-au-Prince, and Fez; and Cairo, Bombay, Madurai, and Dunedin), illustrating how an imperial capital imposes its image on its colonial centers and the degree to which those in

39. Kozloff, *Mekong and memory,* 1996.

Ceramic tile, wood, hand-colored etchings, watercolor, acrylic on paper, 120 x 90 x 48 in.

Courtesy DC Moore Gallery, New York

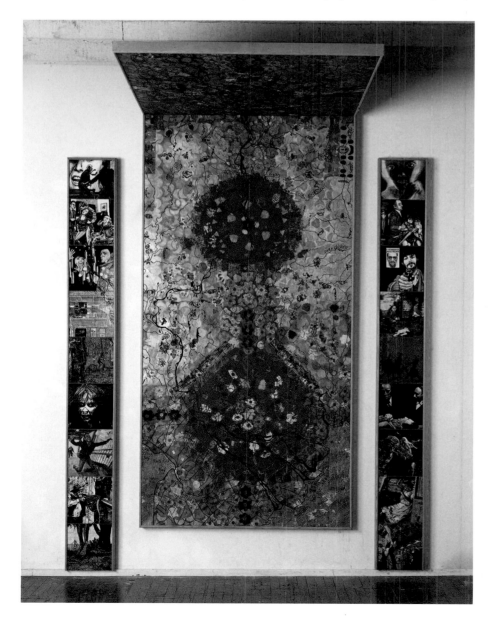

40. Kozloff, *Silk Route,*
2001.

Acrylic, collage on canvas,
dimensions variable

Courtesy DC Moore Gallery,
New York

power stamp their order on subordinates, shaping both the topography and the mentality of their subjects as part of a larger imperial state. In many ways, these collages are not dissimilar to Kozloff's early ceramic tile works, where she integrates decorative patterns found within a city. Here, however, the sources are not decorative features but maps and images of the city, collaged together under the same aesthetic principle. What is different is that the content and associations generated by Kozloff's current sources are narrower than before, and the meaning of the choices and juxtapositions more definite. The viewer, therefore, has a more direct point of entry into the work. But apart from pattern and decoration, the works also speak of Kozloff's fascination with cities and incessant travel:

> I have an insatiable visual appetite. I'm no sooner finished with one trip than I'm plotting the next one. I'm not satisfied with my own surroundings except on a temporary basis, and as the years go on this addiction to travel has only gotten worse. Once I leave New York, I just go with the flow and whatever happens happens. I want to see everything I can within the amount of time allotted. So there is an urgency to it.[27]

After these collages, Kozloff turned her attention to maps of rivers and routes, producing a number of paintings that represent waterways and byways as metaphors of movement and circulation. *Calvino's Cities on the Amazon* (1995), *Mekong and memory* (1996), *Bodies of Water* (1997), and *Silk Route* (2001) are at once responses to Kozloff's travel—via books, films, and direct experience—as well as further investigations into the seemingly endless ways of approaching

and interpreting her cartographic sources. While thoroughly anchored in her current work on maps, *Mekong and memory* [fig. 39] also recalls aspects of *An Interior Decorated.* Likewise, *Silk Route* [fig. 40], which the artist began in 1998, anticipates features in *Targets.* After completing these projects, Kozloff began the fresco series *Knowledge.*

When Kozloff returned to New York from Rome in 2000, maps, politics, war, and gender issues continued to inspire her work, as is demonstrated in a series of paper collages that became Boys' Art.[28] The project began as twenty-four carefully wrought graphite drawings, each representing the plan of a battleground: Nagasaki, Rocca d'Anfo, Havana, Falkland Islands, Panipat, Iwo Jima, Mindanao, Mombasa, Malta, Sevastopol, and Antibes. Kozloff made the drawings during a residency at the Bogliasco Foundation, outside Genoa. She arrived in Italy the morning of September 11, 2001, onboard one of the last American flights to arrive at its scheduled destination that day. With the bulk of her supplies held up in customs, Kozloff spent the entire nine-week residency working on the monochrome drawings. Upon her return to New York, Kozloff sensed that the drawings were "too precious" and viewers failed to comprehend their political intent. Seeking to sharpen the content of the drawings, she thumbed through a box of battle drawings made by her son Nikolas when he was a child (he's thirty-nine now) and decided to incorporate copies of them as collage elements into her drawings. Merging these with combat imagery culled from a variety of other sources, such as Plains Indians, Leonardo da Vinci, Tin Tin, and others, Kozloff assembled hundreds of tiny cutouts on the graphite drawings, amassing

them in attack formations like a field marshal organizing troops on a battle plan [fig. 41]. Such maneuvers remind us of board games (Stratego,™ chess, Risk™) and the legions of green plastic army men that are a staple in virtually every boy's box of toys.

But for all their seriousness, the collages—particularly given the insertions of Nik's warriors—are cleverly conceived and the juxtapositions witty. Indeed, as Kozloff notes, "My art has become funnier over the years. I don't know if other people find it so, but I amuse myself more. In my education, there was no humor in the ideology of modernism; everything was rather grim. It was a long time before I loosened up and made some jokes…I like to juxtapose things that are not humorous separately, but ludicrous when together."[29] Kozloff's humor counterbalances the seriousness of the subject without blunting the point. The viewer grins knowingly but nervously while reconciling the playful imagery, the real consequences of armed conflict, and the tender age at which we toy with war.

In collages such as Boys' Art and the earlier colonial series (*The British Were Here*, etc.), Kozloff's aesthetic horror vacui could not be further from her early studies in hard-edged Minimalism. Regarding her tendency to fill the surface with imagery, Kozloff remarks, "I can't say why I do that, but it's getting worse! I don't categorically approve of the phenomenon, nor do I have an ideology that density and intricacy are 'better' than simplicity. Nevertheless, I'm attracted to that aesthetic out in the world and have a compulsion to emulate it in the studio."[30]

In 2002, Kozloff produced two large-scale paintings, *Dark and Light Continents* [pl. 21] and *Spheres of Influence* [pl. 22]. Similar in scale and concept to *Targets*, the pieces are made of twelve narrow, tapering canvases, which together form a single painting. However, in these works Kozloff flattens the world—and the canvases—into one of those projections we

41. Kozloff, *Boys' Art #7: British Fleet, Falkland Islands* (detail), 2002.

Graphite, collage, colored pencil on paper, 12 x 18 in.

Private collection

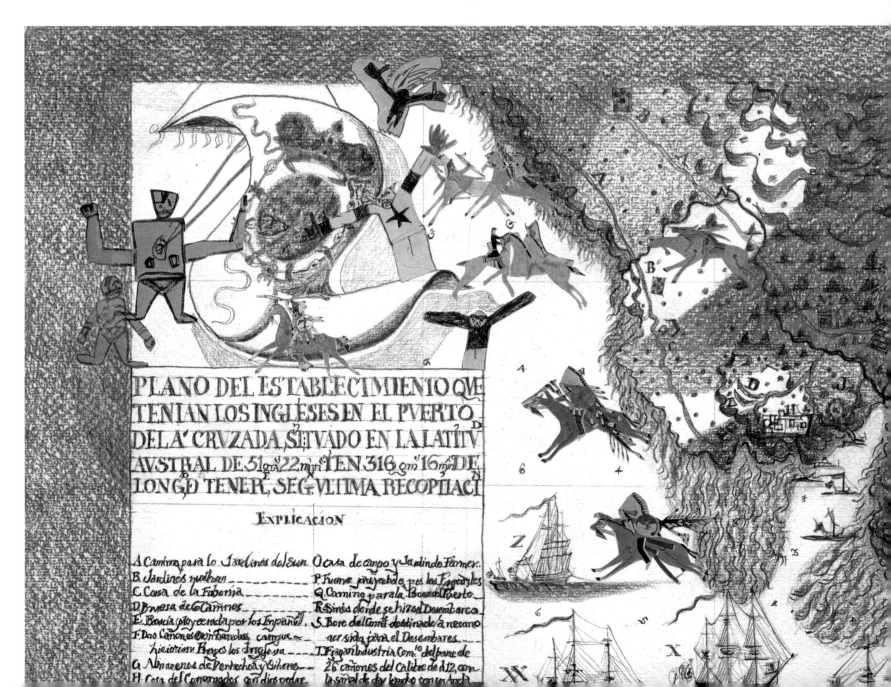

recall from geography class, with the twelve separate panels linked together at the "equator" to form an eight-by-sixteen-foot canvas.

For *Spheres of Influence,* based on an atlas of the Greco-Roman world, Kozloff assigned to each of the separate canvases a different region from around the Mediterranean; in this case, each panel represents part of that ancient world overlaid with mapping imagery drawn from U.S. Government Tactical Pilotage Charts. While Kozloff is not the first to draw parallels between the Roman Empire and the United States, seeing their similarities illustrated in this manner makes the point all the more succinct.

Of the same shape but with a different focus, *Dark and Light Continents* presents a cohesive projection of the world based on a satellite photograph of Earth's surface at night. Kozloff's painting not only indicates relative energy consumption—and, by implication, technological development and wealth—it is also a metaphor for the legacy of the Enlightenment. It is no wonder, then, that the mother of the Enlightenment (Europe) and its child prodigy (the United States) glow so brightly. Those who first seized the power of rational scientific thought and fueled it with ambition, greed, and power were destined to rule and shape those in shadow, whose lives, lands, and resources serve those in the light.

In *Rocking the Cradle,* a three-dimensional work, Kozloff painted the interior of a wooden cradle with an antique map of Mesopotamia superimposed with the battle plan for the invasion of Iraq in 2003 [fig. 43]. The work operates on visual and verbal levels. When displayed in 2004, *Rocking the Cradle* was accompanied by a sign that invited the viewer to rock the cradle "and complete the pun: I rock (Iraq) the cradle of civilization."[31] As is frequently the case in Kozloff's most political works, humor disarms the viewers and holds their attention. *Rocking the Cradle* becomes even more subtly disturbing when one realizes that this interaction highlights the patronizing way in which the United States treats other regions and their citizens.

In autumn 2006 Kozloff presented her work at Thetis in the massive Arsenale complex in Venice [figs. 44–46]. The cavernous hall provided Kozloff with the opportunity to draw upon more than thirty years of experience, dating back to *An Interior Decorated*

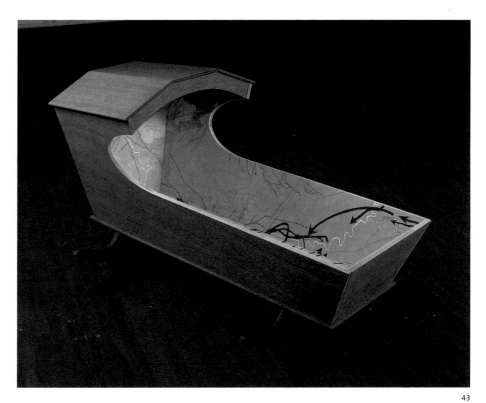

43

and the numerous public art projects, to focus on her recent work with maps and produce a single, sweeping installation. As the venerated shipyard for the once dominant Venetian navy, the Arsenale occupied a central role in the city's rise to maritime supremacy, colonial expansion, and considerable wealth during the late Middle Ages. Now refitted in part as the offices of Thetis S.p.A.—a marine and civil engineering firm committed to "knowledge for a better environment"—the Arsenale was the ideal location for an installation of Kozloff's work. For this project she featured *Targets* as well as a new series of works entitled *Voyages,* which included eighteen large woodblock prints [fig. 45], a series of painted and collaged carnival masks, and an assemblage of painted cut-paper-on-canvas banners.

Kozloff made the woodblock prints at HuiPress in 2005 and 2006 during a pair of residencies at the Hui No'eau Visual Arts Center on Maui. The prints feature two of the Hawaiian islands, Maui and Kaho'olawe. The seven-by-three-foot prints are dominated by a map-based image of the island of Maui or Kaho'olawe integrated into the wavelike decorative surround. Each of the prints is made from five separate woodblock impressions combined with watercolor to create a remarkable textured effect. The subtle layering of translucent inks on the long-fiber Japanese kozo paper is particularly stunning. The rich texture of the island hovering on the sea draws in the viewer. However, at the bottom of the Kaho'olawe prints Kozloff has inserted via *chine collé* an etching showing a profile and aerial view of the island with text and lines remi-

A

42

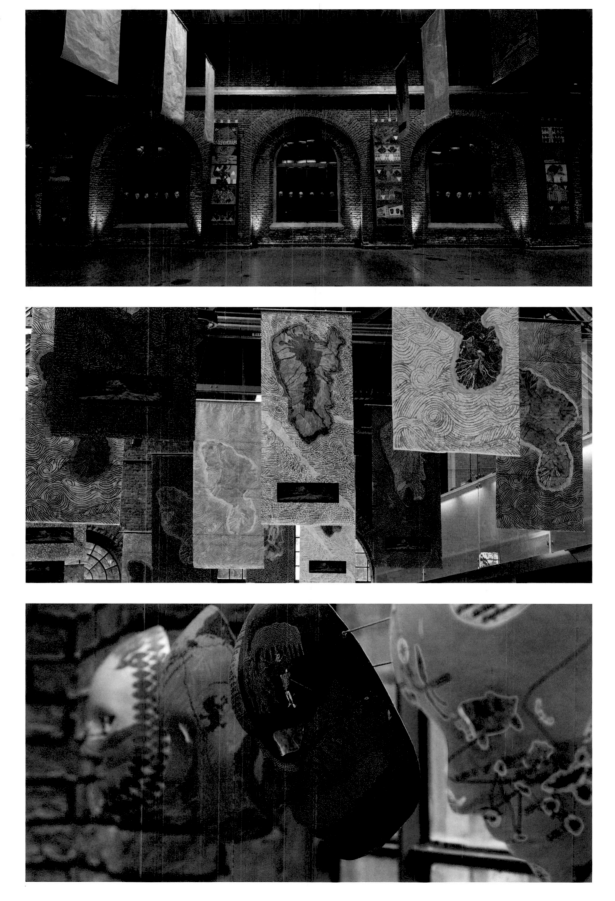

44–46. *Voyages+Targets,*
2006. Thetis, S.p.A.,
Arsenale, Venice

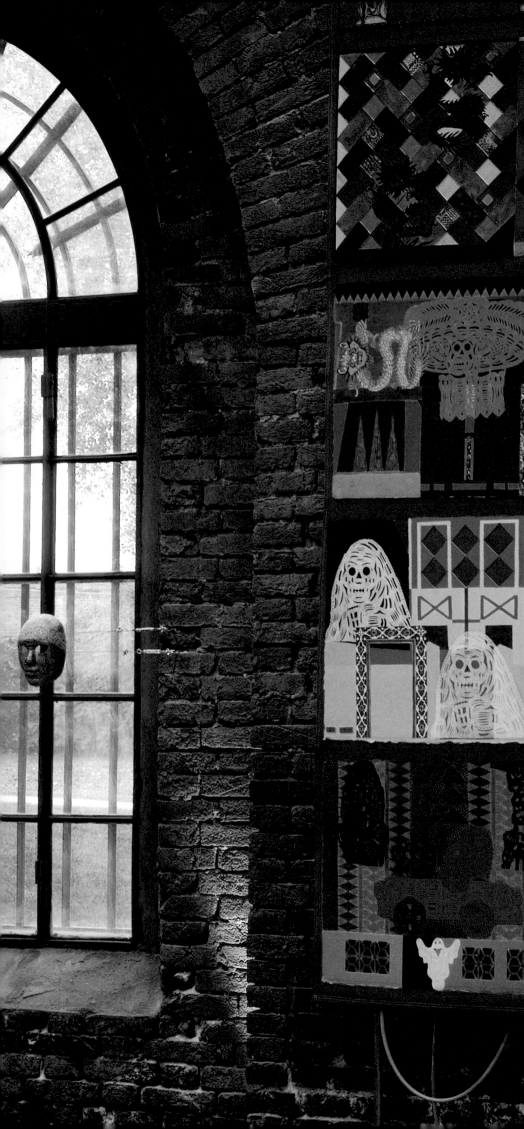

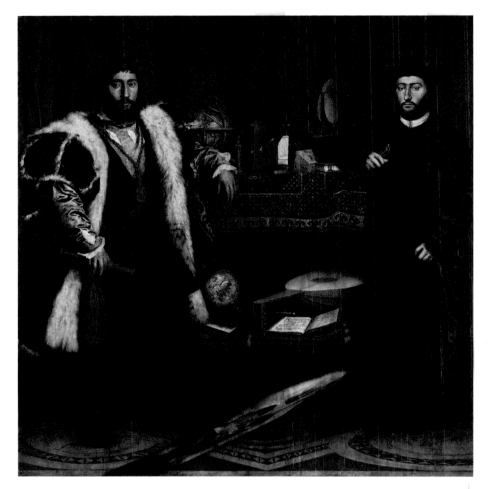

47. Kozloff, *Voyages: Carnevale V*, 2006.

Acrylic, watercolor, collage on paper mounted on canvas, 122½ x 33 in.

Courtesy DC Moore Gallery, New York

48. Hans Holbein, *The French Ambassadors*, 1533.

Oil on oak panel, 81½ x 82½ in.

National Gallery, London; Art Resource, New York

what was then one of the richest cities in the Christian world [fig. 42]. The mask can be read as a mirror, one that reflects events in the face of its wearer. Alternatively, masks identify the wearer with the events and places represented. For as much as masks enable one to momentarily take leave of oneself—hence the attraction of carnival—they also rob one of individuality; they stand in place of independent thought. Within the context of Voyages, the masks represent identities to be donned and traded at will. Kozloff's use of collage is playful and witty and in the spirit of carnival, but as in Boys' Art, seriousness lies just below the decorated surface.

In addition to *Targets* and the masks, the installation at Thetis also featured eight painted, cut-paper banners that bring together Venetian carnival masks, Mexican Dia de los Muertos deathheads, grimacing faces from Japanese kites, Chinese dragons from New Year's celebrations, ornament from tiled mosques in Isfahan, and American Halloween witches and ghosts [fig. 47]. Among the most numerous and recognizable elements are the skulls and skeletons, which cast a raucous but unnerving overtone, inserting a mischievous yet sharp reference to consequences unseen in *Targets*. Although the skeletons dance like comic vestiges of ancient superstitions, alongside *Targets* they resemble the medieval Dance of Death. Numerous skulls appear as the counterpart to the masks. Ironically, the skeletons are more lively than their living mask counterparts. Exhibited together in the Arsenal, they appear as the Quick and the Dead—a modern memento mori. In this sense, they recall Hans Holbein's *French Ambassadors* [fig. 48], with its references to terrestrial and celestial realms, power, wealth, lush decorations, and—in the foreground—the skull of mortality.[32] Stylistically, Kozloff's banners are direct descendants of her work in Pattern and Decoration and are reminiscent of her earlier textile prints for *An Interior Decorated*, but in this instance the visual vocabulary and its sources are readily identifiable and their intent more easily deciphered.

Taken in its entirety, the installation at the Arsenale in Venice drew together Kozloff's interest in history, mapping, decoration, power, and gender; it was a veritable Sala del Mappamondo at the very site where the Venetians had assembled the means by which they achieved their signature military domination. However, unlike the halls of state where decorations featuring maps, territories, and battles glorify and justify the pursuit of nation building, Kozloff's decorations present a sobering rejoinder, one that reminds us of the cost of such ambitions.

As the exhibition at the Arsenale was coming to a close, Kozloff was already at work on a series of circular paintings—tondi—representing maps of the

niscent of the tactical maps used for *Targets*. Perhaps less evident to most visitors, Hawaiian residents would readily recognize the signature shape and profile of the island, its cultural and historic importance, and its use since mid-century by the U.S. military as a bombing range. The visual richness of the prints creates a visual/intellectual conflict that forces the viewer to reconcile image with content, beauty with power.

Like the woodblock prints, the sixty-four decorated carnival masks feature painted designs and collage elements based on maps of islands, including Borneo, Lesbos, Sumatra, Newfoundland, and Galapagos. Most of them are of known sites, but there is room for invention: *#24: men's island, women's island, boats going back and forth*, *#15: Il Mondo, cartographic board game*, and *#17: Three Worlds*. Whereas some of the masks appear to be a playful twist on local tourist kitsch, others reveal more than a decorative surface. In *#12: Venetian War Fleet on the Way to Constantinople*, Kozloff makes a pointed reference to the exhibition's host city and its notorious commandeering of the Fourth Crusade in 1203. In lieu of freeing Egypt and Jerusalem from Arab rule—the object of the Crusade—the Venetians redirected the multinational forces to Constantinople for a wholesale plundering of

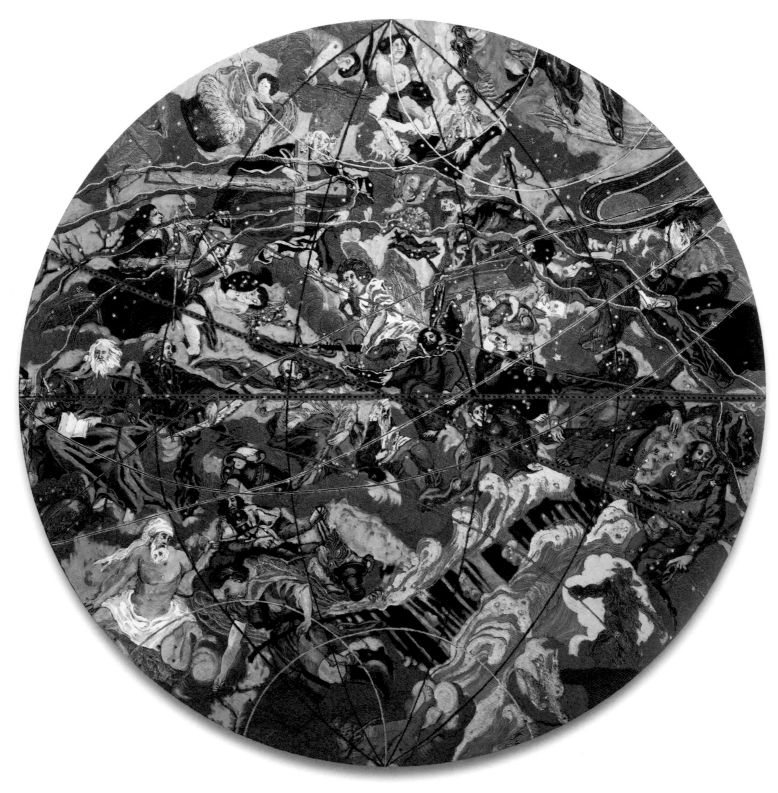

49. Kozloff, *Helium on the Moon*, 2007.

Acrylic, colored pencil, collage on canvas, 60 in. diam.

Collection Montage Hotel, Beverly Hills, California

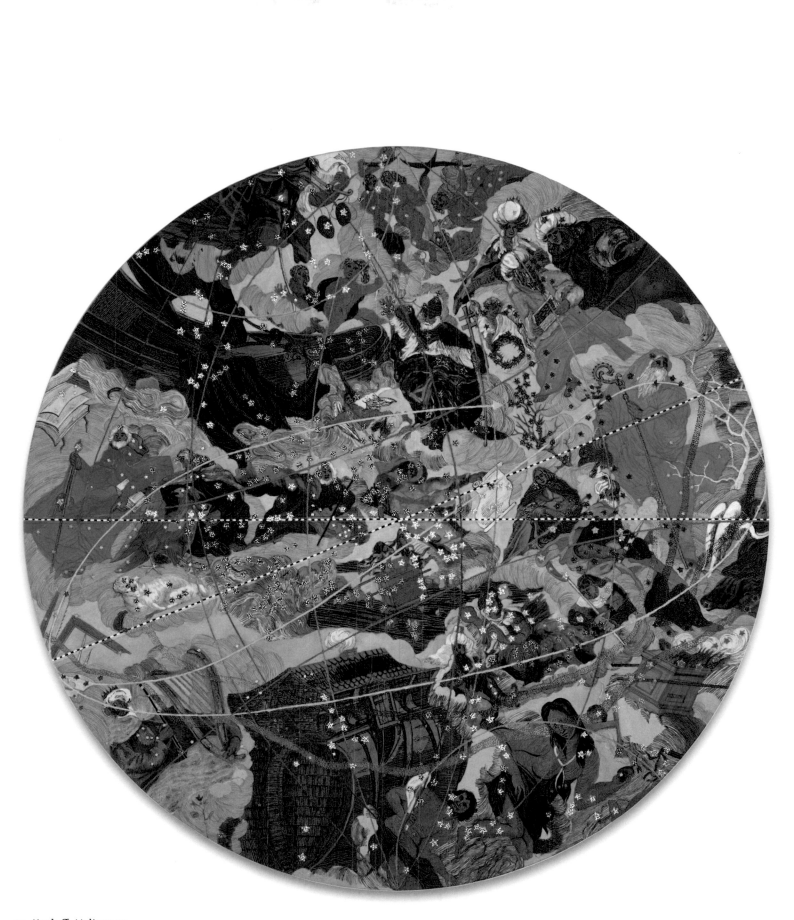

50. Kozloff, *Helium on the Moon II*, (unfinished).

Acrylic, colored pencil, collage
on canvas, 60 in. diam.

Courtesy DC Moore Gallery,
New York

sky and stars. These canvases are based on cosmological and astrological charts from the Age of Exploration, the struggle over land that occupies present-day ambitions gives way to a battle over stars. Distinct from Knowledge, *Targets,* or Voyages, this series of paintings concerns neither the past nor the present but the future, and where our territorial conquests ultimately lead. In *Helium on the Moon* [fig. 49] and *the days and hours and moments of our lives,* the constellations are represented by biblical figures and classical signs of the zodiac, respectively, who appear across a sky marked by the paths of modern satellites. One looks at the cosmological figures in this and other tondi by Kozloff and recalls the power struggles among the gods and heroes, prophets and saints that led to their immortalized presence in the night sky. But unlike the vast surface of Earth, which until the twentieth century could not be seen at a distance and required considerable imagination to comprehend and conquer, the stars were visible and measurable, yet inaccessible. The act of naming the stars, assigning them stories, and fixing them against the sky made them into objects to be known and controlled. Our growing knowledge of their predictable behavior reassured us that we understood and, by extension, controlled them.[33] In these paintings, Kozloff turns the viewer's attention to the charted but as yet un-colonized reaches of space.

For Co+Ordinates, Kozloff created *Revolver,* a circular painting eight feet in diameter made of four wedge-shaped sections that converge at the central point [fig. 51]. The painting turns on a central axis, much as Lorenzetti's lost mappa mundi did. And like the bullet chamber of a six-shooter, the individual sections of the painting revolve around the axis, as if it were a game of roulette or, as Lorenzetti would have known, the wheel of Fortune.[34] And like the turning wheel of Fortune, empires rise to the top and fall, which the Romans, British, and French have learned and the Americans are just beginning to experience. The cycle is endless. But as *Revolver* suggests, for the bulk of the population the losses are greater than the gains, and the turning wheel in the cosmos too frequently turns against them.

51. Kozloff, *Revolver* (detail), 2008.
Acrylic on canvas, 96 in. diam.
Courtesy DC Moore Gallery, New York

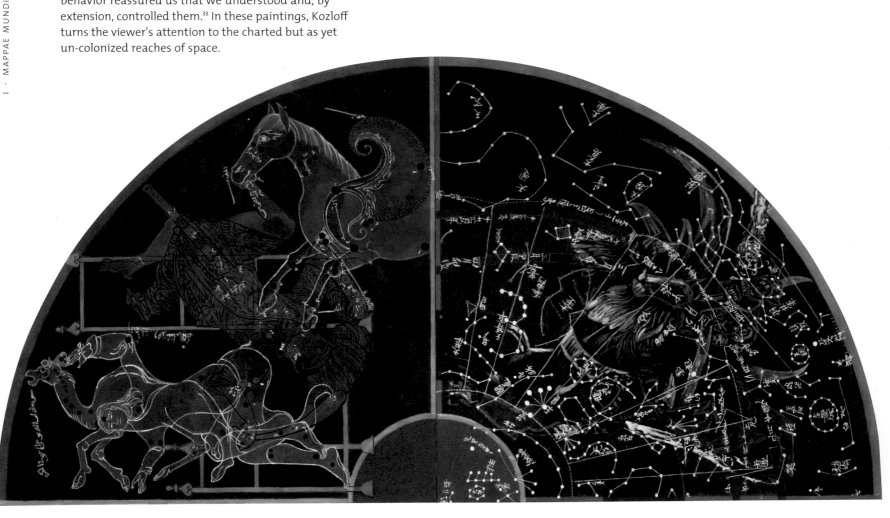

**NOTES**

1. On the decorations in the Sala del Mappamondo, see Thomas de Wesselow, "The Decoration of the West Wall of the Sala del Mappamondo in Siena's Palazzo Pubblico," in Joanna Cannon and Beth Williamson, *Art, Politics, and Civic Religion in Central Italy, 1261–1352. Essays by Postgraduate Students at the Courtauld Institute of Art* (Aldershot, Hants: Ashgate, 2000), 19–68; and Marcia Kupfer, "The Lost Wheel Map of Ambrogio Lorenzetti," *The Art Bulletin* 78 (1996): 286–310.

2. Ambrogio's famed allegorical frescoes in the neighboring room, the Sala dei Nove, address the toll of warfare on the civilian population, but it is not so much a statement against warfare as it is against divisive, tyrannical rule.

3. Matthew H. Edney, "Mapping Parts of the World," in James R. Akerman and Robert W. Karrow, Jr., eds., *Maps: Finding Our Place in the World* (Chicago: The Field Museum and the University of Chicago Press, 2007), 119.

4. Eleanor Heartney, "Maps as Metaphors: Recent Works by Joyce Kozloff," *Joyce Kozloff: Targets* (New York: DC Moore Gallery, 2001).

5. Edney, "Mapping Parts of the World," 119.

6. Patricia Johnston, "Joyce Kozloff: Visionary Ornament: An Overview," *Joyce Kozloff: Visionary Ornament* (Boston: Boston University Art Gallery, 1985), 1–15.

7. Hayden Herrera, "A Conversation with the Artist," *Joyce Kozloff: Visionary Ornament*, 28. Although this interview deals with her public commissions, Kozloff's comments apply widely across her entire oeuvre.

8. Ibid., 29.

9. "Artist's Statement," *Joyce Kozloff: An Interior Decorated* (New York: Tibor de Nagy Gallery, 1979), 8.

10. "Joyce Kozloff: Interview with Robin White," *View* 3, no. 3 (Oakland: Point Publications, 1981).

11. Johnston, "Joyce Kozloff: Visionary Ornament: An Overview," 4.

12. Moira Roth, "Conversation with Joyce Kozloff," *Crossed Purposes: Joyce & Max Kozloff* (Youngstown, OH: Butler Institute of American Art, 1998), 31.

13. "Joyce Kozloff: Interview with Robin White," 4.

14. Critical reassessment of the Pattern and Decoration Movement has surfaced, largely along the lines that were drawn in the 1970s; see Holland Cotter, "Scaling a Minimalist Wall with Bright, Shiny Colors," *New York Times*, January 15, 2008; and Benjamin Genocchio, "A Decade of Patterns and Promise," *New York Times*, December 2, 2007.

15. Artist's statement, *Joyce Kozloff: An Interior Decorated*, 8–9.

16. Ibid., 8.

17. Ibid., 9.

18. Part of this work was included in the exhibition *WACK! Art and the Feminist Revolution* (2007–2008), organized by the Museum of Contemporary Art, Los Angeles.

19. Thalia Gouma-Peterson, "Decorated Walls for Public Spaces: Joyce Kozloff's Architectural Installations," *Joyce Kozloff: Visionary Ornament*, 45–57; and Herrera, "A Conversation with the Artist," 27–32.

20. Roth, "Conversation with Joyce Kozloff," 16. The project team included artists Fred Wilson, Mary Miss, and Mel Chin; landscape architect Michael Van Valkenburgh; architects Paul Willen and Skidmore Owings & Merrill.

21. Moira Roth, "Conversation with Joyce and Max Kozloff," *Crossed Purposes*, 12.

22. Roth, "Conversation with Joyce Kozloff," 16–17.

23. Exhibitions on contemporary artists working with maps and mapping abound and include: Robert Storr, *Mapping* (New York: The Museum of Modern Art, 1994); Susan Bender and Ian Berry with Bernard Possidente and Richard Wilkinson, *The World According to the Most Exact Observations* (Saratoga Springs, New York: The Tang Teaching Museum and Art Gallery, Skidmore College, 2001); Jane England, *The Map Is Not the Territory* (London: England & Co., 2002); Joanna Lindenbaum, *Personal Geographies: Contemporary Artists Make Maps* (New York: Times Square Gallery, Hunter College, 2006); Courtney Gilbert, *Lines in the Earth: Maps, Power and the Imagination* (Sun Valley, Idaho: Sun Valley Center for the Arts, 2007); Gregory Knight and Sofia Zutautas, *HereThereEverywhere*, Chicago Cultural Center, January 19– April 6, 2008; as well as numerous books, including Katherine Harmon, *You Art Here: Personal Geographies and Other Maps of the Imagination* (New York: Princeton Architectural Press, 2004).

24. Roth, "Conversation with Joyce Kozloff," 20.

25. Jeff Perrone, "Approaching the Decorative," *Artforum* 15 (December 1976): 26. See also Johnston, "Joyce Kozloff: Visionary Ornament: An Overview," 7.

26. Roth, "Conversation with Joyce Kozloff," 19–24.

27. Roth, "Conversation with Joyce Kozloff and Max Kozloff," 8.

28. The complete series is reproduced in *Boys' Art* (New York: D.A.P., Distributed Art Publishers, Inc., 2003).

29. Roth, "Conversation with Joyce and Max Kozloff," 10.

30. Ibid., 11.

31. Tom Breidenbach, review in *Artforum* 42 (March 2004): 186.

32. Susan Foister, Ashok Roy, and Martin Wyld, *Making and Meaning: Holbein's Ambassadors* (London: National Gallery Publications, 1997).

33. Kozloff addresses the issue of the power of nomenclature in her works *Naming* and *Naming II*, which illustrate Paris and New York City with their streets renamed after women. See Roth, "Conversation with Joyce Kozloff," 18.

34. On the rotating map as a wheel of Fortune, see Kupfer, "The Lost Wheel Map of Ambrogio Lorenzetti," 286–310.

# QUESTIONS FOR JOYCE KOZLOFF

Phillip Earenfight with the artist

**What was it like at Carnegie Mellon?**

The course which influenced my life was the Oakland Project, taught by Robert Lepper. Oakland is a neighborhood in Pittsburgh, and we were to go out and draw, paint, or represent its infrastructure, people, and buildings. Every week we would bring our work to class and pin it up on the wall. Lepper, an intellectual, would discuss it, going off into different tangents—social, literary, urban. I loved being in the community all the time—sketching, looking, and later back in the dorm, developing and organizing the project. That was my initiation into public art—into the world outside.

**…and Columbia?**

Everybody went in doing different kinds of work, but we all came out painting in the style that was dominant in New York at the time, formal abstraction. It took a couple more years to find my way toward something more personal.

**And after the MFA?**

I continued working in my studio on the Upper West Side. In the late spring of 1970, Max accepted a teaching job in the Critical Studies Program at the brand new California Institute of the Arts. Nik was a year old. Moving to Los Angeles was wrenching for me. I decided to take my slides around before I left, to see if I could make a gallery connection. Tibor de Nagy came to my studio and offered me a show in the early fall.

**And the work for this show?**

On a trip to Sicily in 1968, I had fallen in love with the Greek temples. I made drawings of the columns and spaces between them. The paintings I named after the temples—*Agrigento, Selinunte, Segesta* [fig. 52]. I started working with colors that I associated with those places and my experience of them: the time of day, the quality of light, the wildflowers on the hillsides, the sea beyond. And I layered washes, one on top of another.

52. Kozloff, *Agrigento*, 1970.
Acrylic on canvas, 72 x 72 in.
Collection Allen Blumberg

**During all of this, you've got a lot of things going on politically.**

During the sixties I participated in the antiwar movement. I was part of the crowd, not an organizer.

**Here in New York?**

Yes, in New York. And then in 1970 when we moved to Los Angeles, I became involved with feminism. I joined a consciousness-raising group and was quickly radicalized. We questioned the roles women were expected to play in life, particularly in our relationships with men. Paul Brach had brought Max to CalArts. Paul was married to Miriam Schapiro, who was thinking about women's art and art education. Later that fall she invited me to a brunch at June Wayne's, the powerhouse who had started the Tamarind Lithography Institute. Judy Chicago was there, June, Clare Spark, who hosted a program about the arts on Pacifica Radio, Beverly O'Neill and Moira Roth, art historians. I was designated to organize the women artists of Los Angeles, but I knew only the ones in that room! Everyone gave me lists and I called a meeting: sixty-five women packed into my living room. We called ourselves the Los Angeles Council of Women Artists. Somebody

brought the catalogue for a show that was opening at the Los Angeles County Museum of Art called *Art & Technology*. The museum had paired each artist with a different industry, and there was a grid of fifty faces on the cover, all men.[1]

We decided to take on LACMA. We walked through the museum and counted the works in their permanent collection, and less than one percent were by women. Then we went through the catalogues of all of their solo exhibitions in the library. There had been just one show by a woman and not recently, photographer Dorothea Lange. We made a list of demands and called a press conference. There were meetings between us and the County Museum. I had to become a public person. The museum agreed to mount the first historical survey of women artists, which was curated by Linda Nochlin and Ann Sutherland Harris.[2]

### At what point did you begin integrating politics with your art? Was it conscious? Was it gradual?

It was conscious. Everyone knew that the worst thing you could say about a painting was that it was decorative. During that year in Los Angeles, we began questioning the language used about art. Painter Gilah Hirsh and I went through art magazines underlining adjectives that had a gender bias. Whenever we saw "pretty," "beautiful," "decorative," that went into one pile. "Tough" and "strong" went into another stack. These words carried a value judgment; they weren't just descriptive. The feminine ones had a negative connotation, and the male ones carried a positive meaning. That's when I understood that the word "decorative" was connected to the decorative arts, the products of anonymous women and non-Western artists, and that the bias was the expression of a hierarchy in Western art.

53. Kozloff, *Three Facades*, 1973.
Acrylic on canvas, 78 x 60 in.
Massachusetts Institute of Technology, Cambridge

54. Kozloff, *tent-roof-floor-carpet*, 1975.
Acrylic on canvas, 78 x 96 in.
Collection David and Eileen Peretz

53

54

### And your work?

My paintings were becoming larger and more detailed: each passage was covered with tiny strokes, dashes, stipples. I wanted to build up colors that you could not name, that were evocative of nature and architecture. Initially, it was more like textures, repetitive marks— later it was to become patterning. At the first meeting of the L.A. Council of Women Artists, June Wayne had gone into my bedroom studio and seen my work. After the meeting, she invited me to participate in a two-month residency at Tamarind. In 1972, at her invitation, I went to Albuquerque and made lithographs named after the Native American pueblos of New Mexico. I returned to New York and started tentatively decorating the wedges of my paintings with dots, dashes, and crosshatchings that recalled Southwest carpets and pottery (*Enchanted Mesa, Buffalo Dance*).

We spent the summer of 1973 in Tepoztlán, Mexico. Max was researching the Mexican mural movement and I decided to use the time as a laboratory, to learn about patterns. I carried a sketchbook and drew the patterns on the objects of daily life in the house we were renting as well as pre-Columbian carvings at the archaeological sites we explored. At night in my room I made watercolors, which were more elaborate versions of the sketchbook drawings. They were paintings of patterns. I came back to New York in the fall and began my first patterned paintings on canvas.

**Were you consciously selecting these domestic environments where these patterns appeared, focusing on their relationship to gender?**

Yes. The first pattern paintings were frontal, like quilts. They were based on the tile and brick facades of Churrigueresque churches in Mexico. I sent one to the gallery. Tibor called to ask me to remove it. Clement Greenberg had said it looked like ladies' embroidery! So it was returned to my studio. But then I sent it back with the other paintings for my next show. The first one, which had caused the ruckus, *Three Facades,* was probably the most flat-out decorative painting in that exhibition [fig. 53]. By 1975, I was more and more drawn to the geometric complexity of Islamic patterns. Because they're built on a series of overlapping grids, vertical and horizontal as well as diagonal, I saw the possibility of entering into the space and moving around in it. We went to Morocco, where we visited a deconsecrated mosque at the palace in Meknes. Although we were not allowed to enter the other mosques, we could wander into the courtyards, where I had partial views of the interiors. The paintings in the next series (*tent-roof-floor-carpet, Zemmour, a maze, White Walls, Silver Dome*) have odd angles, views from above in a tower or through doors and passageways [figs. 54, 57]. I wanted to treat those paintings like travel, so they became horizontal, almost mural scale with different episodes, like walking the streets of a new city, turning a bend, and discovering something unexpected. I wanted to slow the viewer down to a meander. I still have that impulse.

**How did the Pattern and Decoration Movement get started?**

The pattern painting group came together in 1975. I was invited by Miriam to the first meeting. I met Bob Kushner, Bob Zakanitch, Tony Robbin, and Amy Goldin, a critic. All of us had a California connection. The men were great—they still are great. They had an openness which had emerged among younger men in the counterculture of that time.

**As opposed to Manhattan?**

They'd all been in California, either as students or teachers. Later, other artists joined the group who didn't have a California history. That initial meeting was incredible, discovering the others, because I'd thought that Miriam and I were making decorative art in isolation. The group discussed two things: our rejection of the dominant styles in New York—formalism and minimalism—and our embrace of the arts of the rest of the world. We were coming from different life experiences. Tony Robbin's father had been in the foreign service, and Tony had lived in Iran and

Japan. Amy and Bob Kushner had spent months traveling in Iran and Afghanistan together.

We were excited about our sources and shared them with one another. Amy was trying to find a language with which to write about traditional arts, folk art, decoration—no one had done that. She would show us her writing and we would discuss it, just as we would show her our work. The Islamic wing opened at the Met in 1975, and there were a number of important shows of decorative arts in other New York museums at that time.

**And the criticism?**

There was a lot of negative criticism, but we also had our supporters who wrote extensively about us, particularly Jeff Perrone, John Perreault, Carrie Rickey, April Kingsley, and Amy Goldin. A lively dialogue ensued among admirers and detractors. We suddenly were a "hot" movement in the U.S. and Europe, and we were in many shows together in the late seventies.

**The recent reviews of the Pattern and Decoration Movement return to the same old positions, same old arguments.[3] Do you think this is productive?**

This is such a different moment. I don't know how to compare them. The art world is global now, and so many kinds of work are emerging simultaneously. Then, a small group of artists who were outrageous and provocative could stir up everyone.

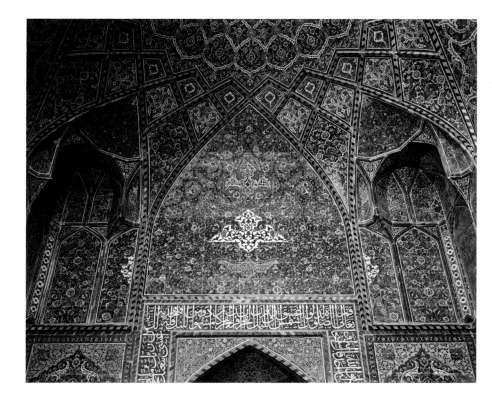

55. Eastern Iwan, Eastern Madrasah beside the Royal Mosque (Masjed-e Shah), 17th century
Maidan-e-Shah, Isfahan, Iran
SEF/Art Resource, New York

56

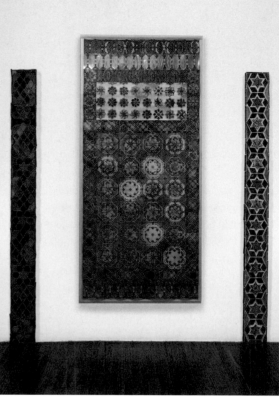

57

58

56. Kozloff, *Striped Cathedral*, 1977.
Acrylic on canvas, 72 x 180 in.
Collection the artist

57. Kozloff, *a maze*, 1977.
Acrylic on canvas, 72 x 180 in.
Collection Bruno Bischofberger

58. Kozloff, pilaster, *longing*, pilaster, 1977–1979.
Installation in *WACK! Art and the Feminist Revolution*, 2008, P.S. 1, Contemporary Art Center, Long Island City, New York

Ceramic tile, wood, lithographs, collage, colored pencil on paper, 92 x 75 in.

Collection Mintz, Levin, Cohn, Ferris, Glovsky, and Popeo, P.C., Boston

Pop artists were copying and working with sources in ways not unlike those of you in the Pattern and Decoration Movement. What did those in P&D make of Pop Art?

When Pop Art appeared, it was loudly condemned. We in the P&D Movement were fans. We especially loved Warhol's wallpaper cow installations and floating silver pillows. Artists have always appropriated from other artists and from the popular culture of their times. You could talk about Marcel Duchamp's readymades! I was just at the Takashi Murakami retrospective at the Brooklyn Museum, a clever appropriation of Japanese pop culture.

### How do you see your work within the context of feminism?

I was a feminist artist, a decorative artist, a public artist, a cartographic artist, and a political artist. I never stopped being any of them. There were as many different kinds of feminist art as there were feminist artists, and the decorative was one of the forms of feminist art. Today, most younger scholars and curators think of feminist art as being about the body, gender, and sexuality; perhaps some of the other feminisms are not as sexy or interesting at this moment. Maybe they have been absorbed into the culture. But that was radical, controversial work in its time.

You describe yourself as a feminist artist—yet your work does not seem "feminist" in an obvious way.

For me, feminism is a motivating force, which is absorbed into my way of working.

### I think for the patterned work, but your current work...?

I was a much more politicized person then than I am now. I was living and breathing feminism during those years, and I've mellowed.

### How did your pattern work go from canvas to wall?

I was giving lectures on my pattern paintings at universities around the country. There would always be someone in the audience who would say, "You're not breaking down the hierarchies—you're taking from crafts and making paintings." I didn't have an answer for that, and it began to disturb me.

### You ended up working in ceramics...

Max and I went to teach at the University of New Mexico in 1978, and I started hanging out in the ceramics room. I would roll out slabs of clay and cut stars and hexagons with cookie cutters, so that they created an interlocking pattern. I painted them with commercial underglazes and fired them in the school's kilns. They were crude and funky, lively and colorful. When we came back to New

York, I had boxes of them. I wanted my next show at Tibor de Nagy Gallery to be a composite of all the decorative arts, and these tiles were to become the central floor piece.

**And this led to *An Interior Decorated*?**

*An Interior Decorated* was meant to evoke that degraded category, interior decoration [fig. 59]. I was making long paintings that had become like walls, so I knew I had to move literally onto the wall. My friend architectural historian Robert Jensen said, "Don't make the tile pilasters the height of the ceilings because you don't want to pretend they're structural—they're ornamental." So they were a foot lower than the ceilings at the Tibor de Nagy Gallery. The hanging textiles were printed at the Fabric Workshop in Philadelphia. It was the first time that I treated a whole room three-dimensionally. I used luster glazes and printed in metallic and iridescent inks, so the space would shimmer like my places of inspiration in the Near East.

**How did you get involved in Public Art?**

I entered a competition for the Cambridge, Massachusetts, Arts on the Line program, and won a commission for the Harvard Square Subway Station. My first public art projects were an extension of my gallery work. They were decorative, architectural, and were composed of interlocking tile patterns. And then I started working in glass mosaic in addition to the ceramic tiles. After awhile, I wanted to break up the

grid. The first pieces to move away from allover patterning were in Detroit and Philadelphia. I would displace vignettes from one locale to another, juxtaposing host city images with faraway allusions. At One Penn Center, Suburban Station, in Philadelphia, I made fanciful leaps. In the left niche, *Galla Placidia in Philadelphia* re-creates the Byzantine tomb in Ravenna, Italy, but substitutes William Penn, the founding father of Philadelphia, for the Good Shepherd [fig. 60]. On the right, in *Topkapi Pullman*, the ornate entrance is copied from the fabulous tiled harem at the Topkapi Palace in Istanbul [fig. 61], but the iconic train from an Art Deco "Orient Express" poster is rushing through the door, right toward us, and the logo of the Pennsylvania Railroad is underneath. It was an exciting departure from what I had been doing before. Altogether, I've created sixteen public projects, but I almost never entered competitions after the first one for Harvard Square. The others came my way, or didn't.

**What are public art commissions like to work on?**

Each of mine is based on some local subject, some hook, so I would spend time in the cities. Some cities revealed themselves more readily than others. Sometimes architects and administrators facilitate; sometimes they obstruct. I had terrible problems with some of them and wonderful times with others. In Wilmington, Delaware, I built a scaffold with my own studio assistants—it was freezing, but we put it up. In Boston, union tile setters were working in all of the

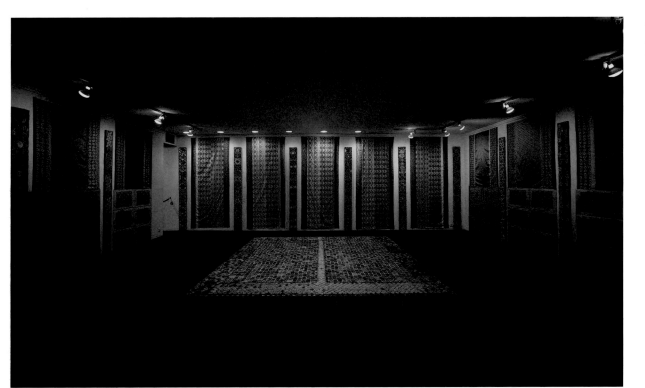

59. Kozloff, *An Interior Decorated*, 1979
Tibor de Nagy Gallery, New York

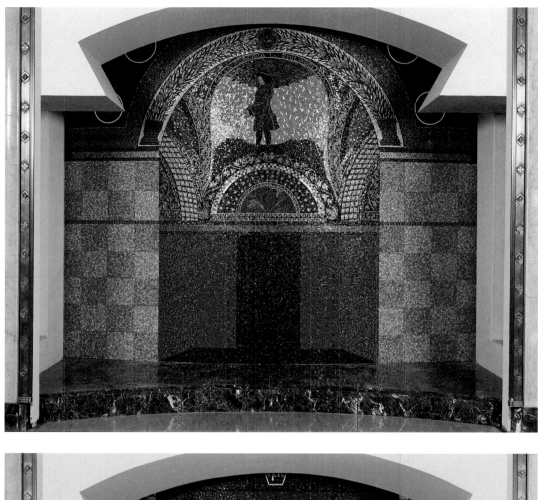

60. Kozloff, *Galla Placidia
in Philadelphia*, 1985.

Glass mosaic, ceramic tiles,
156 x 192 in.

One Penn Center, Suburban
Station, Philadelphia

61. Kozloff, *Topkapi
Pullman*, 1985.

Glass mosaic, ceramic tiles,
156 x 192 in.

One Penn Center, Suburban
Station, Philadelphia

62. Interior of the
Harem, Topkapi Palace,
Istanbul, Turkey
Art Resource, New York

63. Kozloff, *Los Angeles
Becoming Mexico City
Becoming Los Angeles*,
1993.
Watercolor, lithographs, collage
on paper, 22 x 87 in.
Private collection

64. Kozloff,
*Bodies of Water*, 1997.
Acrylic, collage on canvas,
78 x 78 in.
Courtesy DC Moore Gallery,
New York

stations. They did the physical work, but I was always on site. We would have all of the tiles boxed and numbered and laid out; then I'd hand them up to the workers. Sometimes it took weeks. Usually I brought an assistant along, for companionship as much as aid.

### How did the public art projects fit into your studio work?

Public art is almost a separate field from the art world. There is one journal, called *The Public Art Review* out of Minneapolis-St. Paul, a quarterly. So a lot of public art is off the mainstream art world's radar. Some artists can maintain two separate practices, the public and the private. That was difficult for me because I painted every single tile and each project took over my life for at least a year.

### Did feminism figure into your public art projects?

There's a lot of politics in public art. I was addressing each problem, each site, each city, as a new beginning. Feminism was not primary in my mind anymore. In the eighties, feminists of my generation were upset because we were labeled essentialists by the deconstructivists. Those who were making studio art and showing in galleries felt embattled. I was spared because in the public art field, theory was irrelevant. I didn't exhibit nearly as frequently in those years

because the public commissions were my art. I traveled a lot, and I would give lectures about public art. It gave me the opportunity to work on a scale I could never imagine, tackle big problems, reach a general audience, expand my vocabulary, and place my work in public spaces. It was a win-win situation.

### How did you move from public art projects to your current work in map-based images?

When one starts a public art project, the architects send you floor plans, diagrams, blueprints. I would employ an architecture student to make a simple cardboard model. I'd imagine myself as a little person moving through that model, what I would see from different vantage points. Then the piece would start to develop in my mind—how it would be perceived by the viewer, its scale, its content, the way it would resonate visually. I would make detailed watercolor studies, and then I'd reduce them down and place them in the model. I began to imagine using that approach in my private art—a map could be the starting point, a structure for wide-ranging, diverse information, a web in which to weave other material.

63

64

**And this led to your early mapping pieces?**

The project focused my attention on urban issues, but I realized I was more interested in the myths and mysteries of cities than their sewage and transportation systems! For a year or two, I drew and then cut out different cities and combined them. I wanted to create hybrids—cities that didn't exist but that had elements of other cities. The first was called *Los Angeles Becoming Mexico City Becoming Los Angeles* [fig. 63]. It was an idea about the blurring of borders. We had first lived in L.A. in 1970–71. When I moved there again in the late eighties and early nineties, creating four public art projects, the city had changed completely. It was practically all Mexican on the east side. The diversity wasn't an easy, comfortable blend. So I cut up Mexico City and Los Angeles and juxtaposed them, collaging elements from both cities' histories onto their surfaces. That was my pilot piece. I used some of the same strategies for *Imperial Cities*, *The British Were Here*, *The French Were Here*, and *The Spanish Were Here*.

**What were your feelings when you departed from a purely non-representational to a representational mode?**

I don't think that way. Decorative art can be either abstract or figurative—either/or, both/and. We were taught those categories in school, and they always annoyed me.

**Writers are now talking about the subject of your work rather than the question of the decoration as the subject. How do you respond to this change?**

Like all visual artists, I want critics to look long and closely at my work, to be moved and affected by it, to describe and analyze it well, and to place it in the context of related contemporary ideas. I want them to come to it fresh, but most simply repeat what they have read elsewhere. Discussing the subject is merely the beginning.

**What made you move in this direction?**

In 1992, I worked on a team planning project here in New York, Riverside South. We utilized maps of the area, Fifty-ninth to Seventy-second Streets along the Hudson River. We were commissioned by a consortium of seven community groups, including the Parks Commission. At the end of the year, we had a huge table model the size of a room, and we would make presentations to city agencies and community groups. But ultimately it was to become a horrible development, not what we proposed. We had been used, and we were naive. That's when I started burning out on public art.

**Did your public art projects change your private work —namely the maps? You seem to communicate more directly and more overtly with them than with your earlier Pattern and Decoration work.**

I never make such conscious choices. I returned to the studio to follow my own dreams and fantasies. Public art had become too constraining. In the studio, I follow a private impulse to see where it will lead. My work requires a slow read—I'm always hopeful that people will be willing to graze and absorb.

**For *Bodies of Water,* what led you into this subject of the body, a very strong current in contemporary art?**

Max and I went sailing in the Swedish archipelago with architect Mannie Lionni, who had a sailboat outside Stockholm. We were his crew, alongside his wife, artist Barbara Zucker. I was fascinated by his navigational charts of the Baltic Sea, which were essential to our movements. When I returned to New York, I bought some for myself. The three Bodies of Water paintings are based on those sea charts [fig. 64]. I had large diagrams of the human digestive system, circulatory system, and respiratory system in my studio for a while. One day, I started cutting them up and laying them across the Baltic Sea. This sounds gruesome, but the pictures are dreamy and floaty.

**You were in Rome as a fellow at the American Academy. What led you to apply for it?**

I wanted that year in Rome. I've spent time in Rome before and since, and have friends there. It's my favorite place to be.

**I imagine that the panel would probably have responded strongly to the notion of maps and mapping, given what Rome is.**

It just depends on who's on the jury and whether they like your work—I got lucky that year. I was called for the interview and blurted out, "I've been applying for thirty-two years but I was never a finalist before." I saw their jaws drop. I thought I had made a mistake. But maybe when I left the room, they looked at each other and said, "Let's just give it to this lady."

**Did you already have the project in mind?**

I probably said that I wanted to develop the mapping work.

**Once in Rome, how did you arrive at what you were going to do?**

I had completed the frescoes and shown them. I had made seventy-two, starting during the summer of '98, when I taught at Skowhegan for nine weeks, where

65. Kozloff, *Knowledge #21: Japan and Ezo, 1661,* 1998.
Fresco on wood, 8 x 10 in.
Collection Brian Kenny

66. Kozloff, *Knowledge #10: Japan, 1570,* 1998.
Fresco on wood, 10 x 8 in.
Private collection

they teach fresco. When I wasn't giving critiques to the participant artists in their studios, I was Daniel Bozhkov's student in the fresco barn.

**This sounds like your ceramic tile story.**

Yes. Daniel, a charismatic installation and performance artist, learned fresco and egg tempera at the Academy in Bulgaria. He teaches on eight-by-ten-inch panels because it's hard to control anything larger. I created my work corner, and as the summer went on, my eight-by-ten panels accrued. When I returned to New

67. Donato Bramante,
San Pietro in Montorio
("Tempietto"), Rome
Scala/Art Resource, New York

68. Kozloff, *Targets*, 2000.
Acrylic on canvas over wood,
108 in. diam.
Courtesy DC Moore Gallery,
New York

69. Kozloff, *Voyages:
Carnevale VI*, 2006.
Acrylic, watercolor, collage
on paper, mounted on canvas,
129 x 33 in.
Courtesy DC Moore Gallery,
New York

York, I set up a messy fresco operation in my studio and continued. Right before I went to Skowhegan, there was a show at Japan Society, European maps of Japan from the sixteenth to the nineteenth centuries. The show was hilarious—each map was different, and wrong. My first frescoes were appropriated from the catalogue of that exhibition [figs. 65, 66]. Then it occurred to me that if the early cartographers were wrong about Japan, they were probably wrong about the rest of the world, and I extended the series. They cover the whole planet, and I exhibit them clustered by continent. They are in many different languages. Color is saturated, and surfaces densely treated—some are vertical and some horizontal. For me, their errors—which were copied and reproduced as engravings throughout Europe—became political. Although obviously wrong to us, they were based on the knowledge, as well as the biases, of their times. In the same way, our own "knowledge" is equally arbitrary.

### So these led to the globes?

I brought seven small Rand McNally globes to Rome, planning to extend the Knowledge series three-dimensionally. I covered them with plaster or gesso and painted them in watercolor. They're also wrong. I chose maps of the whole world that I could stretch around a globe. I had a beautiful, big studio in Rome with a thirty-foot-high glass ceiling and a terrace. I could stand outside, overlooking the city. I started feeling guilty that I was sitting in a corner painting little globes. I had to make something bigger to justify my splendid space. Earlier, I had covered the walls of my New York studio with Tactical Pilotage Charts that I'd ordered during the wars in Bosnia and the Gulf. I was thinking about aerial war, about unseen civilian death and how to represent that in art, so I brought those maps to Rome and pinned them up once again. I began to conceive of a really large globe.

### Did you have any models in mind?

Two structures in Rome inspired me. One was the Pantheon, which I liked to visit when I was in the city

center. The other was near the Academy, the Tempietto of Bramante, a small jewel, which is primarily a dome [fig. 67]. I always knew that *Targets* had to be painted on the inside, and one would need to enter it (it's a female thing). And I'd seen pictures of the big walk-in globe at the World's International Exposition in London (1851). I decided to map all the places that the U.S. had bombed since 1945 [fig. 68]. I kept calling that agency in Washington from Rome, ordering more and more

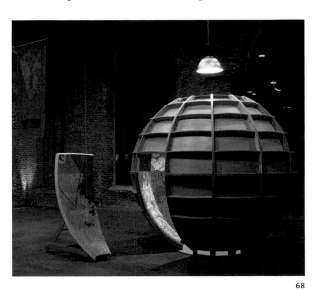

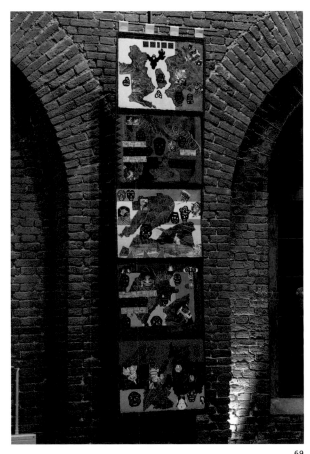

67

charts. I had five panels to go when I left, which I painted here in New York. Each panel has a separate color range, to differentiate it from the others.

*Targets* was built by Italian woodworkers, Antonio and Alessandra Potena, a couple whose shop was down the hill from the Academy. They figured out how to build it: she drew the technical drawings and he experimented with woods and glues. The big decision was how to build the door, so that the observer could enter and close it from within. Every time I'd go there, they'd be saying, "La porta, la porta"—you can't have it swing out and you can't have it lift up. They were more worried about it than I was! There was an emergency room hospital nearby and a doctor, who builds boats on the weekend, came into the shop and said, "Put the door on wheels." And that's what we did. When people enter *Targets*, they close the door, and if they talk, there's a loud echo. Some visitors become claustrophobic and find the amplified sound frightening. It wasn't planned, it was a gift, adding to the effect of the piece.

### What do you envision for it?

I hope that it will find a home. It's been shown in about twelve different venues in this country and Italy. I like to keep it on the road, but I can't imagine an American public institution buying it because of its content. It's a storage problem unless it's on permanent display—and nothing remains on permanent display these days.

### Were the globes your first 3-D works or had you done others?

I don't usually make objects, but I work with rooms and spaces. Objects are surfaces to paint on. The tiles were surfaces to paint on, the masks were surfaces to paint on, the cradle was a surface to paint on, and so were the globes.

### Many artists work well on a very small scale but don't do large well.

I love working on an intimate scale, and a very public scale. It's the in-between, normal, living-room scale that gives me trouble. Often I put a lot of small works together and it becomes a large piece. And that's what happened with the tiles. Individual, hand-painted units built a wall that then created a room. The tiles were my palette.

### How important are residencies to you?

I love going to residencies. I get three times more work done than I do here. You have only one obligation: to show up for dinner. For a while, I was going to residen-

cies all the time, which coincided with a transitional period from the public art back to being a studio artist. I had to re-create my career. During the public art years, I had occasional exhibitions, but often I would show studies for the projects or documentations of them. In the nineties, I was starting over.

### What was the idea behind Voyages?

Voyages was about islands, and Venice, which is an island, was at its core. I too live and work on an island, Manhattan. I painted islands around the world from old maps across the faces of sixty-five Venetian carnival masks, and many of them have stories. They were painted different colors on both sides and hung at eye level inside the windowpanes at Thetis, a fifteenth-century shipyard in the Arsenale. When light came through those windows, the masks glowed. During the Age of Exploration, boats departed from this place and circled the globe, colonizing lands far and near. Against the brick walls between those windows, I hung bright, bold collage banners, which I called *Voyages: Carnevale* [fig. 69]. For once, I used primary colors, since they had to stand out against the earth tones behind them. They evoke the morphing of carnival as it was carried across the seas, intermingling with other raucous traditions. There were views of Venice amongst skulls and grimacing faces from Mexican, Chinese, and Japanese popular arts, which echoed the nearby masks.

### How did the Hawaiian prints fit in?

I created them on the island of Maui, and they depict two Hawaiian islands, Maui and Kaho'olawe. The islands float among waves, which are appropriated from antique maps but larger. At Thetis, they were hung up high overhead, to utilize the forty-foot ceilings.

### Why Hawaii?

The printer, Paul Mullowney, has his shop at the Hui No'eau Visual Arts Center. He creates assertive, big prints himself, which excited me—and he encouraged me to do the same. The first time I was there for two weeks to cut and print *Maui*, working with him and several RISD interns, and the second time for three weeks, making *Kaho'olawe*.

### What were your image sources?

The first day, we went to the historical society in a nearby town, where I found a big 1885 property map of Maui divided into sugar and pineapple plantations. Kaho'olawe is a small island off the coast of Maui that you can see from almost everywhere. It's a sacred site of the Hawaiian people, but in the twentieth century it

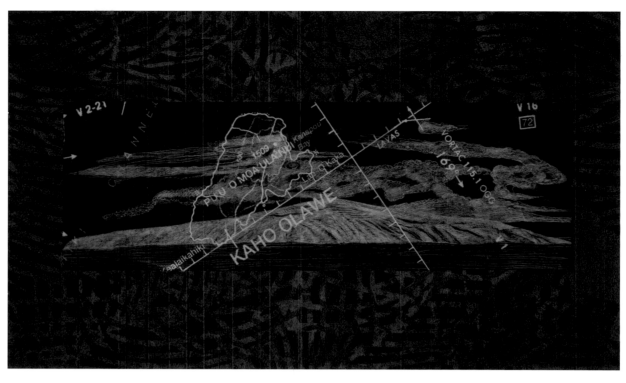

70. Kozloff, *Voyages: Kaho'olawe II* (detail), 2006.

Woodblock, etching, watercolor, 84 x 36 in.

Collection the artist

was used as a U.S. Navy bombing range. There is a dedicated group of people cleaning up the ordnance and replanting. In a hundred years, it will be habitable. I went to a high point on Maui and drew Kaho'olawe's familiar profile, which I later copied onto an etching plate. We layered an offset print made from an aerial chart, looking down on the island from the air, over the etching [fig. 70].

**This close working with local sources sounds like one of your public art projects, or even your work on the Oakland Project as an undergraduate. Do you think about these earlier experiences when you approach new projects?**

Not consciously—I'm always reinventing myself—but then later I might see connections.

**How was *Targets + Voyages* received?**

In Venice, people were interested in *Targets*, period. They got it. In America, I need a wall label with the list of countries and the years they were bombed. The rest of Voyages, a more subtle and complex rumination on European colonialism, didn't interest them.

**The masks, like many of your works, are part of a series—what is it about the series process that you find attractive?**

I don't always know it's a series at first. I didn't know that Boys' Art and Patterns of Desire were books. I made drawings or watercolors until I ran out of ideas. Friends would see the stack of images, the same size on the same theme, and say, "This should be a book."

**Your tendency toward series reminds me of the individual chapters in Calvino's *Invisible Cities*—they stand as independent elements but combine to shape a much larger, more richly textured idea, as in the case of your books or exhibitions. Do you think about your works in this way, as being part of a grander concept?**

I do often think of the parts as parallel to passages in a book or scenes in a film.

**How do you feel about works being sold out of series?**

I've never been able to keep a large body of work together. Maybe if I were more hard-nosed and insisted that they stay together—but then I would never sell anything.

**You provide an extensive amount of material on your sources.**

DC Moore always asks me to write out my sources. You asked me about my library of mapping books; I haven't read most of them. I look intently at the pictures, which help me think and free-associate. I have read the more literary books about cartography, though, like *Atlas of Emotion/Journeys in Art, Architecture, and Film* by Giuliana Bruno, which is rich in ideas about all the things that interest me.

**So you don't feel any desire to be coy with the public in that sense?**

No. Among the artists in the Pattern and Decoration group, I was the most literal translator of sources. Most of the other artists transformed them more, so that they wouldn't necessarily be recognizable. I'm an appropriator, not an inventor of forms. I re-contextualize them to give new meanings. We were accused of cultural imperialism in the seventies, and that was hard for me because I thought of my art as an homage.

**And thirty years later…?**

It's much less of an issue now because so much material is available everywhere, and it's all free-floating. But there was a moment when this was considered a no-no; it was one of the criticisms of Picasso and Matisse. But my art is only as good as my sources.

One of my favorite more recent projects was a floor piece for the Chubu Cultural Center in Kurayoshi, Japan [figs. 71, 72]. I worked from exquisite antique Japanese maps of that region which the project architect sent from Tokyo, juxtaposed like a crazy quilt kimono against traditional local textile patterns. The fabric swatches were executed in sandblasted marble, the map fragments in marble mosaic. Lake Tougo, a dark amoeboid shape, appears about a dozen times, large and small, bouncing up against more delicate passages. I collaborated with a Japanese mosaicist, Haruya Kudo, who was trained in Spilimbergo, Italy, where I have often worked with a family of artisans, the Travisanuttos.

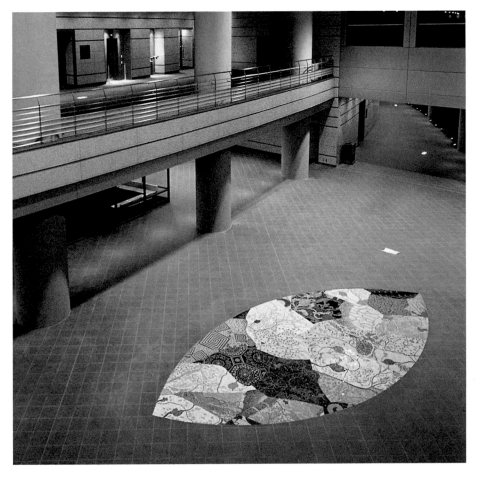

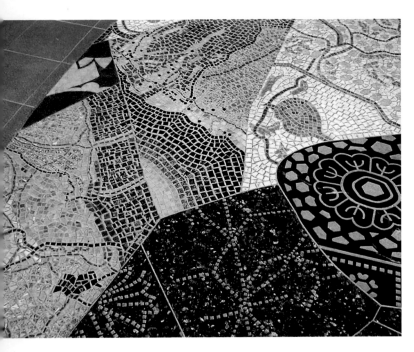

**How did *Rocking the Cradle* come about?**

I'm part of a group called Artists Against the War. During the invasion of Iraq and afterward, there were big antiwar demonstrations everywhere. I proposed making a giant cradle in Central Park. During the Vietnam War, the artists built a Peace Tower in Los Angeles. I always thought that was a phallic image but a cradle is female, and our group is mostly women. Nobody was interested, and I realized that it was an art idea, and I had to make it myself. I wanted to make the Cradle of Civilization, too big for a baby but not big enough for an adult. Bridget Moore, my art dealer, had a nineteenth-century wooden cradle that was hers when she was a baby, which I brought to a carpenter as a prototype. I painted the interior baby blue and lifted ancient Mesopotamia from the *Barrington Atlas of the Greek and Roman World*. For ten days as allied forces approached Baghdad, I clipped the daily maps of troop movements from the *New York Times*. Their blood red lines are laid over one another, until they strangle the capital.

71–72. Kozloff, *Untitled*, 2001.

Marble mosaic and sandblasted marble, 324 x 192 in.

Chubu Cultural Center, Kurayoshi, Japan

Overleaf. Kozloff, *Knowledge #78: 1154* (detail), 1999.

Watercolor, gesso, rope, cardboard, porcelain, 9⅛ in. diam.

Memphis Brooks Museum, Memphis; purchase with funds from Marjorie Liebman Bequest

**Is the blank canvas bothersome, or do you just start working on it, laying out the basic form and working from there?**

I usually know what I'm going to start with, although sometimes I don't know what the next layer will be.

**What are countries going to be fighting over next?**

We're fighting over resources. That's what *Helium on the Moon* and *Helium on the Moon II* are about. These two tondi, which I have been working on during the last year, are my most intricate, tightly executed paintings; people have said they look like tapestries. The first was painted on a buff ground, the second on pink, so they have a warm tonality, almost Rococo. In these and other recent works, I apply gold and silver star stickers to plot the constellations—they shine at certain angles, depending on the light. The imagery is appropriated from Andreas Cellarius's seventeenth-century *Harmonica Macrocosmica*. They're swarming with biblical characters (saints, patriarchs, and angels), all buoyantly bobbing around among the clouds, while Noah's Ark and the Bark of St. Peter plow their way through. Then on top, looping through these archaic creatures, are satellite tracks off the Internet.

**How is this related to the *Whether Weather* prints?**

Those playful pastel colored monoprint/lithographs are variations on the orbits of weather satellites [pls. 46–58]. I'm trying to think within my language, within my personal iconography, whether there is a way that I can represent future wars. And that's why I've been working with the astrological charts, the night sky. All of the images that I found online show the ways in which satellites circle the earth, but I want to look up through them into the stars.

**In some ways working with the past is easier because it comes with ready-made references.**

But the other is a challenge. If you want to make art about future wars, ideally you'd want to scare people. Some people found the masks scary, but I don't think they were scary enough. This idea started about a year ago when the Chinese shot down one of their own satellites in space, to demonstrate that it could be done. It suddenly clicked that Star Wars was a reality. The young boys are playing this out every day in video games. I said to my son Nikolas, "Well, that's good. Then we won't be killing civilian populations on earth, if we just have a few guys up there shooting each other in space." And he said, "Mom, you don't know what it's going to do to the environment, how horrific it could be."

The most pointedly political piece in my last show was *Now/Later,* a double tondo [pl. 45]. It's based on two maps that were published in a U.S. Army publication, which came to me over the Internet. The first is the Middle East as we know it today, and the second is the Middle East as the U.S. government would like to reconfigure it. People were gathered around this piece at my opening, trying to figure it out, which pleased me enormously. Some Jews assumed it was about Israel. Iranians were frightened, seeing their country radically reduced in size. Like many of my paintings, its sweet colors hide the evil intent that is revealed.

**Do you feel a kinship with the present artists working with maps?**

I have rarely met any map artists, although I have been in a number of group mapping shows. There are some names that keep recurring in the shows, and new names all the time. To me, the more interesting are Kim Jones, Mark Lombardi, Nina Katchadourian, and Paula Scher, but I have had no dialogue with them. We're clearly all obsessives! Maybe there is a cluster of cartographic artists somewhere, talking to each other. I've asked myself, "Why is it in the air?" For starts, it's one of the ways that we receive information in today's world.

**Many writers have commented on the traditional association between maps, power, and gender. In what ways, if any, did this association factor into your interest in working with maps?**

I wasn't aware of it, but I often blunder into ideas by looking at pictures closely and figuring out what they communicate. When I did my "pornament" series, I had not read the feminist literature on pornography, for instance.

**Which artists inspire you?**

It depends on which day you ask. I can be turned on by Giovanni Bellini or Alighiero e Boetti, or friends like Elaine Reichek, or by anonymous quilters.

**You described yourself earlier as a feminist artist when you referred to the earlier phases in the seventies. Do you still describe yourself as one now?**

I always describe myself as a feminist.

**A feminist artist?**

It's not always the central content of my work. It certainly was for Boys' Art and *Rocking the Cradle.* In the course of one's long life as an artist, one can make art about different subjects. I'm restless, and I know when I am through with something. Then sometimes I later circle back to it.

**NOTES**

1. Maurice Tuchman, *Art & Technology: A Report on the Art & Technology Program of the Los Angeles County Museum of Art, 1967–1971* (New York: Viking Press for the Los Angeles County Museum of Art, 1971).

2. Ann Sutherland Harris and Linda Nochlin, *Women Artists, 1550–1950* (Los Angeles: Los Angeles County Museum of Art; New York: Distributed by Random House, 1976).

3. Holland Cotter, "Scaling a Minimalist Wall with Bright, Shiny Colors," *New York Times*, January 15, 2008; and Benjamin Genocchio, "A Decade of Patterns and Promise," *New York Times*, December 2, 2007.

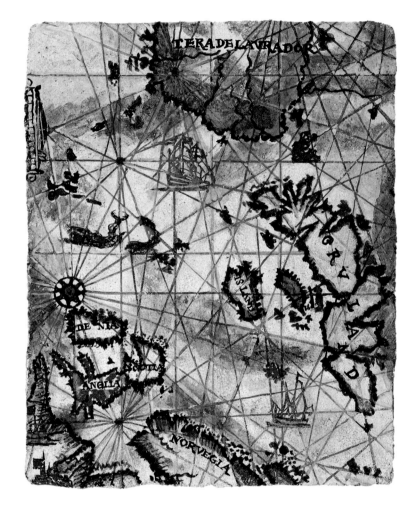

## Knowledge

1. *#1: Labrador, Iceland, Greenland, Scandinavia and the British Isles, 16th Century*, 1998.   Collection Mr. and Mrs. Judson P. Reis
2. *#4: The New World, 1541*, 1998.   Private collection, New York
3. *#14: South America, 1585*, 1998.   Collection Laurance S. Rockefeller Outpatient Pavilion, Memorial Sloan-Kettering Cancer Center, New York
4. *#26: New York and New Jersey, 1777*, 1998.   Collection Laurance S. Rockefeller Outpatient Pavilion, Memorial Sloan-Kettering Cancer Center, New York

5.  *#28: The Near East, 1154*, 1998.   Private collection
6.  *#41: China, 1470*, 1998.   Collection Mr. and Mrs. Judson P. Reis
7.  *#70: The Cape of Good Hope, 1578*, 1999.   Collection Sydney and Walda Besthoff

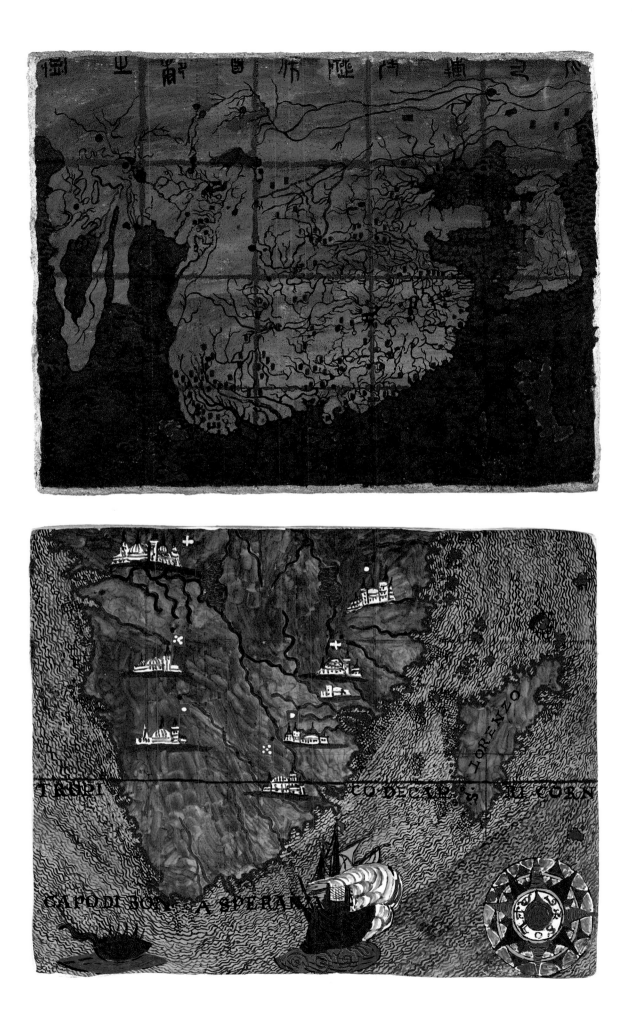

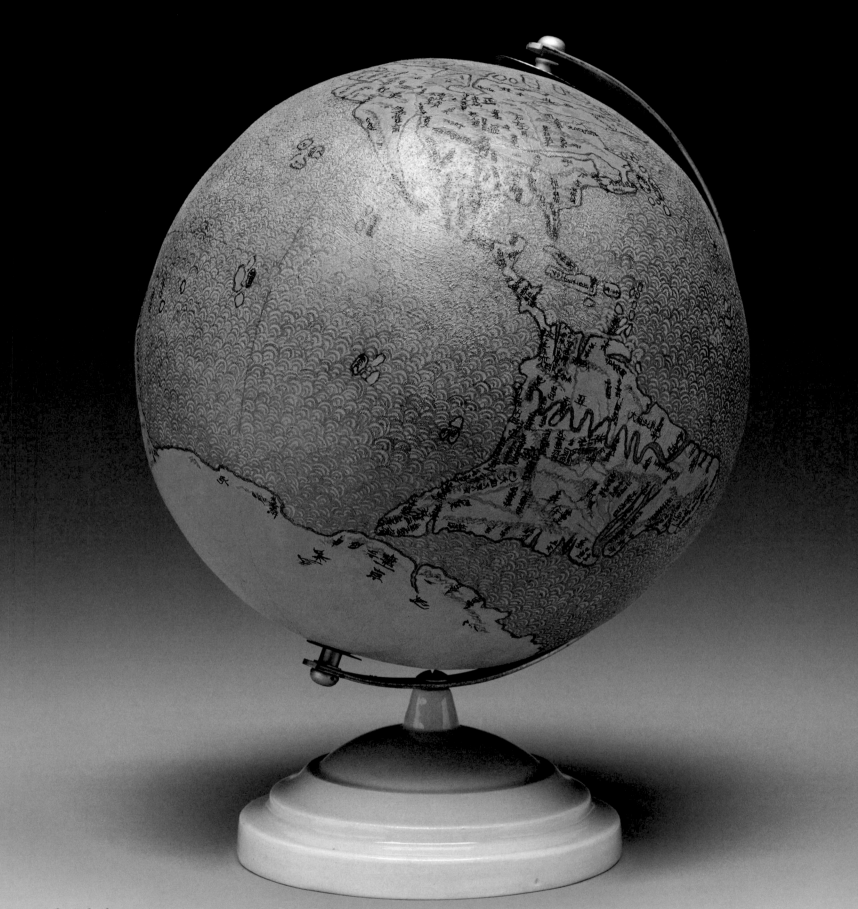

8. *#76: 1602*, 1999. Courtesy DC Moore Gallery, New York

9. *#73: 1st Century A.D.*, 1999. Collection Nicholas Pentecost

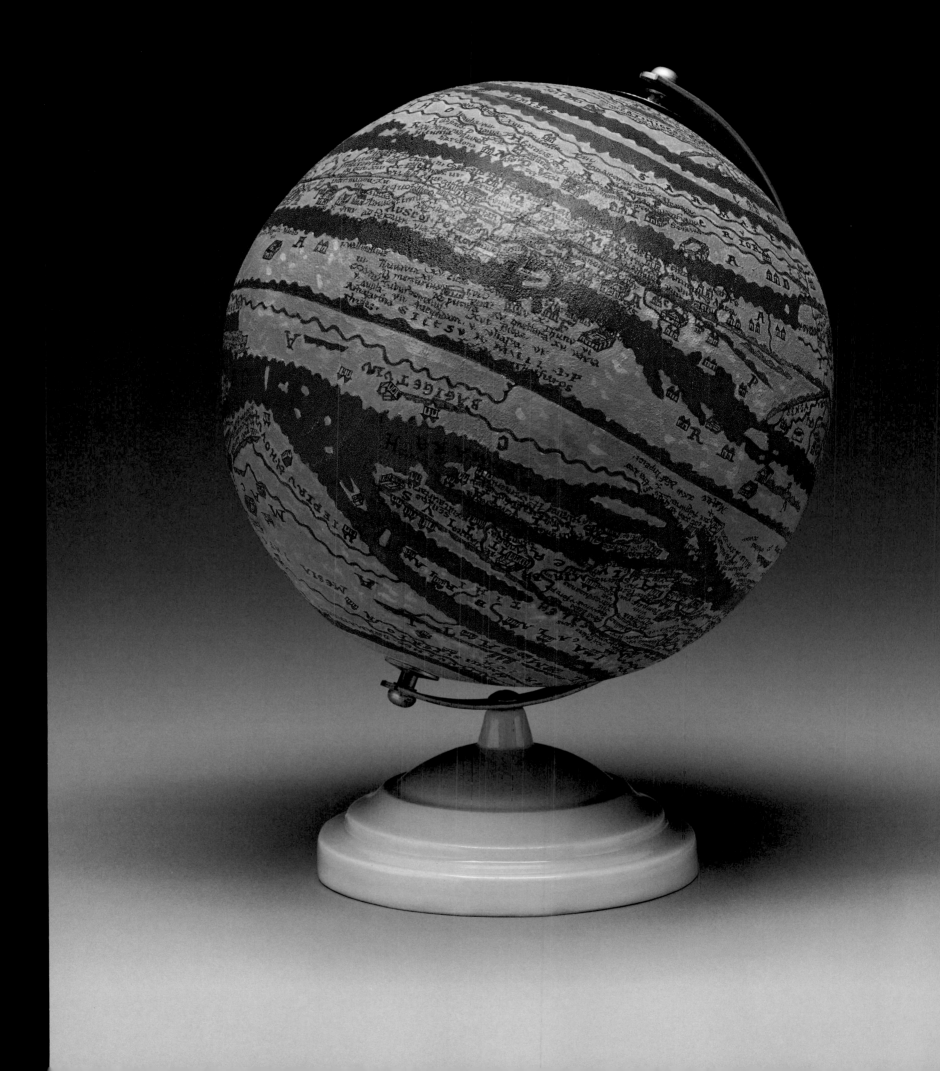

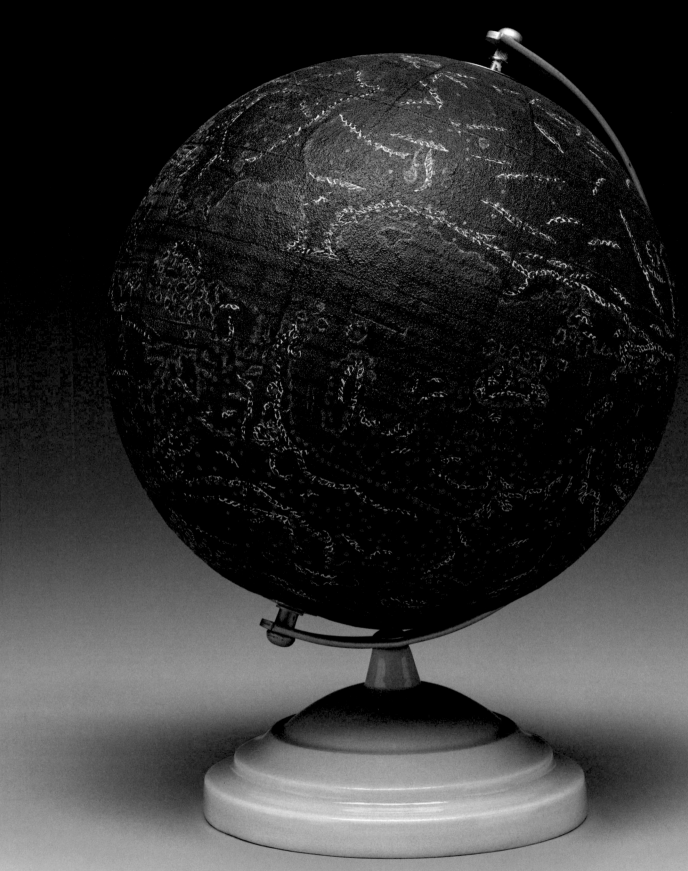

10.  *#78: 1154, 1999.*
Memphis Brooks Museum, Memphis; purchase with funds
from the Marjorie Liebman Bequest

*La Conquista*

11.  *La Conquista*, 1999.
Private collection

## Targets

12–16. *Targets,* 2000.  Courtesy DC Moore Gallery, New York

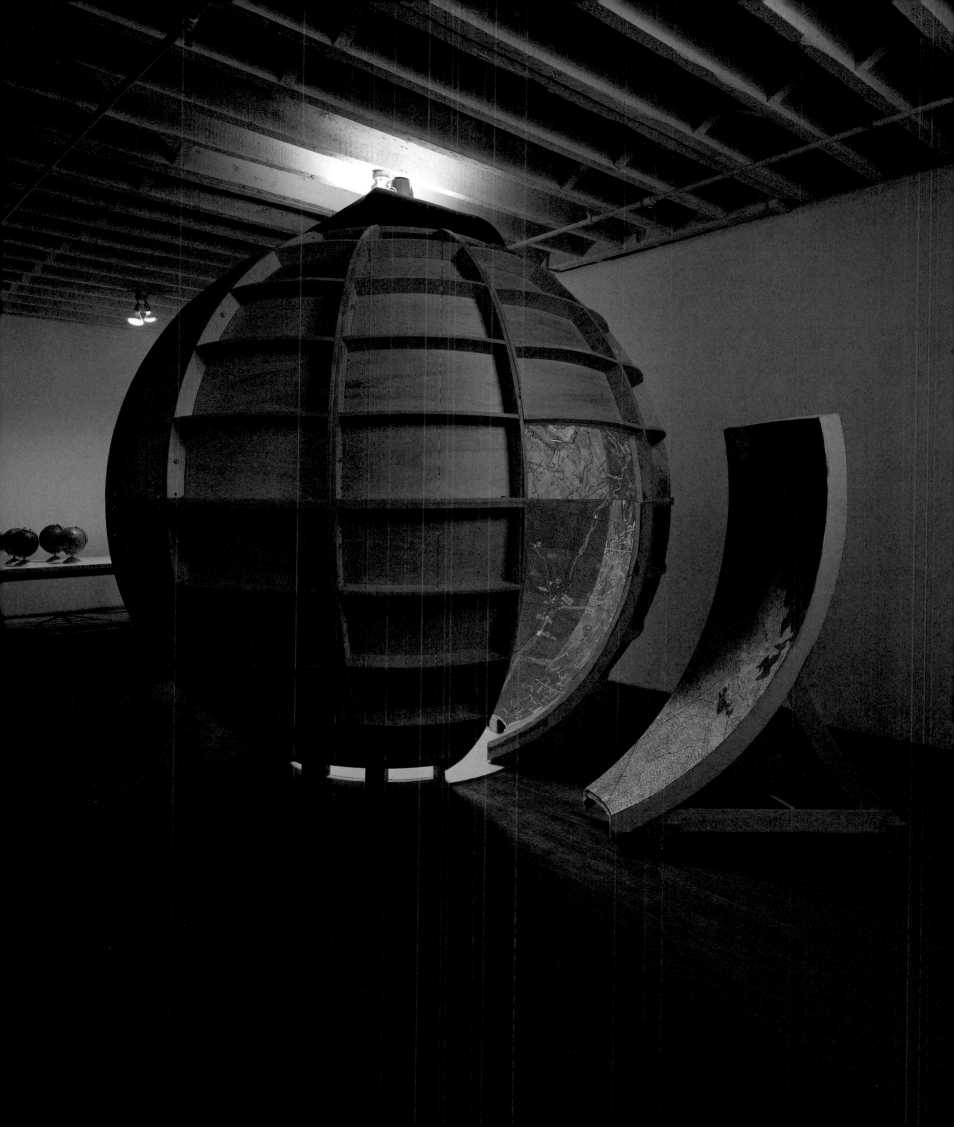

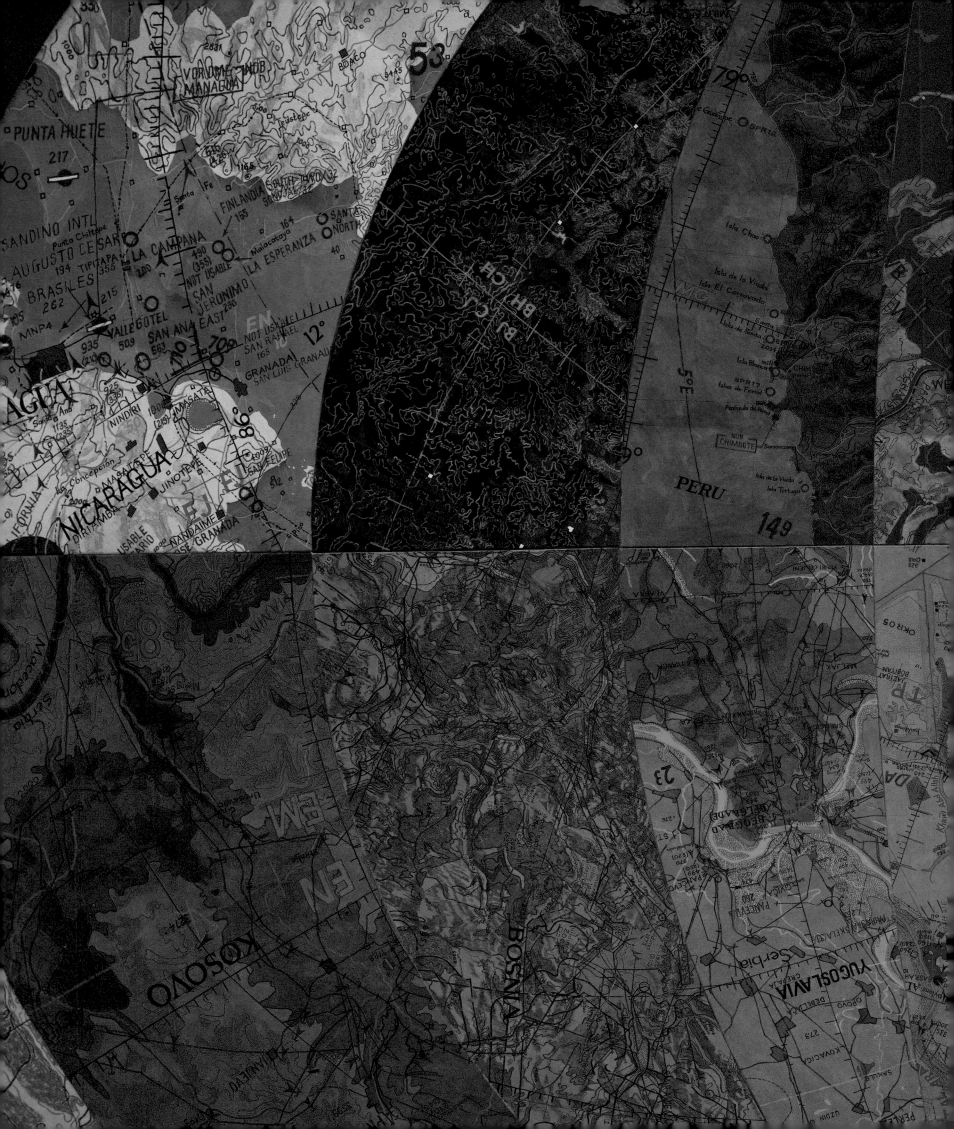

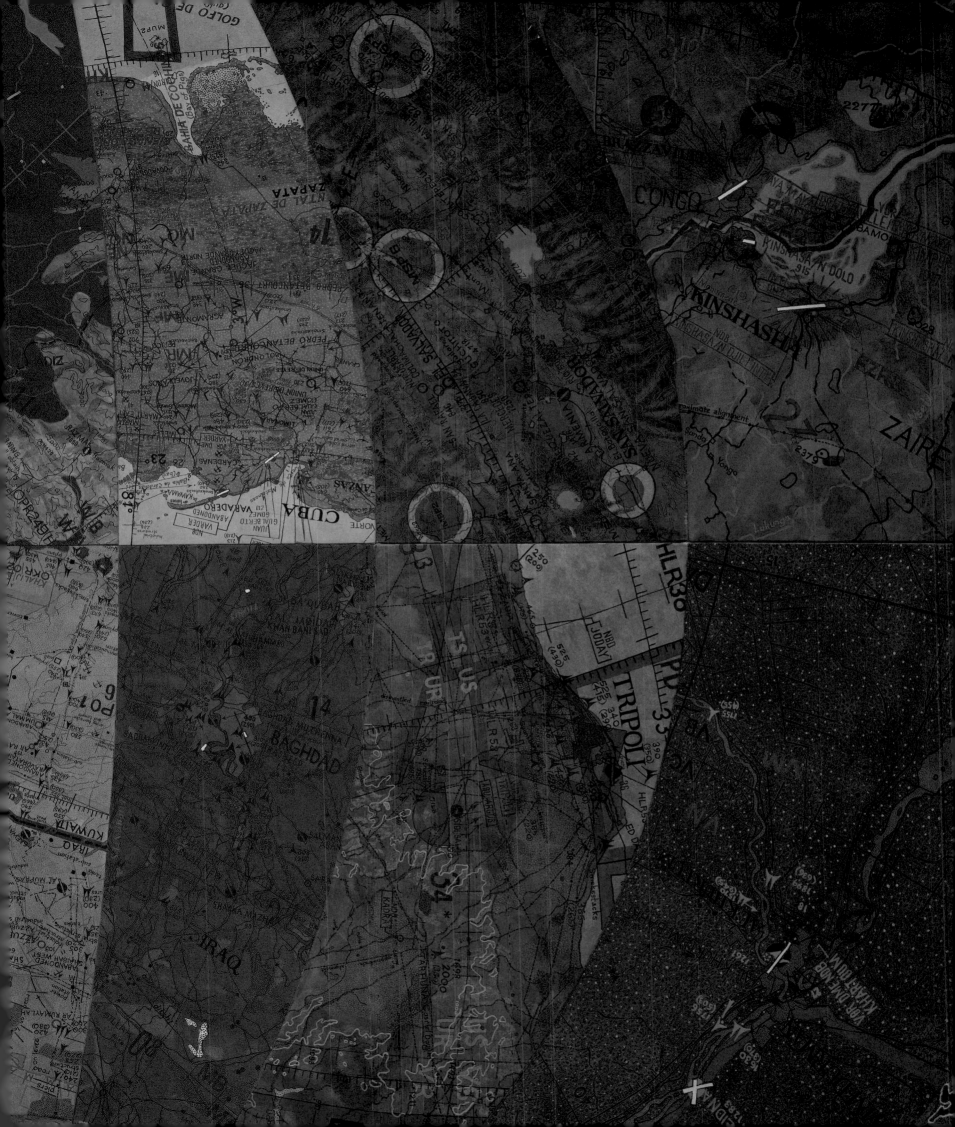

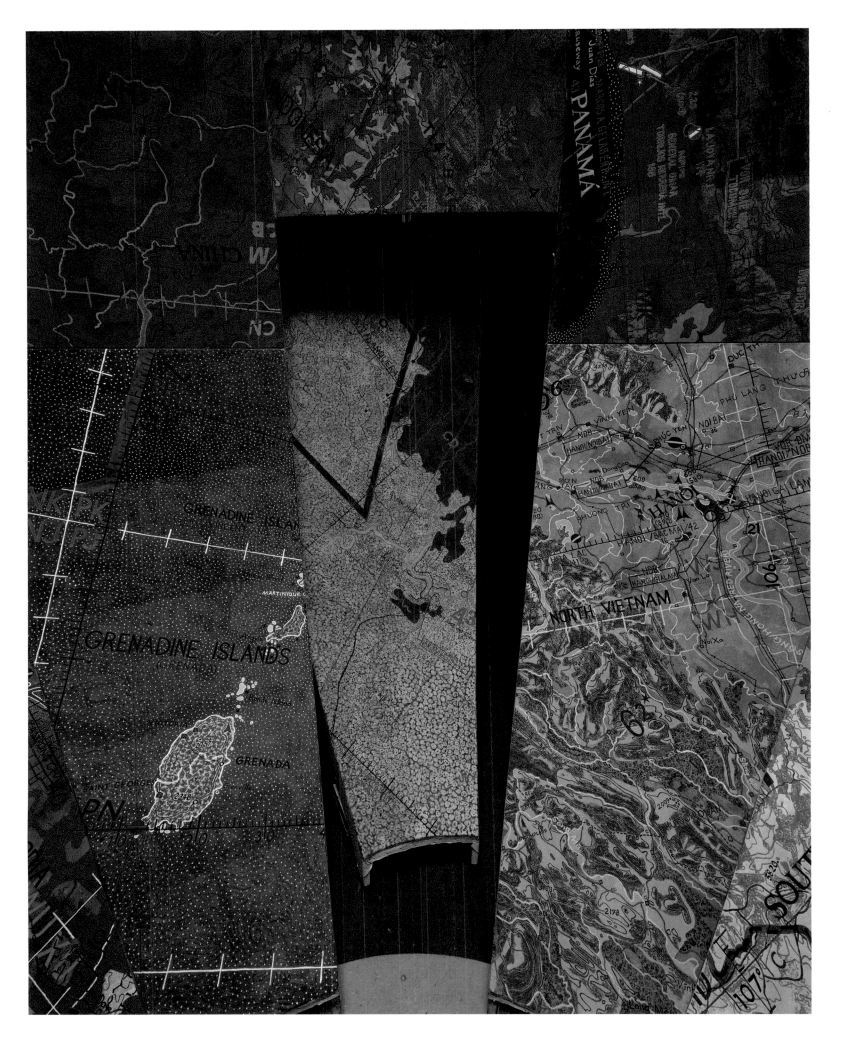

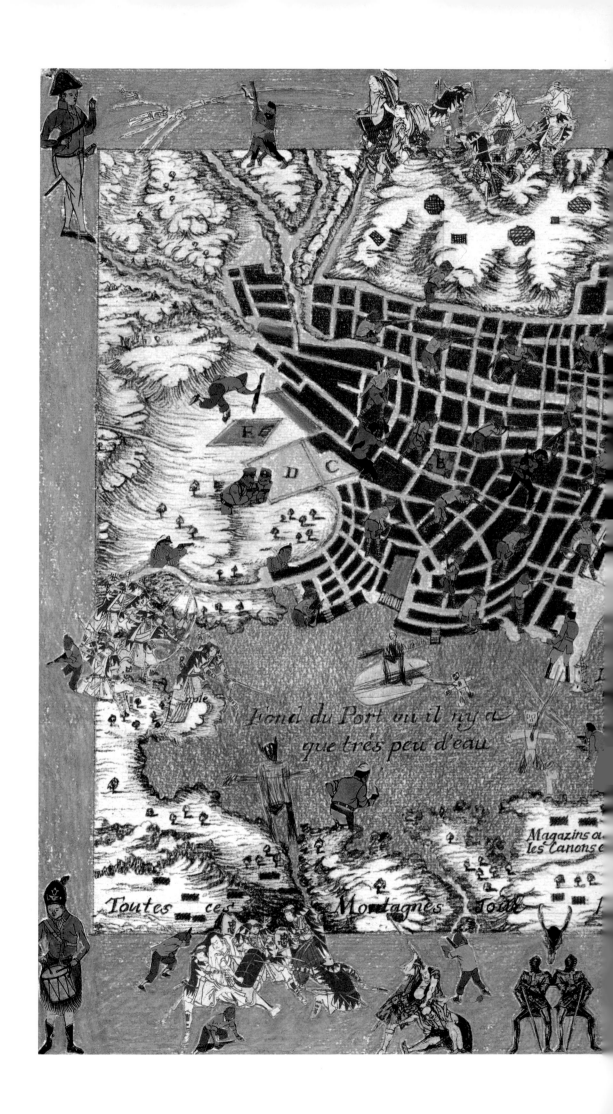

## Boys' Art

17. *#2: Nagasaki*, 2002.
Collection Ellen Saltonstall and Robert Kushner

18. *#7: British Fleet, Falkland Islands*, 2002.
Private collection

19. *#16: Aztec Military Map*, 2002.
Courtesy DC Moore Gallery, New York

20. *#17: Norwegian Fjords*, 2002.
Courtesy DC Moore Gallery, New York

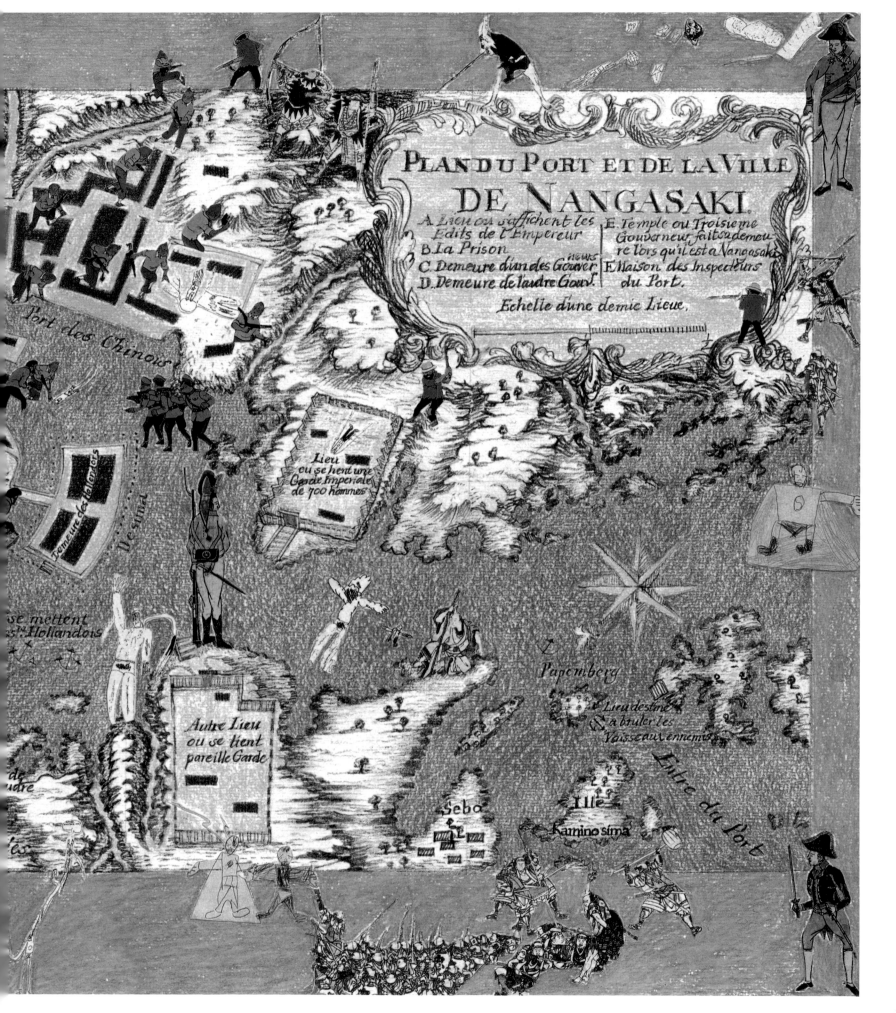

# PLANO DEL ESTABLECIMIENTO QVE TENIAN LOS INGLESES EN EL PVERTO DE LA CRVZADA SITVADO EN LA LATITV AVSTRAL DE 51 grs 22 mns TEN 316 grs 16 mns DE LONG D TENER, SEG VLTIMA RECOPILACI

## EXPLICACION

A Camino para lo Jardines del Sur

B Jardines nuebos

C Casa de la Faborita

D Ombesa de 6 Caminos

E Batería proyectada por los Españoles

F Dos Cañones embarcados, con que hicieron Fuego los Ingleses

G Almazenes de Pertrechos y Giheros

H Casa del Comandante con dos pedreros Jeromias en Batería

I Muelles de Piedra

J Torreon de madera con 4 cañones del calibre de à 12 y del mismo con 10 dos los demas que tenian

K Fuente y Aguada para Navios

L Jardin de Malvi

M Casa y Corral para tener ganado de Animal

N Arroyos de buena Agua

O Casa de campo y Jardin de Farmer

P Fuerte proyectada por los Españoles

Q Camino para la Boca del Puerto

R Sitio donde se hizo el Desembarco

S Bote del Comandante destinado à reconocer sido para el Desembarco

T Fragata Industria Comandante del porte de 26 cañones del Calibre de à 12, con la señal de dar Jonado con un Ancla

V Idem Sta Rosa del porte cte 20 cañones del Calibre de à 6

V Chambequin Andaluz de 52 con 22 del Calibre de à 8 y 8 de à 4

X Fragª Sta Catalina de 26 de à 12

XI Idem Sta Barbara de 26 de à 8

Y Idem la Favorina de 20 de à 8

O Montes que resguardan el Puebla de los Puertos y Fuente à terres del Sur, Ciudad ...

### Nota

La Ramazon que cosa en la casa aun y arbustos que nacen en el Suelo y se tienden sua caja Pital gasa, se puede passar muy immediata à ellos en qualquier pene de la cruzada, pues de hallan en ha 14 brazas de fondo hasta las 3, 2 S con la delto arenia que tira al fondo donde de crian as Piedra.

Aztec Military Map

Cuauhtinchan in the Historia
Tolteca-Chichimeca

Celestial + Terrestrial

21. *Dark and Light Continents*, 2002.
Courtesy DC Moore Gallery, New York

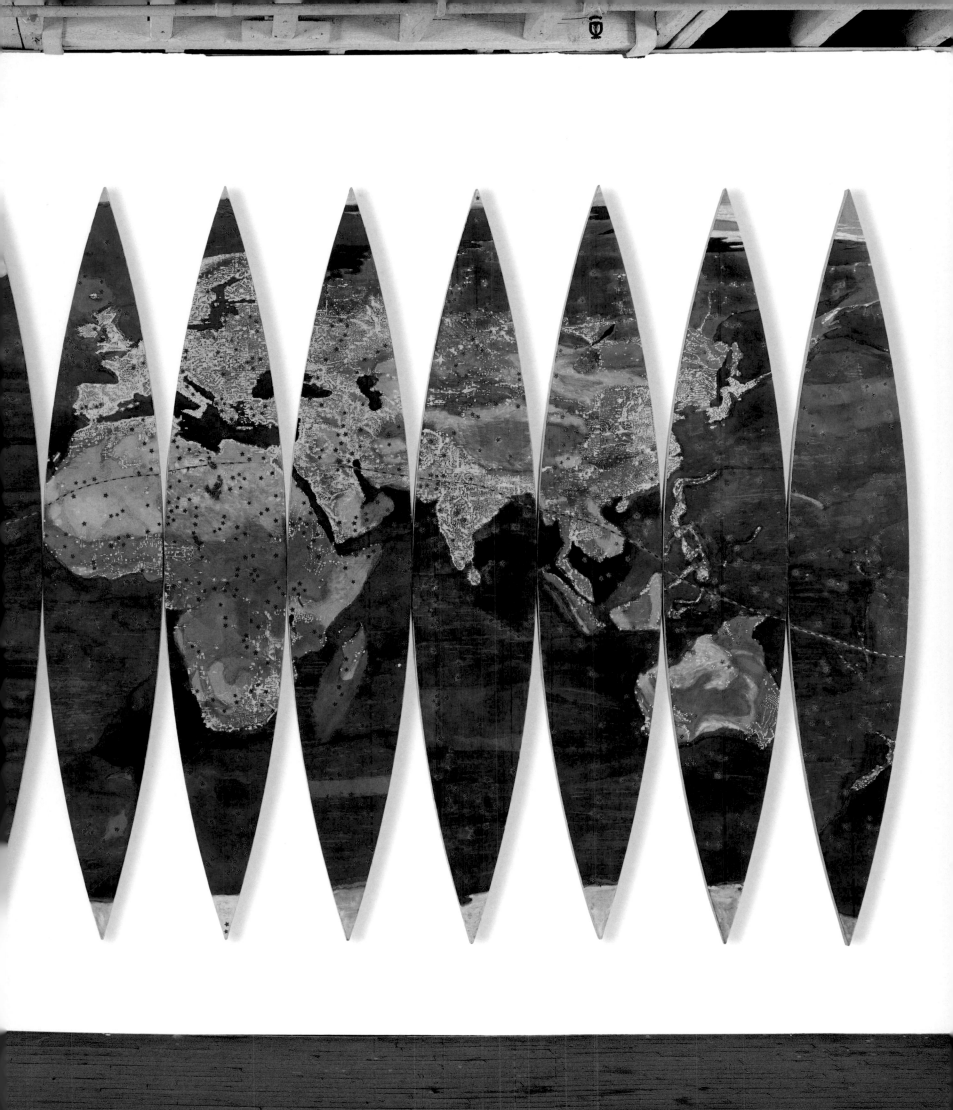

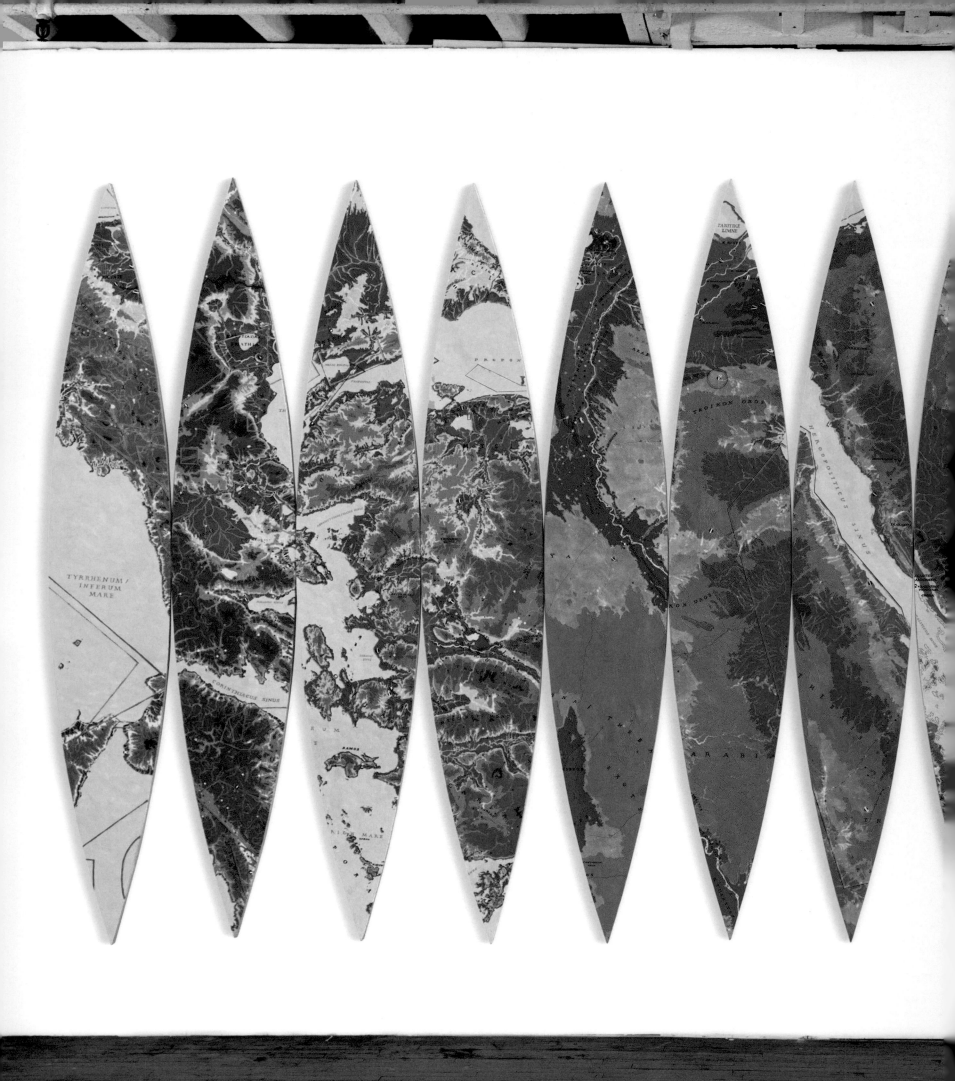

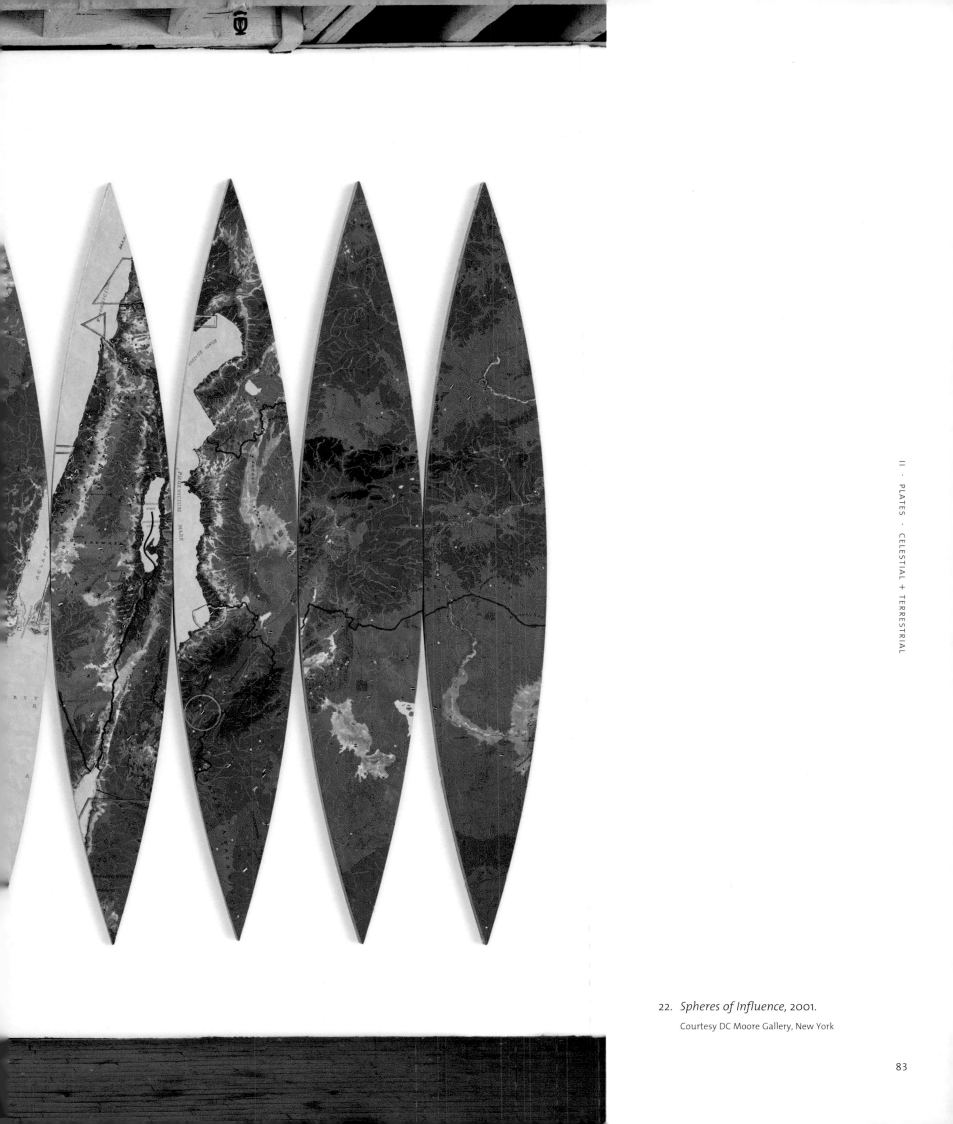

22.  *Spheres of Influence*, 2001.

Courtesy DC Moore Gallery, New York

*Rocking the Cradle*

23–24. *Rocking the Cradle*, 2003.

Courtesy DC Moore Gallery, New York

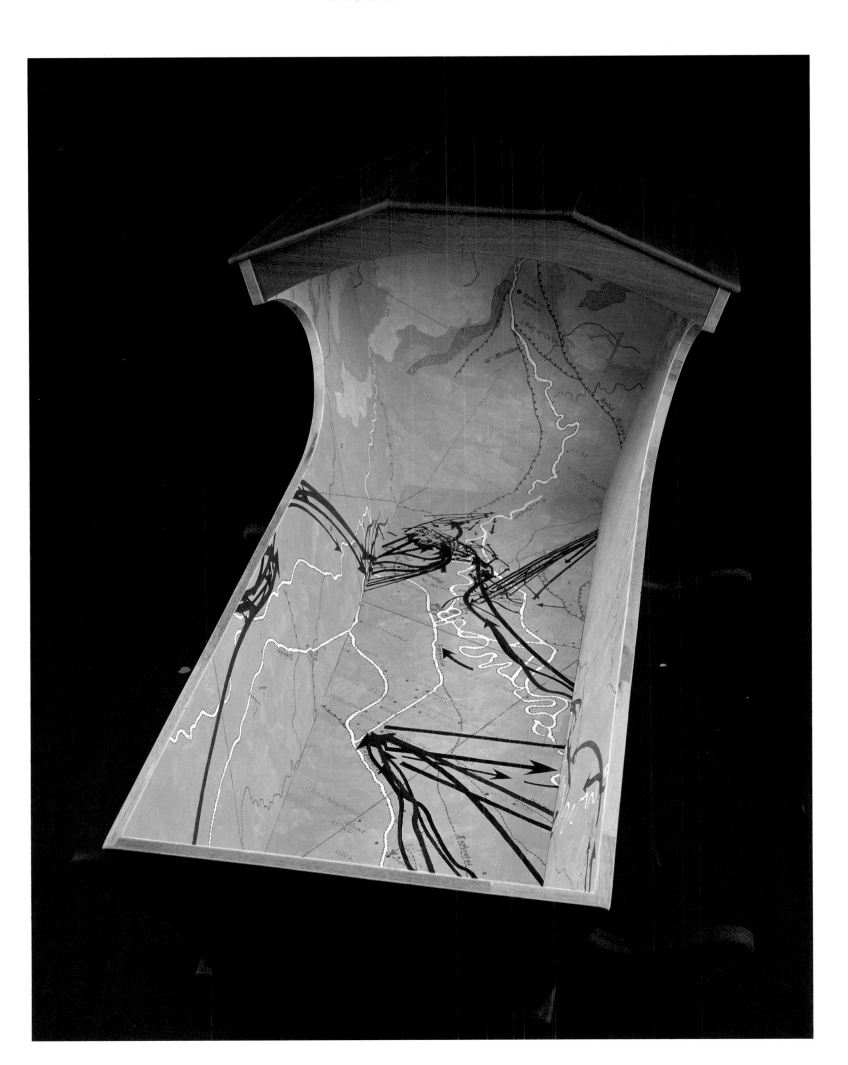

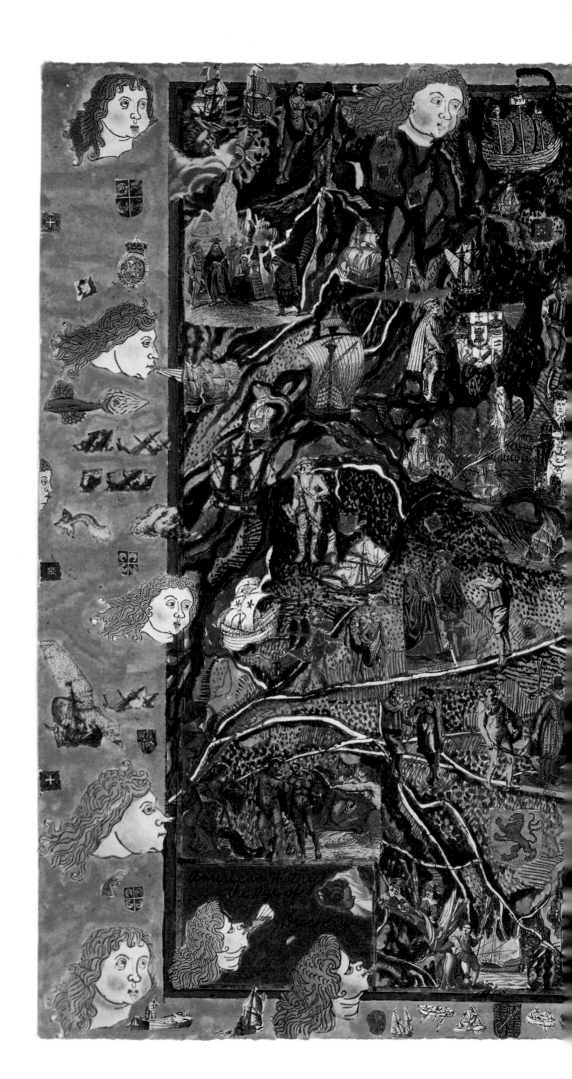

## American History

25. *The Age of Discovery*, 2004.

Courtesy DC Moore Gallery, New York

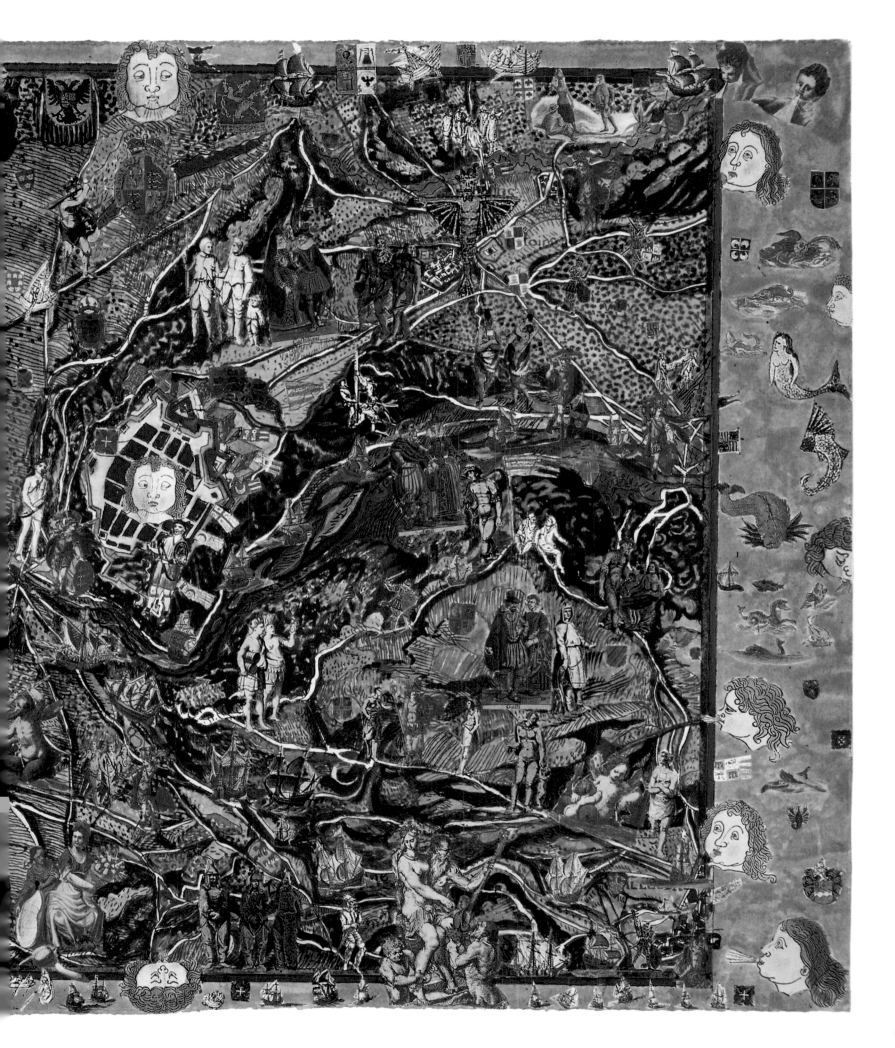

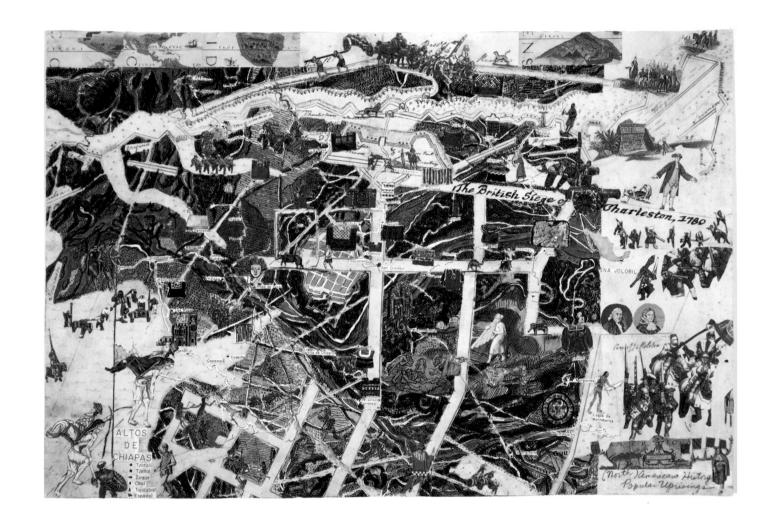

26. *(North) American History: Popular Uprisings*, 2004.

27. *Sing-along American History: White Bread*, 2004.

28. *Sing-along American History: Cowboys and Indians*, 2004.

29. *Sing-along American History: War and Race*, 2004.

30. *Wars in Old Europe*, 2004.

31. *Nuking the Japs*, 2004.

32. *21st Century Crusades*, 2004.

All courtesy DC Moore Gallery, New York

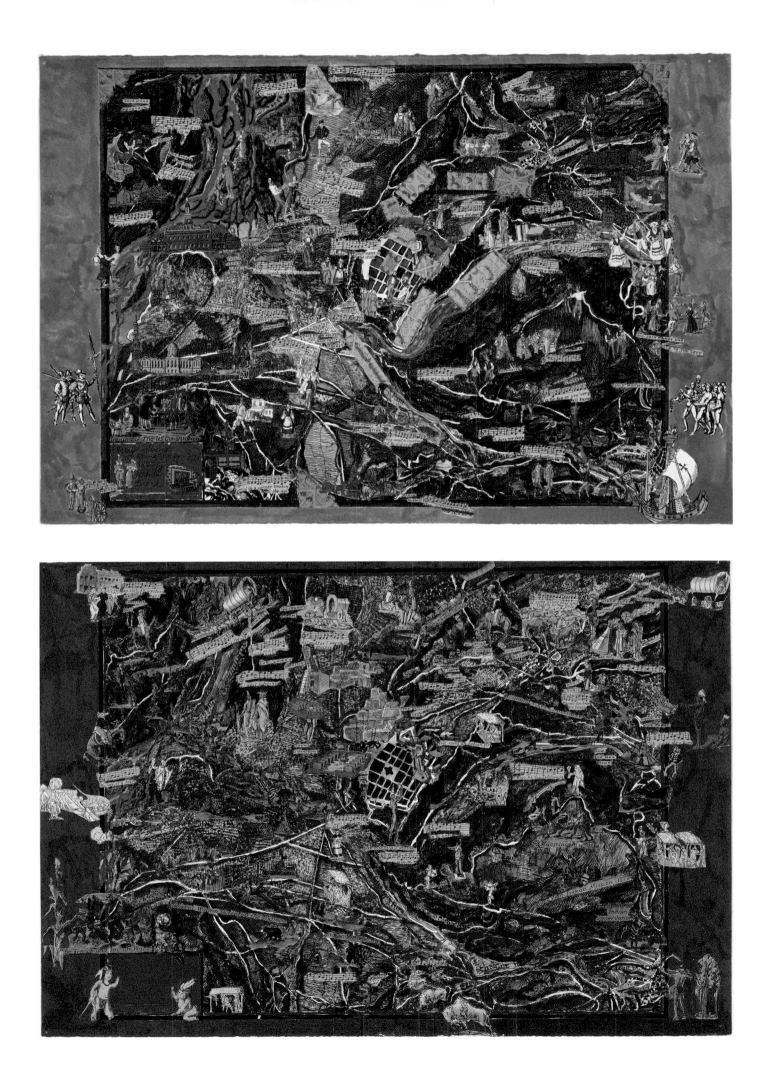

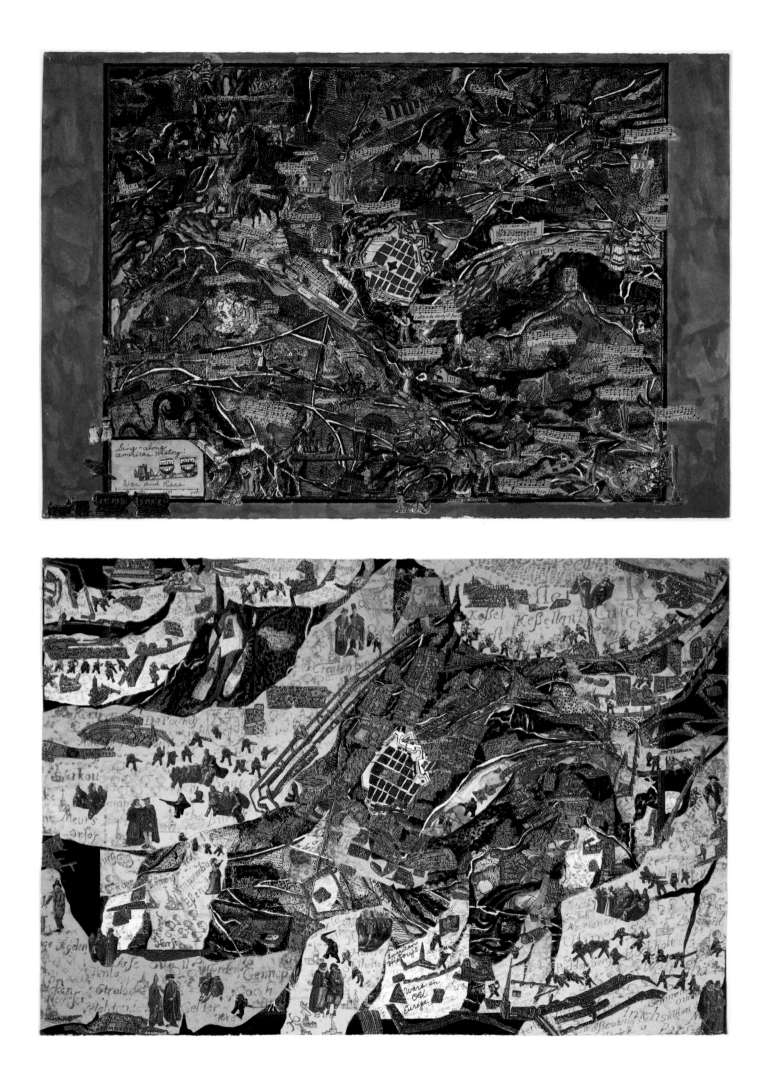

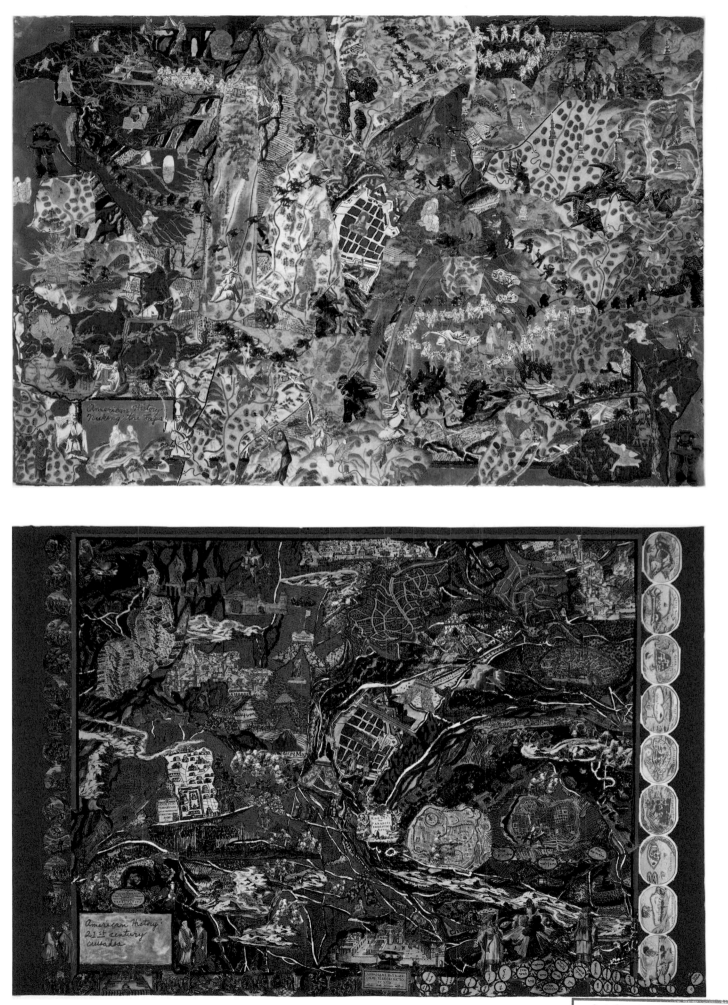

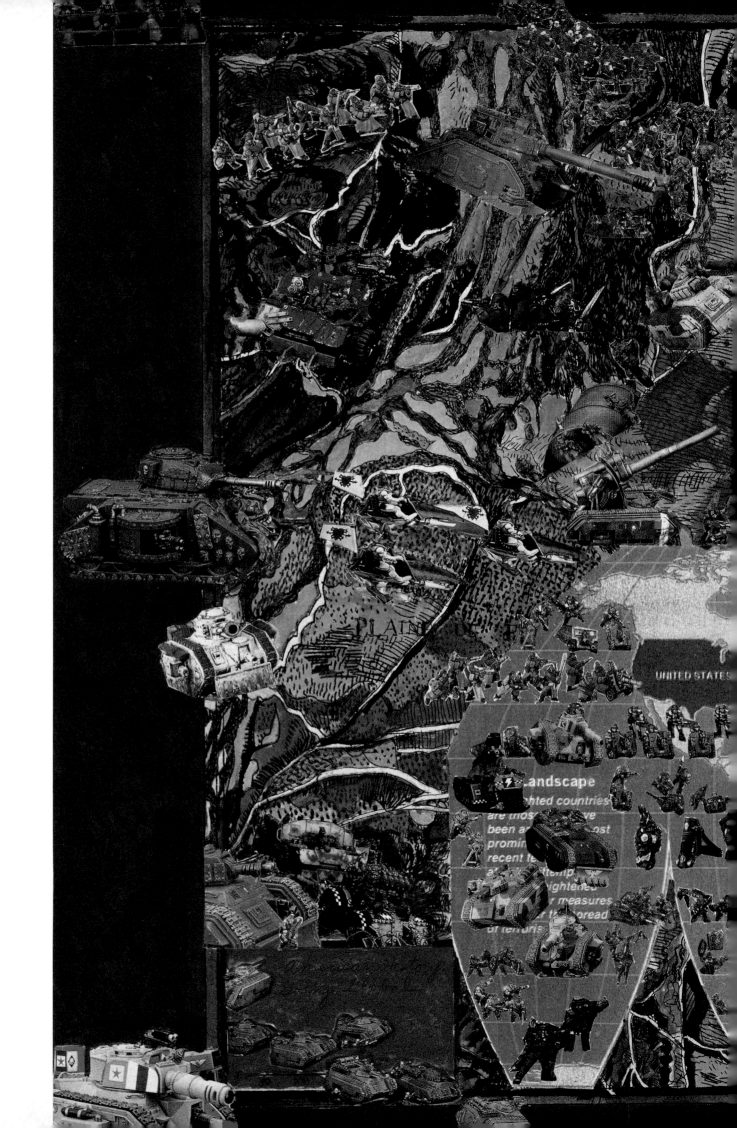

33.  *Going Global*, 2004.
Courtesy DC Moore Gallery,
New York

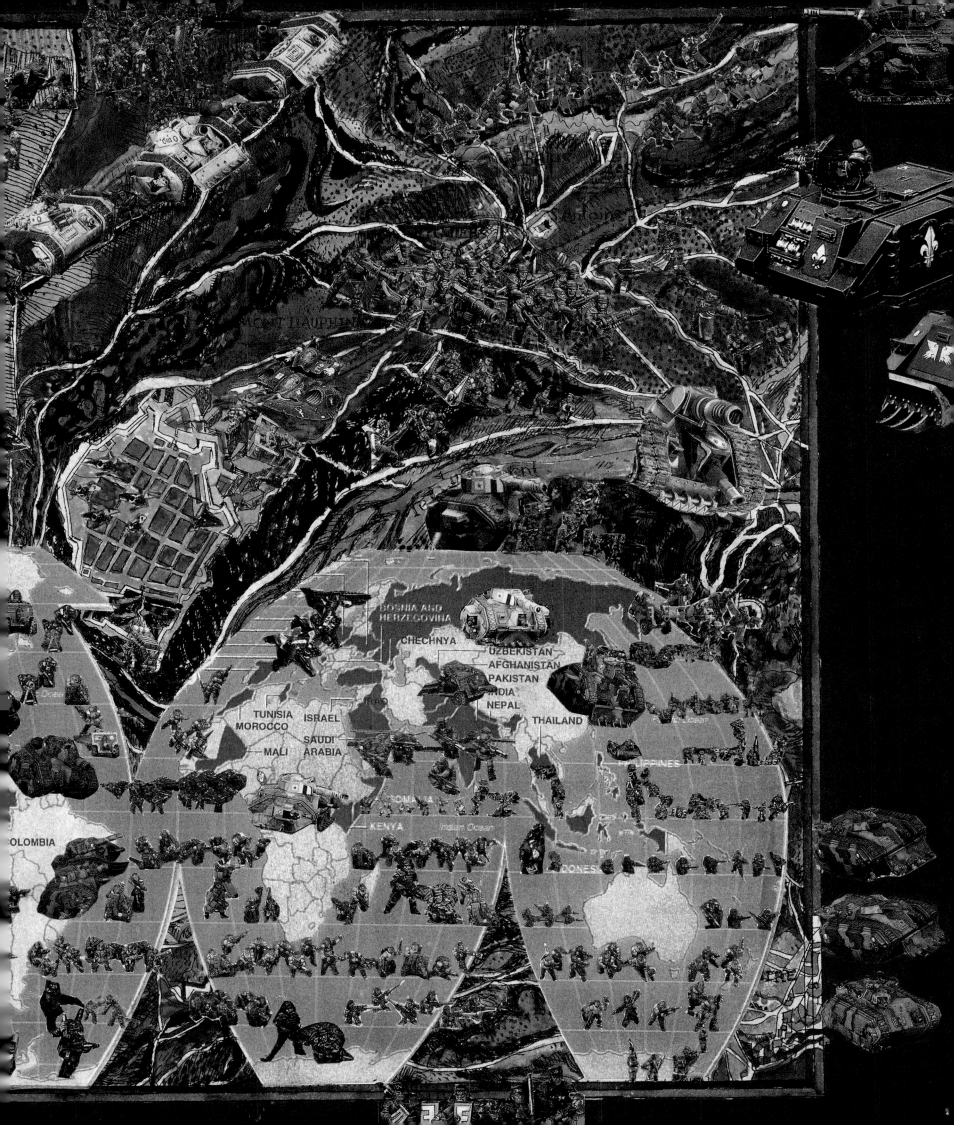

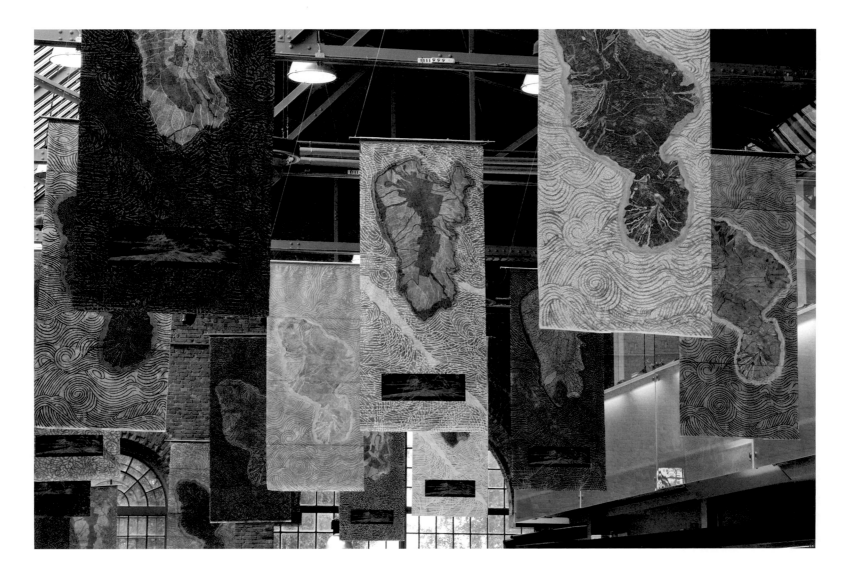

## Voyages

34. *Voyages+Targets*, Thetis, S.p.A., Arsenale, Venice, 2006.
35. *Kaho'olawe I*, 2006.   Courtesy HuiPress, Makawao, Hawaii
36. *Kaho'olawe II*, 2006.   Courtesy of the artist

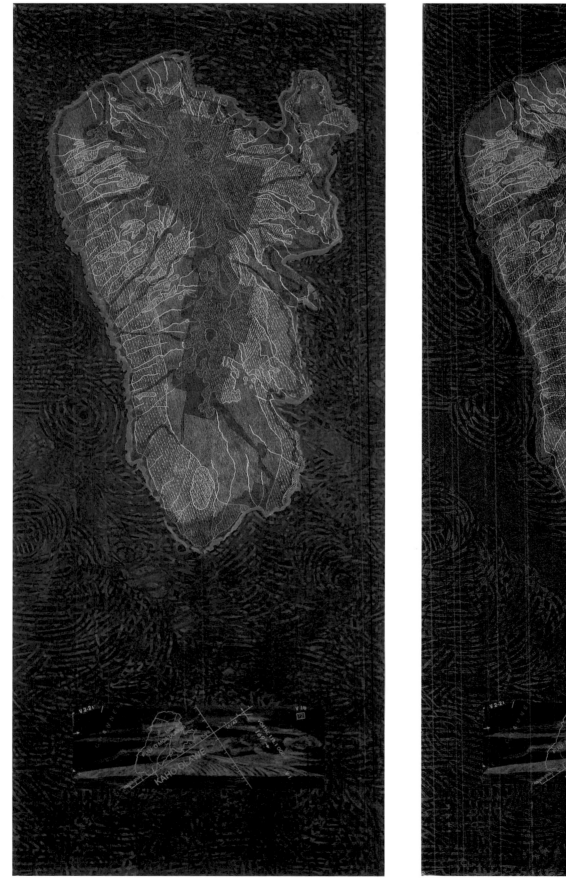
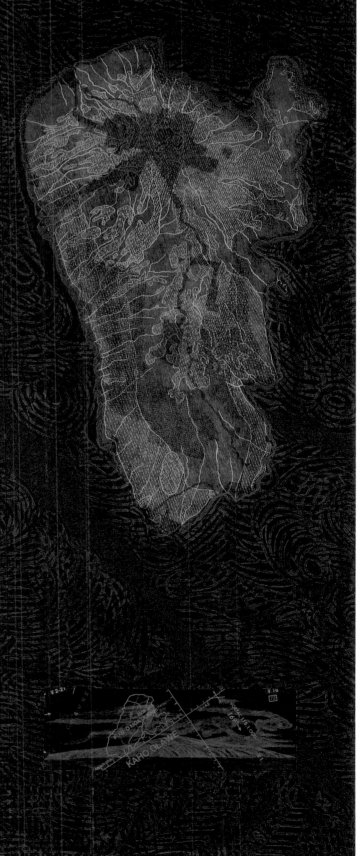

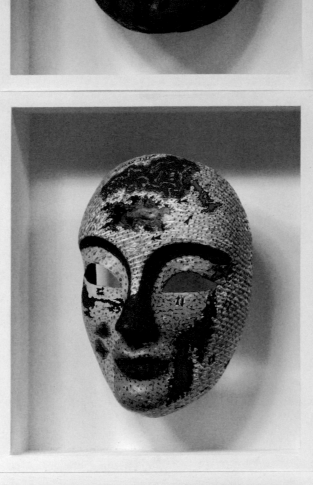
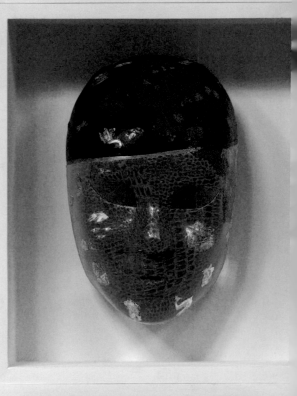
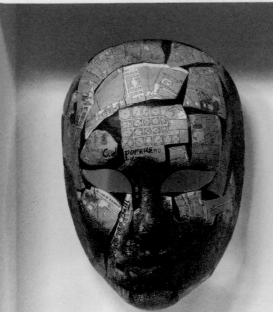
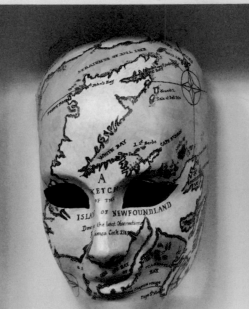

37. *Masks, 2004–6.*

Unless otherwise noted, masks courtesy
DC Moore Gallery, New York

TOP ROW, LEFT TO RIGHT:

*#18: Sooloo archipelago*

*#13: Sardaigne*

*#22: Maria Bay*

*#51: Riviere du Menam*

   Private collection

*#1: Sicilie*

MIDDLE ROW, LEFT TO RIGHT:

*#2: Veglia*

*#47: Lop Buri, Siam*

*#9: Rhodi*

*#53: Iava*

*#54: Espiritu Santu*

   Private collection

BOTTOM ROW, LEFT TO RIGHT:

*#49: I. Balij*

*#50: Island of Newfoundland*

*#10: Isles des Larrons*

*#57: Feejee Islands*

*#58: Cape Verde to Cape Rosso*

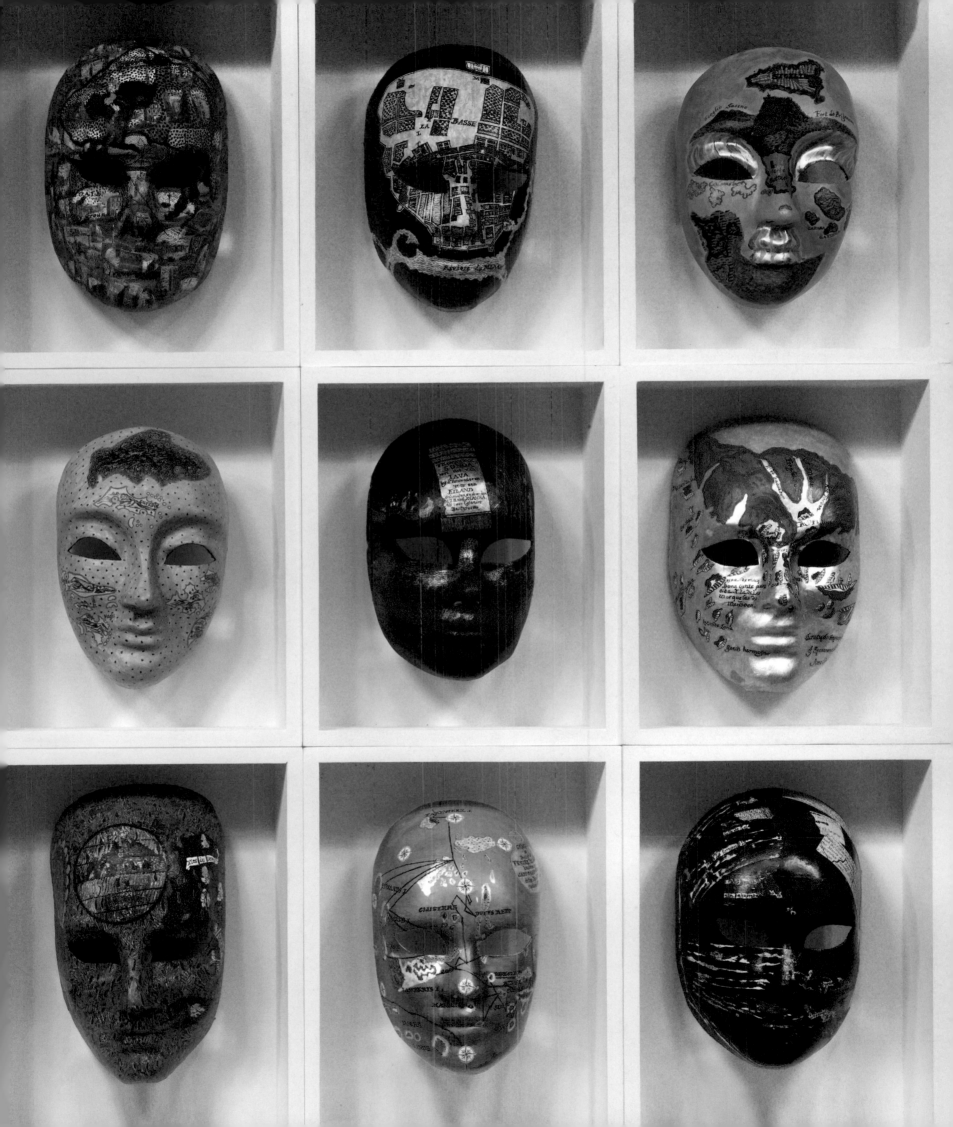

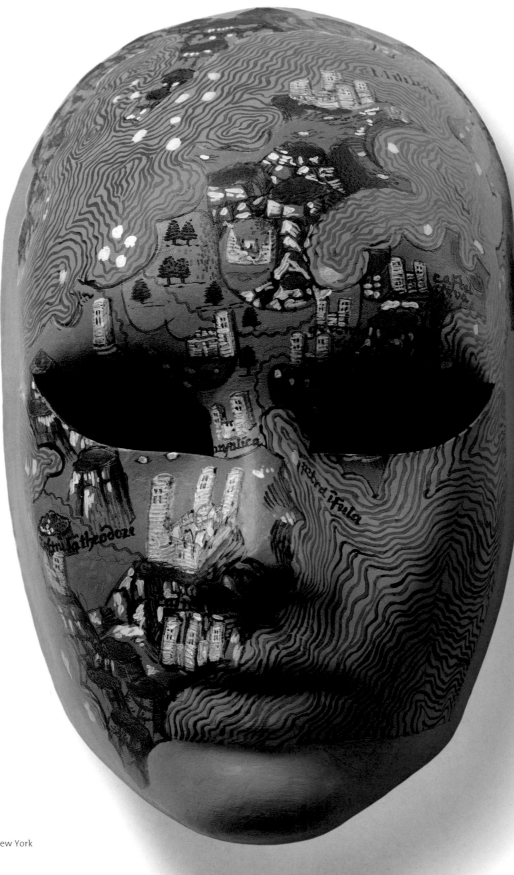

38.  #41: *Lesbos*, 2005.
     Courtesy DC Moore Gallery, New York

39.  #16: *Malluco*, 2005.
     Courtesy DC Moore Gallery, New York

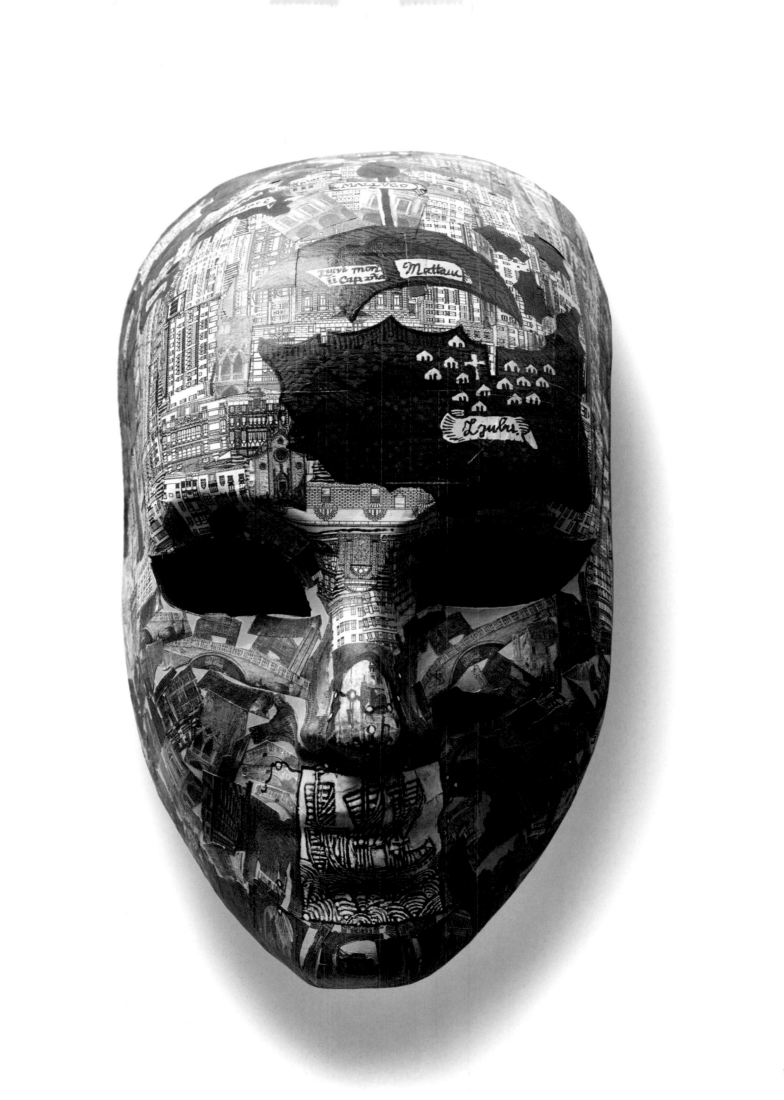

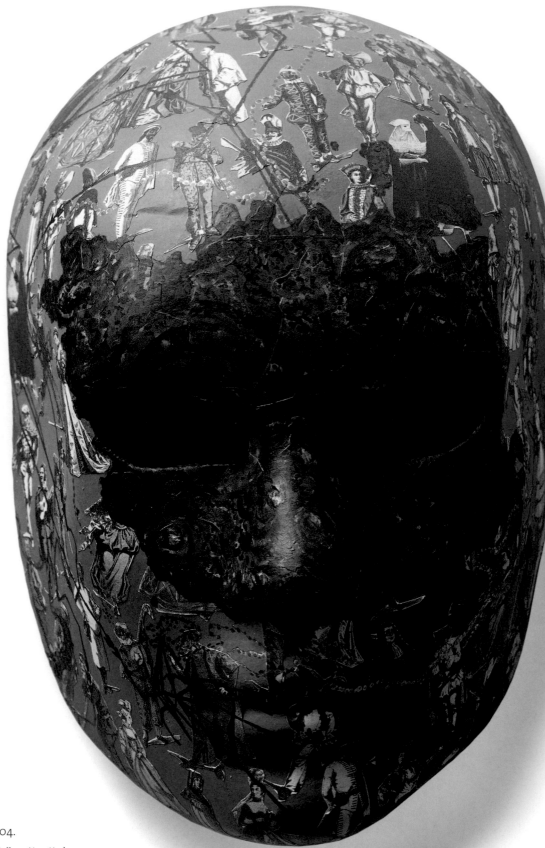

40.  *#21: Pohnpei,* 2004.

Courtesy DC Moore Gallery, New York

41.  *#53: lava* (detail), 2004.

Courtesy DC Moore Gallery, New York

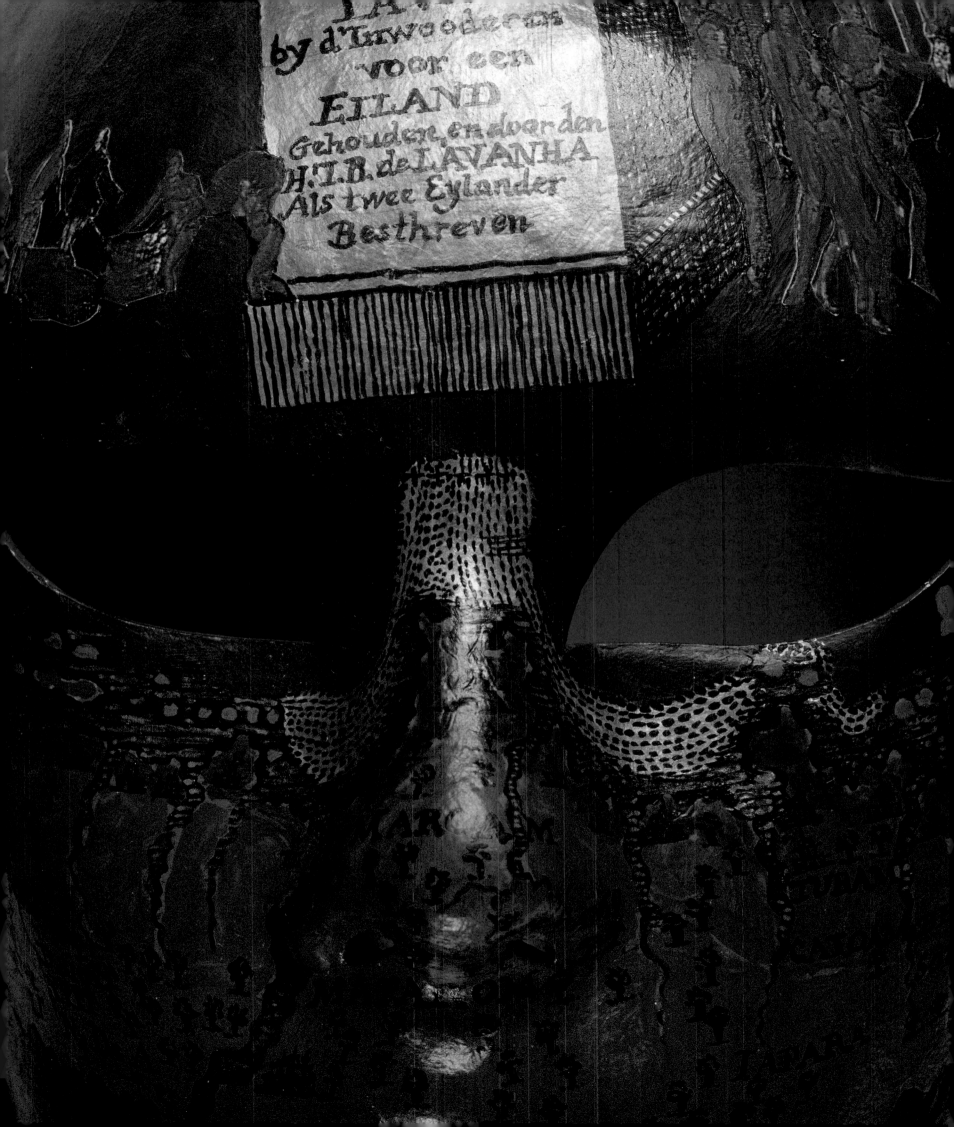

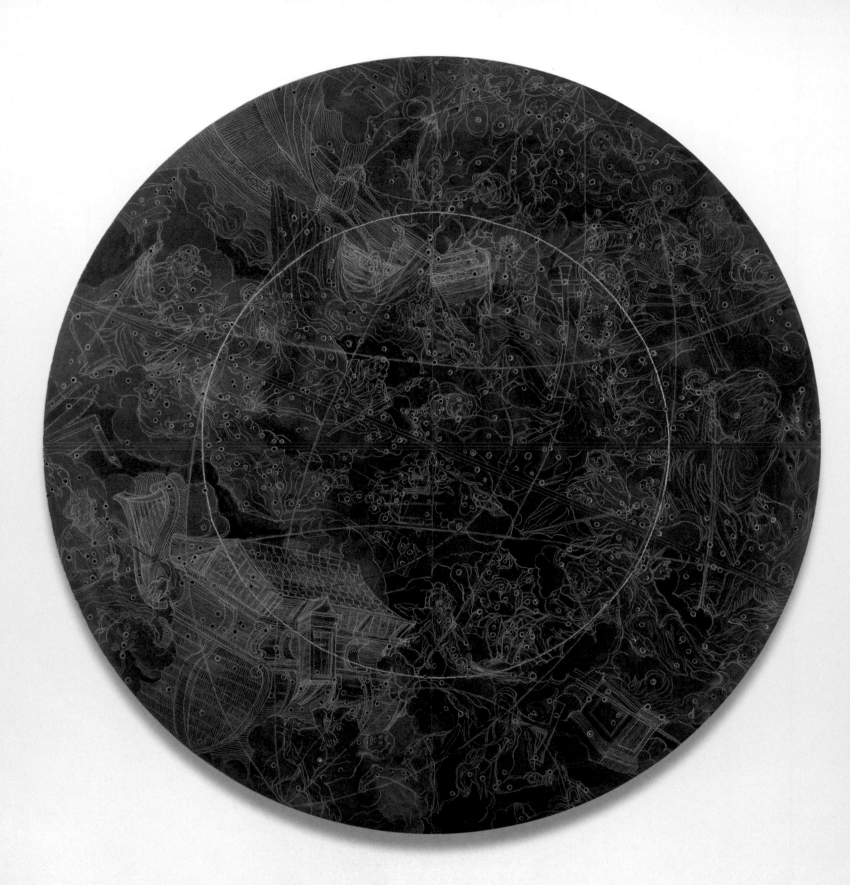

## Tondi

42. *the moments and hours and days of our lives, 2007.*  Courtesy DC Moore Gallery, New York
43. *the days and hours and moments of our lives, 2007.*  Courtesy DC Moore Gallery, New York

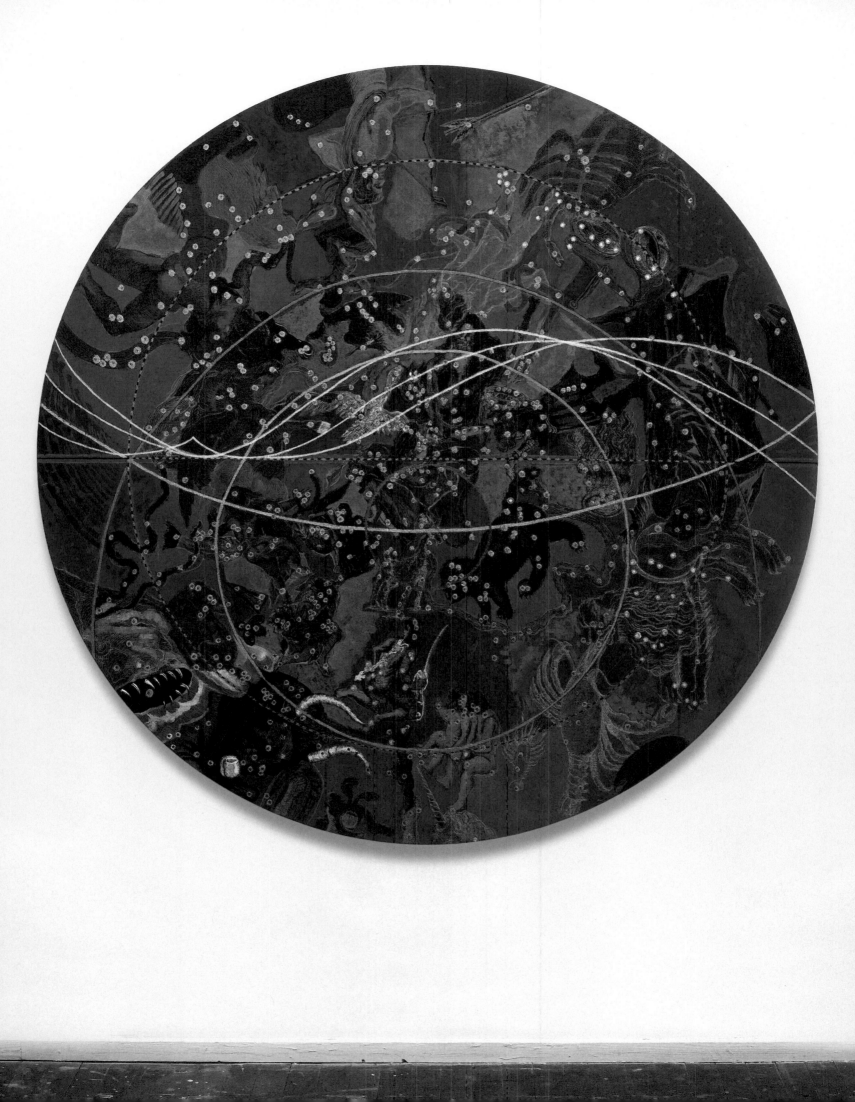

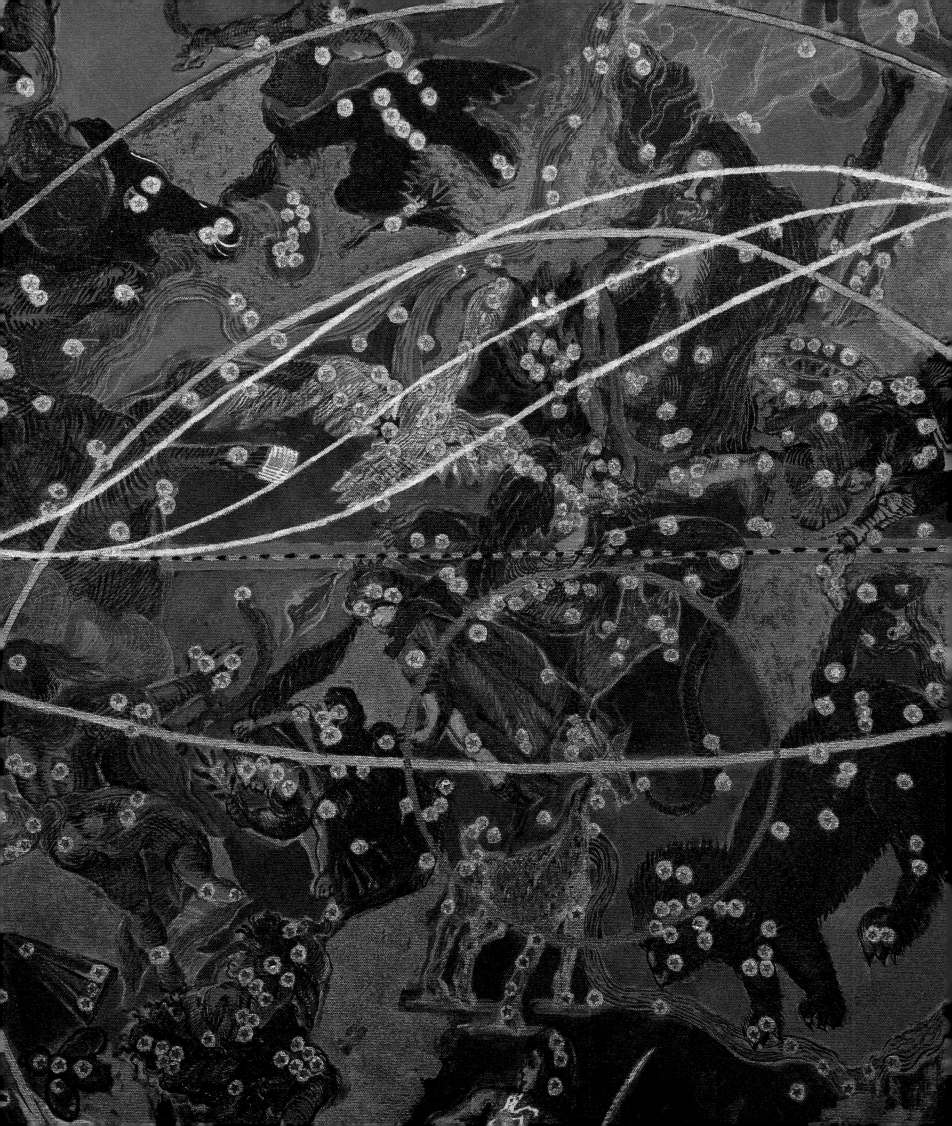

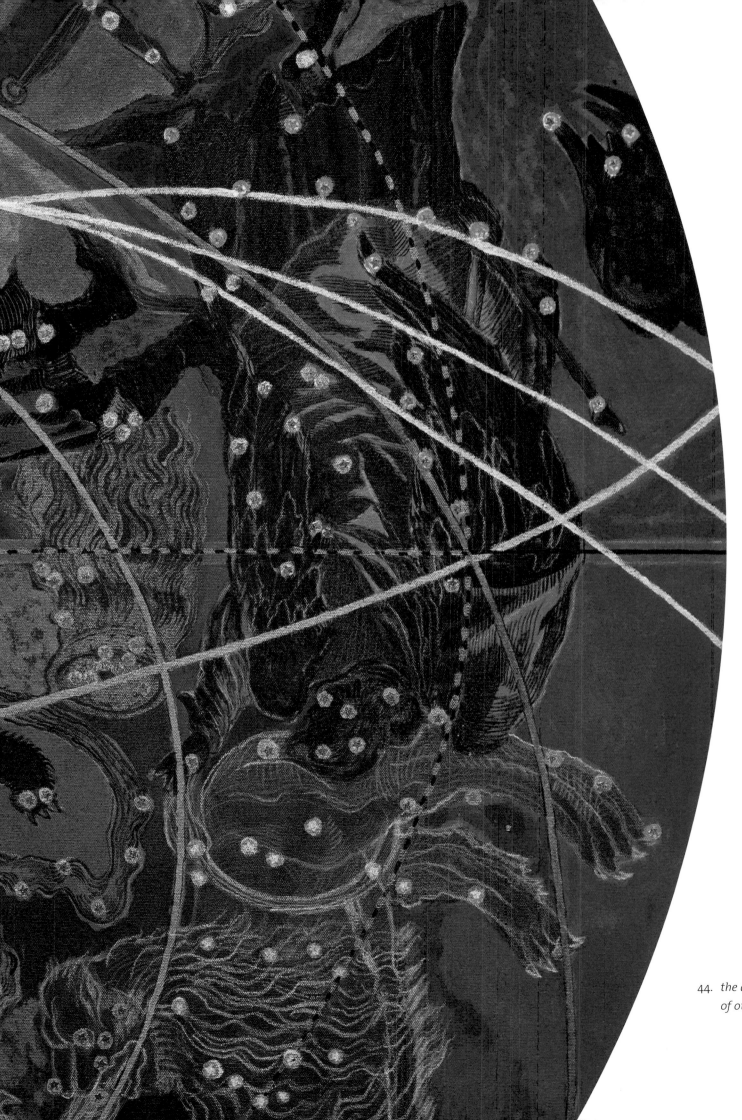

44. *the days and hours and moments
of our lives* (detail)

Tondi

45. *Now/Later,* 2007. Courtesy DC Moore Gallery, New York

#1

#4

46–47. *Whether Weather #1, 4, 2007.*

#1: Courtesy SOLO Impression, New York; #4: Collection Wachtell, Lipton, Rosen & Katz, New York

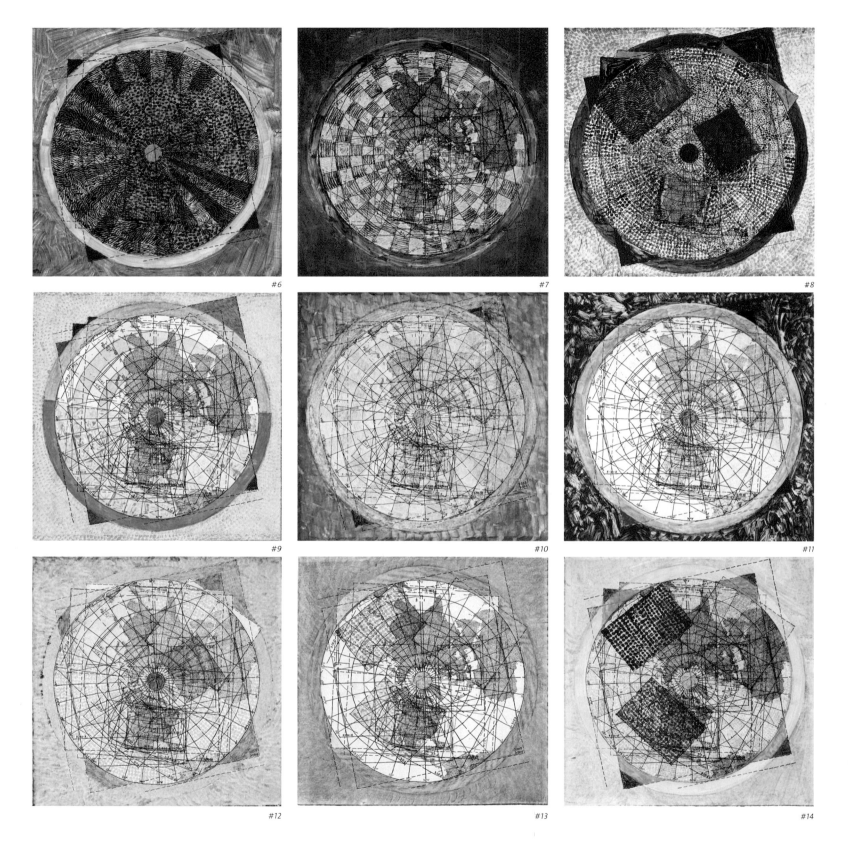

48–56. *Whether Weather #6–14, 2007.* Courtesy SOLO Impression, New York

#9, 13: Collection Wachtell, Lipton, Rosen & Katz, New York; #11: Collection of the artist

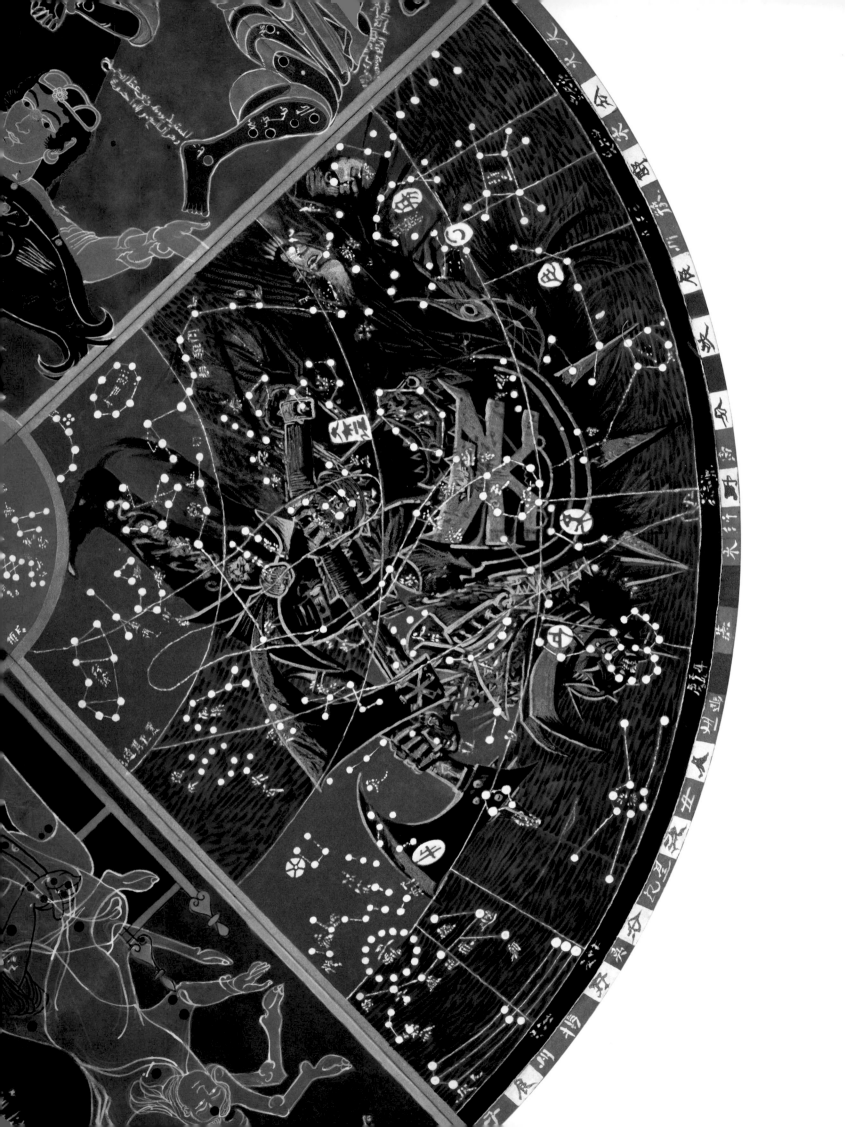

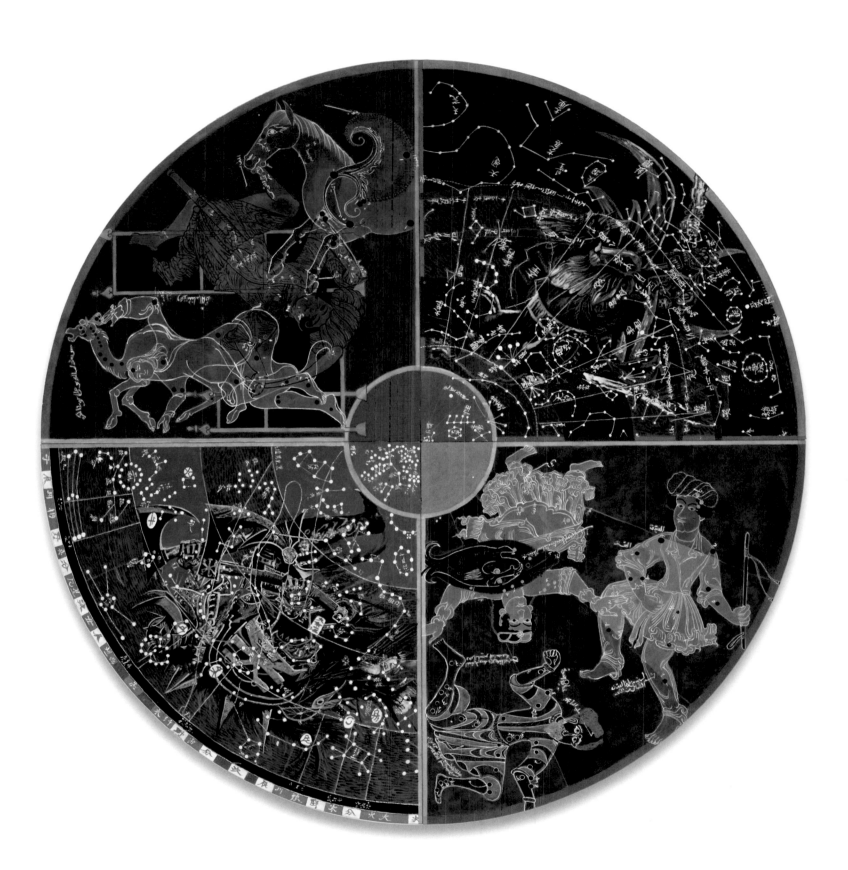

57–58. *Revolver,* 2008.   Courtesy DC Moore Gallery, New York

# PLATE NOTES

## 1. Knowledge

Frescoes, 1998–1999. Fresco on panel,
each approx. 8 x 10 in. (oriented variously)

*#1: Labrador, Iceland, Greenland, Scandinavia and the British Isles, 16th Century; #2: The New World, 1534; #3: The World, 1541; #4: The New World, 1541; #5: South America, 1543; #6: The New World, 1546; #7: Labrador, Newfoundland and Canada, 1556; #8: Italy, 1595; #9: Asia, 1570; #10: Japan, 1570; #11: South America, 1570; #12: Japan, 1570; #13: The New World, 1572; #14: South America, 1585; #15: The Pacific Ocean, 1589; #16: Virginia, 1590; #17: Japan and the Island of Korea, 1595; #18: Japan and the Island of Korea, 1596; #19: Florida, 1597; #20: North America, 1625; #21: Japan and Ezo, 1661; #22: Massachusetts and Rhode Island, 1676; #23: The Island of California, 1696; #24: The Hudson Bay, Greenland and Labrador, 1703; #25: Japan and Ezo, 1705; #26: New York and New Jersey, 1777; #27: Carolina, Georgia and Florida, 1797; #28: The Near East, 1154; #29: China, 1585; #30 a–b: South China Coast, late 18th or Early 19th Century; #31: The Holy Land, 1584; #32: The Holy Land, 1584; #33: Arabia, 1492; #34: Palestine and the Holy Land, 1482; #35: China, 1555; #36: China, 1609; #37: Palestine, 1475; #38: Europe and the Near East, 13th Century; #39: Arabia, 1516; #40: Gulf of Mexico, 1524; #41: China, 1470; #42: The Nile River, 1540; #43: The Nile River, 150 A.D.; #44 a–b: New Galicia, 1550; #45: The British Isles, 1550; #46: Scandinavia, 1425; #47: Africa and Europe, 1490; #48: The World, 1566; #49: The World, 1581; #50: Europe as a Virgin, 1592; #51: The Map of Tenderness, 1678; #52: The British Isles and Brazil, 1586; #53: Western Europe and North Africa, 1154; #54: Island of Rhodes and North Africa, 16th Century; #55 a–b: Grand Canal, Eastern Central China, late 18th or early 19th Century; #56: New England, 1677; #57: West Africa, 1550; #58: Tartaria and America, 16th century; #59: The World, 220 BC; #60: The World, 1578; #61: The Northern Pacific, 1720; #62: The Strait of Magellan, 16th Century; #63: Tierra del Fuego and Staten Island, 1652; #64: The Strait of Magellan, 1671; #65: Scandinavia, 1539; #66: Western Europe, Late 16th Century; #67: The Arctic Circle, 1595; #68: Asia Minor as Pegasus, 1581; #69: South America, 1685; #70: The Cape of Good Hope, 1578; #71: The World from the South Pole, 1531; #72: The South Atlantic, 1558; The British Isles and Brasil, 1513.*

Globes, 1999–2000. Watercolor, acrylic, plaster or gesso, rope, cardboard, porcelain, from 9⅛ in. diam. to 10⅛ in. diam.

*#73: 1st Century A.D.; #74: 1561; #75: 1290; #76: 1602; #77: 1564; #78: 1154.*

## 2. *La Conquista*

*La Conquista*, 1999. Watercolor, plaster, rope, cardboard, metal, wood, 12¾ in. diam.

## 3. *Targets*

*Targets*, 2000. Acrylic on canvas on wood, 108 in. diam.

## 4. Boys' Art

*Boys' Art*, 2002. Graphite, collage, colored pencil on paper, 12 x 18 in. (oriented variously)

*#1: Pitcairn Island; #2: Nagasaki; #3: Plan of the Battle of the Prut; #4: Imola; #5: French Fortifications, Rocca d'Anfo; #6: Havana; #7: British Fleet, Falkland Islands; #8: Battle of Panipat; #9: Iwo Jima; #10: Mindanao; #11: New York Harbor; #12: Foreign Occupation, Sacramento; #13: Han Dynasty Garrison Map; #14: Military Map of the Korat Plateau; #15: The Citadel of Hué; #16: Aztec Military Map; #17: Norwegian Fjords; #18: Mombasa; #19: Skagerrak; #20: Ottoman Attack on Malta; #21: Ottoman Campaigns; #22: Sevastopol; #23: Iron Jar Fortress, Korea; #24: Siege of Antibes.*

## 5. Celestial+Terrestrial

*Spheres of Influence*, 2001. Acrylic, collage on canvas, 96 x 192 in.

*Dark and Light Continents*, 2002. Acrylic, collage on canvas, 96 x 192 in.

## 6. *Rocking the Cradle*

*Rocking the Cradle*, 2003. Acrylic on wood, 56 x 37 x 30 in.

## 7. American History

*American History*, 2004. Small series: etching, collage, watercolor, 11⅛ x 16¼ in.

*The Age of Discovery; (North) American History: Popular Uprisings; Sing-along American History: White Bread; Sing-along American History: Cowboys and Indians; Sing-along American History: War and Race; Wars in Old Europe; Nuking the Japs; 21st Century Crusades; Going Global.*

## 8. Voyages

*Masks*, 2004–6. Acrylic and collage on cast paper, 8⅜ x 5⅜ x 4 in.; 8¼ x 6¼ x 3½ in.; or 9¼ x 6 x 4¼ in.

*#1: Sicilie; #2: Veglia; #3: Cefalonia; #4: Isole Simie; #5: Lemnos; #6: Hawaii; #7: Tahiti; #8: Arbe; #9: Rhodi; #10: Isles des Larrons; #11: Creta; #12: Venetian War Fleet on the Way to Constantinople; #13: Sardaigne; #14: Australia; #15: Il Mondo, cartographic board game; #16: Malluco; #17: Three Worlds; #18: Sooloo archipelago; #19: Pola; #20: Mindoro; #21: Pohnpei; #22: Maria Bay; #23: Philippines; #24: men's island, women's island, boats back and forth; #25: Archipelagus S. Lazari; #26: Insularum Moluccarum; #27: Baffins Bay; #28: Insulae Mariana; #29: Imaginary Island Buss; #30: Tarry Islands; #31: Borneo; #32: Terra incognita Nova Guinea; #33: La Californa Isles; #34: Isle de Zanzibar; #35: Pulo Penang; #36: Balearides Insulae; #37: Sumatra with G.I. Joes; #38: Tongataboo; #39: Cuba; #40: Iaponiae Insulae; #41: Lesbos; #42: Indochina interior; #43: La Dominica; #44: Stretto di Cook; #45: Banda; #46: The Arabian Gulf; #47: Lop Buri, Siam; #48: Hochelaga; #49: I. Balij; #50: Island of Newfoundland; #51: Riviere du Menam; #52: Island of Juan Fernandes in the South Seas;*

*#53: Iava; #54: Espiritu Santu; #55: Galapagos Islands; #56: Chao Phraya River Valley, Laos; #57: Feejee Islands; #58: Cape Verde to Cape Rosso; #59: Burma; #60: Islas de Salamon; #61: Dutch Attacking Tidor, Spice Islands; #62: Columbus and the Indians; #63: Navigational Chart of Admiral Zheng He; #64: Muhyiddin Piri Re'is.*

*Maui I–VIII*, 2005. Woodblock print and watercolor, 84 x 36 in.

*Kaho'olawe I–X*, 2006. Woodblock print, watercolor, etching, 84 x 36 in.

*Carnevale I–VIII*, 2004–6. Acrylic, watercolor, collage on paper mounted on canvas, 122½ x 33 in.

## 9. Tondi

*the days and hours and moments of our lives*, 2007. Acrylic, colored pencil, collage on canvas, 60 in. diam.

*the moments and hours and days of our lives*, 2007. Acrylic, colored pencil, collage on canvas, 60 in. diam.

*Now/Later*, 2007. Acrylic on canvas, 48 in. diam. ea.

*Now, Voyager*, 2007. Lithograph with glitter, 31½ x 31½ in.

*Now, Voyager II*, 2007. Lithograph with glitter, 31½ x 31½ in.

*Whether Weather #1–15*, 2007. Lithograph and monoprint, 13 x 13 in.

*Helium on the Moon*, 2007. Acrylic, colored pencil, collage on canvas, 60 in. diam.

*Helium on the Moon II*, 2008. Acrylic, colored pencil, collage on canvas, 60 in. diam.

*Revolver*, 2008. Acrylic on canvas, 96 in. diam.

*Descartes Heart*, 2008. Acrylic on canvas, 48 in. diam.

# SELECTED BIOGRAPHY

**BORN DECEMBER 14, 1942,
SOMERVILLE, NJ**

## Education

**1964**

B.F.A., Carnegie Institute of
Technology, Pittsburgh, PA

**1967**

M.F.A., Columbia University,
New York, NY

## Solo Exhibitions

**2008**

*Co+Ordinates*, Trout Gallery,
Dickinson College, Carlisle, PA

**2007**

*Voyages*, DC Moore Gallery, New
York, NY

*Voyages: Time Travel*, SOLO
Impression Gallery, New York, NY

**2006**

*Voyages+Targets*, Thetis, S.p.A.,
Venice, Italy *(traveled to: Museo
d'Arte Contemporanea di Villa Croce,
Genoa, Italy)*

*Joyce Kozloff: Interior and Exterior
Cartographies*, Regina Gouger
Miller Gallery, Purnell Center
for the Arts, Carnegie Mellon
University, Pittsburgh, PA
*(traveled to: Olin Art Gallery, Kenyon
College, Gambier, OH)*

**2005**

*Boys' Art*, Allcott Gallery,
University of North Carolina,
Chapel Hill, NC

**2004**

*Kozloff & Kozloff* (with Max
Kozloff), University Art Gallery,
New Mexico State University,
Las Cruces, NM

*Six Feet Under: Make Nice*, White
Box, New York, NY

**2003**

*Boys' Art and Other Works*,
DC Moore Gallery, New York, NY

*Joyce Kozloff: Topographies*,
Contemporary Art Center of
Virginia, Virginia Beach, VA

*Joyce and Max Kozloff*, Gulf
Coast Exploreum Science Center,
Mobile, AL

*Targets*, DC Moore Gallery,
New York, NY

**1998/2000**

*Crossed Purposes* (with Max
Kozloff), List Gallery, Swarthmore
College, Swarthmore, PA

*(traveled to: Mills College Art Museum,
Oakland, CA; Sweeney Art Gallery,
University of California, Riverside, CA;
Otis Art Gallery, Otis College of Art and
Design, Los Angeles, CA; Butler Institute
of American Art, Youngstown, OH;
Polk Museum of Art, Lakeland, FL;
Albuquerque Museum, Albuquerque,
NM; Muscarelle Museum of Art, College
of William and Mary, Williamsburg,
VA; Sidney Mishkin Gallery, Baruch
College, New York, NY)*

**1999**

*Knowledge: An Ongoing Fresco
Project by Joyce Kozloff*, DC Moore
Gallery, New York, NY

**1997**

*Other People's Fantasies: maps,
movies and menus*, DC Moore
Gallery, New York, NY

**1995**

*Mapping Public and Private*,
Midtown Payson Galleries, New
York, NY

*Around the World on the 44th
Parallel*, Tile Guild, Los Angeles,
CA

**1992**

*Informed Sources, NY* (with Jeff
Perrone and Kim MacConnel),
SUNY College at Old Westbury,
Old Westbury, NY

**1991**

*The Movies: Fantasies*, 152
Wooster Street Space, New York,
NY

**1990/93**

*Patterns of Desire*, Lorence-Monk
Gallery, New York, NY

*(traveled to: Nina Freudenheim
Gallery, Buffalo, NY; Robert Berman
Gallery, Santa Monica, CA; Nancy
Drysdale Gallery, Washington, DC;
Galerie Feuerle, Cologne, Germany;
Allrich Gallery, San Francisco, CA)*

**1986/87**

*Visionary Ornament*, Boston
University Art Gallery, Boston, MA

*(traveled to: University of New Mexico
Art Museum, Albuquerque, NM;
College of Wooster Art Museum,
Wooster, OH; Hunter Museum of Art,
Chattanooga, TN; Goldie Paley Gallery,
Moore College of Art, Philadelphia, PA)*

**1985**

*Architectural Caprices*, Barbara
Gladstone Gallery, New York, NY

**1984**

San Antonio Art Institute, San
Antonio, TX

*Joyce Kozloff Mural for Harvard
Square Subway Station: New
England Decorative Arts*, P.S. 1,
Long Island City, NY

*Three Train Stations*, Delaware
Art Museum, Wilmington, DE

**1983**

*Investigations 4: Joyce Kozloff*,
Institute of Contemporary Art,
Philadelphia, PA

Lincoln Center for the Performing
Arts (with Judith Murray and
Elizabeth Murray), New York, NY

*Architectural Fantasies/Urban
Sites* (with Richard Haas and
Ned Smyth), McIntosh/Drysdale
Gallery, Houston, TX

Barbara Gilman Gallery (with
Miriam Schapiro), Miami, FL

Berkshire Community College,
Pittsfield, MA

**1982**

*I-80 Series: Joyce Kozloff*, Joslyn
Art Museum, Omaha, NE

*Projects and Proposals*, Barbara
Gladstone Gallery, New York, NY

*Etchings and Other Works on
Paper*, Crown Point Gallery,
Oakland, CA

**1981**

*Joyce Kozloff/Betty Woodman*,
Tibor de Nagy Gallery, New York,
NY

**1979/81**

*An Interior Decorated*, Tibor de
Nagy Gallery, New York, NY

*(traveled to: Everson Museum,
Syracuse, NY; Mint Museum, Charlotte,
NC; Renwick Gallery, Smithsonian
Institution, Washington, DC)*

**1978**

University of New Mexico (with
Max Kozloff), Albuquerque, NM

**1977**

Ross Graphics (with Herb
Jackson and Adja Yunkers),
Minneapolis, MN

Wilcox Gallery, Swarthmore
College, Swarthmore, PA

Jasper Gallery, Denver, CO

Watson/de Nagy Gallery,
Houston, TX

Tibor de Nagy Gallery,
New York, NY

**1976**

Paul Klapper Library, Queens
College of the City of New York,
Queens, NY

Women's Building,
Los Angeles, CA

Tibor de Nagy Gallery,
New York, NY

**1975**

Atholl McBean Gallery,
San Francisco Art Institute, San
Francisco, CA

Kingpitcher Gallery
(with Howardena Pindell),
Pittsburgh, PA

**1974**

University of Rhode Island Fine
Arts Center, Kingston, RI

Tibor de Nagy Gallery,
New York, NY

**1973**

Mabel Smith Douglass Library,
Douglass College, Rutgers
University, New Brunswick, NJ

Tibor de Nagy Gallery,
New York, NY

**1971**

Tibor de Nagy Gallery,
New York, NY

**1970**

Tibor de Nagy Gallery,
New York, NY

## Selected Group Exhibitions

**2009**

*All Over the Map,* Kohler Arts
Center, Sheboygan, WI

**2008**

*Mapped,* Contemporary
Museum of Honolulu, HI

*L(A)ttitudes,* Ann Loeb Bronfman
Gallery, District of Columbia
Jewish Community Center,
Washington, DC

*HereThereEverywhere,* Chicago
Cultural Center, Chicago, IL

*Legend Altered—Maps as
Method and Medium,* Carrie
Secrist Gallery, Chicago, IL

*Midnight Full of Stars,* Visual
Arts Center of New Jersey,
Summit, NJ (exhib. cat.)

*New Prints 2008/Winter,*
International Print Center, New
York, NY *(traveled)*

*Pretty Things: Confronting
Sensuousness,* ArtSpace, New
Haven, CT (exhib. cat.)

*New Prints 2008/Spring,* International Print Center, New York, NY

*Envisioning Maps, Hebrew Union
College,* New York, NY

*Messages & Magic,*
Kohler Arts Center,
Sheboygan, WI (exhib. cat.)

*Evening Light,* DC Moore Gallery,
New York, NY

*Burning Down the House:
Building a Feminist Collection,*
Brooklyn Museum, NY

**2007**

*Pattern and Decoration: An Ideal
Vision in American Art, 1975–85,*
Hudson River Museum, Yonkers,
NY (exhib. cat.)

*WACK! Art and the Feminist
Revolution,* Museum of
Contemporary Art, Los Angeles,
CA (exhib. cat.); *(traveled)*

*From the Inside Out: Feminist Art
Then and Now,* Dr. M.T. Geoffrey
Yeh Art Gallery, St. John's University, Queens, NY (exhib. cat.)

*Claiming Space: The American
Feminist Originators,* Katzen
Art Center, American University
Museum, Washington, DC
(exhib. cat.)

*Mapwork,* Spencertown
Academy, Spencertown, NY

*Witness to War: Revisiting
Vietnam in Contemporary Art,*
International Center for the
Arts, San Francisco State
University, San Francisco, CA
(exhib. cat.)

*Agents of Change: Women,
Art and Intellect,* Ceres Gallery,
New York, NY

*The 182nd Annual: An Exhibition
of Contemporary American Art,*
National Academy of Design,
New York, NY (exhib. cat.)

*Brodsky Center Annual
Exhibition—New Work from
2006,* Judith K. and David J.
Brodsky Center for Print and
Paper at Mason Gross School of
the Arts, Rutgers University,
New Brunswick, NJ

*Imaginary Geographies,*
Sun Valley Center for the Arts,
Sun Valley, IA (exhib. cat.)

*PostDec,* Joseloff Gallery,
Hartford Art School, Hartford, CT

*Zoom +,* Arena 1, Santa Monica,
CA

*15th Anniversary Exhibition,*
Woman Made Gallery, Chicago, IL

**2006**

*Couples Discourse,* Palmer
Museum of Art, Pennsylvania
State University, University Park,
PA (exhib. cat.)

*Collecting CFA,* Regina Gouger
Miller Gallery, Purnell Center for
the Arts, Carnegie Mellon
University, Pittsburgh, PA

*From Postwar to Postmodernism,*
LeRoy Neiman Gallery, Columbia
University, New York, NY
(exhib. cat.)

*Global,* Westport Arts Center,
Westport, CT

*Ten Plus Ten: Revisiting Pattern
and Decoration,* University
Galleries, University of Florida,
Gainesville, FL (exhib. cat.)

*The Eye of the Collector: Jewish
Vision of Sigmund R. Balka,*
Hebrew Union College Museum,
New York, NY (exhib. cat.);
*(traveled)*

*What War? Which War?* White
Box, New York, NY

*Personal Geographics,* Hunter
College Art Gallery, New York,
NY (exhib. cat.)

**2005**

*Upstarts & Matriarchs: Jewish-
American Women Artists and the
Transformation of American Art,*
Mizel Arts Center, Denver, CO
(exhib. cat.)

*Contemporary Women Artists:
New York,* Indiana State University Art Gallery, Terre Haute, IN

*Memento Mori: Artists Grapple
with Issues of War and Peace,*
Cleveland State University
Gallery, Cleveland, OH

*Solitude and Focus: Recent Work
by MacDowell Colony Fellows in
the Visual Arts,* Aldrich
Contemporary Art Museum,
Ridgefield, CT

*Out of Conflict,* LeRoy Neiman
Gallery, Columbia University,
New York, NY

*New Prints 2005/Spring,* International Print Center, New York, NY

*Disegno, 180th Annual Exhibition,*
National Academy of Design,
New York, NY (exhib. cat.)

*How American Women Artists
Invented Postmodernism:
1970–1975,* Mason Gross School
of the Arts Galleries, Rutgers
University, New Brunswick, NJ
(exhib. cat.); *(traveled)*

**2004**

*Watercolor Worlds,* Dorsky
Gallery, Long Island City, NY
(exhib. cat.)

*Uncharted Territory: Subjective
Mapping by Artists & Cartographers,* Julie Saul Gallery, New
York, NY

*Al Fresco,* Schiavone Edward
Contemporary Art, Baltimore, MD

*Watch What We Say,* Schroeder
Romero Gallery, Brooklyn, NY

*Preserving the Past, Building for
the Future,* United States
Embassy, Dushanbe, Tajikistan
(exhib. cat.)

*Invitational Exhibition of
Painting and Sculpture,*
American Academy of Arts and
Letters, New York, NY (exhib. cat.)

*Good Morning, America,* Ezra and
Cecile Zilkha Gallery, Wesleyan
University, Middletown, CT

*178th Annual Exhibition,*
National Academy of Design,
New York, NY (exhib. cat.)

*Art During Wartime,* IT Gallery,
New York, NY

*Challenging Tradition: Women
of the Academy, 1826–2003,*
National Academy of Design,
New York, NY (exhib. cat.)

*Drawing Conclusions: Work by
Artist-Critics,* New York Arts,
New York, NY

*Mapping It Out,* The Work Space,
New York, NY

*Wake Up Call: Politically Engaged
Art for the 21th Century,* Klemm
Gallery, Siena Heights University,
Adrian, MI

*Artists and Maps: Cartography
as a Means of Knowing,* Hoffman
Gallery of Art, Lewis & Clark
College, Portland, OR (exhib. cat.)

*NYPD,* Shoshana Wayne Gallery,
Santa Monica, CA

*From Here to There: Maps as
Muse,* Hirschl & Adler Galleries,
New York, NY

Too Much Joy: Re-visiting the Pattern & Decoration Movement, Center for Curatorial Studies, Bard College, Annandale-on-Hudson, NY

To Kiss the Spirits, Artemesia Gallery, Chicago, IL

Personal and Political: Feminist Artists and the Women's Movement, 1969–1975, Guild Hall, East Hampton, NY (exhib. cat.)

Print Publisher's Spotlight, Barbara Krakow Gallery, Boston, MA

**2001**

Patterns: Between Object and Arabesque, Kunsthallen Brandts Klaedefabrik, Odense, Denmark (exhib. cat.); (traveled)

New Prints/Summer, International Print Center, New York, NY

Beauty Without Regret, Bellas Artes Gallery, Santa Fe, NM (exhib. cat.)

A View of MacDowell, St. Botolph Club, Boston, MA

The World According to the Newest and Most Exact Observations: Mapping Art and Science, Tang Teaching Museum and Art Gallery, Skidmore College, Saratoga Springs, NY (exhib. cat.)

Fresh/Fresco: Contemporary Fresco Painting, Educational Alliance Ernest Rubenstein Gallery, New York, NY

SOLO Impression, University Art Galleries, Myers School of Art, University of Akron, Akron, OH

Best of the Season: Highlights from the 2000–2001 Manhattan Exhibition Season, Aldrich Contemporary Art Museum, Ridgefield, CT (exhib. cat.)

**2000**

Tibor de Nagy Gallery—The First Fifty Years 1950–2000, Tibor de Nagy Gallery, New York, NY (exhib. cat.)

First International Art Biennial—Buenos Aires: The Globalization of Urban Culture, National Museum of Fine Arts, Buenos Aires, Argentina

Mapping Cities, Boston University Art Gallery, Boston, MA (exhib. cat.)

Annual Exhibition, American Academy in Rome, Italy (exhib. cat.)

Home Abroad, Sala Uno, Rome, Italy

Yaddo On Site, I.S. 218, New York, NY

Memory and Material, Constructions and Compilations, DC Moore Gallery, New York, NY

The Likeness of Being: Contemporary Self-Portraits by Sixty Women, DC Moore Gallery, New York, NY (exhib. cat.)

**1999**

The American Century: Art & Culture, 1900–2000, Whitney Museum of American Art, New York, NY (exhib. cat.)

Summer Group Show, DC Moore Gallery, New York, NY

Together/Working, The Art Museum, University of New Hampshire, Durham, NH (exhib. cat.); (traveled)

World Views: Maps & Art, Frederick R. Weisman Art Museum, University of Minnesota, Minneapolis, MN (exhib. cat.)

**1998**

Legacy, Brevard Museum, Melbourne, FL

Collaborations 1998, printworks, Chicago, IL

Food for Thought: A Visual Banquet, DC Moore Gallery, New York, NY

**1997**

The Private Eye in Public Art, Nationsbank Plaza Gallery, Charlotte, NC (exhib. cat.)

The Game of Chance, printworks, Chicago, IL (exhib. cat.); (traveled)

Generations, A.I.R. Gallery, New York, NY

Patchworks: Contemporary Interpretations of the Quilt Form, Islip Art Museum, East Islip, NY

Printer's Choice, Works on Paper Gallery, Philadelphia, PA

Evolving Forms/Emerging Faces: Trends in Contemporary American Printmaking, Jane Voorhees Zimmerli Art Museum, Rutgers University, New Brunswick, NJ (exhib. cat.)

**1996**

Inaugural Exhibition, DC Moore Gallery, New York, NY

Graphics from SOLO Impression, Inc., Members' Gallery, Albright-Knox Art Gallery, Buffalo, NY

Scuola di Mosaico & Mosaici, Palazzina delle Mostre, Spilimbergo, Italy (exhib. cat.)

Women Artists Series 25th Year Retrospective, Mabel Smith Douglass Library, Douglass College, Rutgers University, New Brunswick, NJ (exhib. cat.)

Partners in Printmaking: Works from SOLO Impression, National Museum of Women in the Arts, Washington, DC

**1995**

Division of Labor: Women's Work in Contemporary Art, Bronx Museum of Art, Bronx, NY (exhib. cat.)

Sniper's Nest: Art That Has Lived with Lucy R. Lippard, Center for Curatorial Studies, Bard College, Annandale-on-Hudson, NY (exhib. cat.); (traveled)

**1994**

The Lure of the Local, Colorado University Art Galleries, Boulder, CO

Prints from SOLO Impression, Inc., New York, College of Wooster, Wooster, OH (exhib. cat.)

Art for Learning, Municipal Art Society, New York, NY (exhib. cat.)

**1993**

Architectural Clay, The Clay Studio, Philadelphia, PA

Women's Art, Women's Lives, Women's Issues, New York Commission on the Status of Women, Tweed Gallery, New York, NY

Coming to Power: 25 Years of Sexually Explicit Art by Women, David Zwirner Gallery, New York, NY

The Return of the Cadavre Equis, Drawing Center, New York, NY

**1992**

Visiting Artist Program, 20th Anniversary Show, Colorado University Art Galleries, University of Colorado, Boulder, CO (exhib. cat.)

**1991**

Drawings, Lorence-Monk Gallery, New York, NY

Show of Strength, Anne Plumb Gallery, New York, NY

Presswork: The Art of Women Printmakers, National Museum of Women in the Arts, Washington, DC

The Artist's Hand, San Diego Museum of Art, La Jolla, CA (exhib. cat.); (traveled)

**1990**

Grids, Vrej Baghoomian Gallery, New York, NY

Hassam and Speicher Fund Purchase Exhibition, American Academy of Arts and Letters, New York, NY

40th Anniversary Exhibition, Tibor de Nagy Gallery, New York, NY

**1989**

The Spectacle of Chaos, Kaos Foundation, Chicago, IL (exhib. cat.)

From Concept to Completion: The Artwork Commission Process, Gallery at the Home Savings Tower, Los Angeles, CA

Architectural Art: Affirming the Design Relationship, American Craft Museum, New York, NY (exhib. cat.); (traveled)

Art for The Public: New Collaborations, Dayton Art Institute, Dayton, OH (exhib. cat.)

American Herstory: Women and the U.S. Constitution, Atlanta College of Art Gallery, Atlanta, GA (exhib. cat.)

Private Works for Public Spaces, R.C. Erpf Gallery, New York, NY

Global Perspectives, State Transportation Building, Boston, MA

Dwelling, 56 Bleecker Gallery, New York, NY

*Making Their Mark: Women Artists Today, A Documentary Survey 1970–1985*, Cincinnati Art Museum, Cincinnati, OH (exhib. cat.); *(traveled)*

*Gardens: Real and Imagined*, Bernice Steinbaum Gallery, New York, NY (exhib. cat.); *(traveled)*

### 1987

*Prints in Parts*, Crown Point Gallery, New York, NY

*The Eloquent Object*, Philbrook Art Center, Tulsa, OK (exhib. cat.)

*A Graphic Muse, Prints by Contemporary Women Artists*, Mount Holyoke College Art Museum, South Hadley, MA (exhib. cat.); *(traveled)*

*Borrowed Embellishments*, Kansas City Art Institute, Kansas City, MO (exhib. cat.)

*Utopian Visions*, Museum of Modern Art, New York, NY

*In Defense of Sacred Lands*, Harcus Gallery, Boston, MA

*A Decade of Pattern: Prints, Pieces and Prototypes from the Fabric Workshop*, Institute of Contemporary Art, Philadelphia, PA (exhib. cat.)

*Contemporary American Collage 1960–1986*, Herter Art Gallery, University of Massachusetts, Amherst, MA (exhib. cat.); *(traveled)*

### 1986

*Let's Play House*, Bernice Steinbaum Gallery, New York, NY (exhib. cat.)

*Camino a Cuba*, Museo Universitario del Chopo, Mexico City, Mexico

*Architectural Images in Art*, Fay Gold Gallery, Atlanta, GA

*Home Works/Public Works*, Gallery Camino Real, Boca Raton, FL

*The Freedman Gallery: The First Decade*, Albright College, Reading, PA

*The Law and Order Show*, Barbara Gladstone Gallery, New York, NY

*Hassam and Speicher Fund Purchase Exhibition*, American Academy of Arts and Letters, New York, NY

*Por Encima del Bloqueo*, II Bienal de la Habana, Casa de la Obra Pia, Havana, Cuba (exhib. cat.)

*Public Visions/Public Monuments*, Soho 20 Gallery, New York, NY

### 1985

*Art and the Environment*, Lever House, New York, NY

*Not Just Black and White*, City Gallery, Department of Public Affairs, New York, NY

*American Art: American Women*, Stamford Museum and Nature Center, Stamford, CT (exhib. cat.)

*Working on the Railroad: Art Projects for the Amtrak Stations*, Whitney Museum of American Art, Fairfield, CT (exhib. cat.)

*Tamarind: 25 Years 1960–85*, University Art Museum, University of New Mexico, Albuquerque, NM (exhib. cat.)

*Tamarind 25th Anniversary Exhibition*, Associated American Artists, New York, NY (exhib. cat.)

*After Matisse*, Queens Museum, Flushing, NY (exhib. cat.); *(traveled)*

*American Women in Art: Works on Paper*, U.N. International Conference on Women, Nairobi, Kenya (exhib. cat.); *(traveled)*

*Public Art in the Eighties: Documentation of Selected Projects*, Jamie Szoke Gallery, New York, NY

*Artists and Architects, Challenges in Collaboration*, Cleveland Center for Contemporary Art, Cleveland, OH (exhib. cat.)

*Celebration 1977–85*, McIntosh/Drysdale Gallery, Washington, DC

*Women Artists*, Hartmann Center Gallery, Bradley University, Peoria, IL

*Public Visions/Public Monuments*, Soho 20 Gallery, New York, NY

*Palladium Guerrilla Girls Exhibition*, Palladium, New York, NY

*Opening Exhibition*, Crown Point Gallery, New York, NY

### 1984

*Forms that Function*, Katonah Gallery, Katonah, NY

*The Fabric of Ornamentalism*, Bruce Museum, Greenwich, CT

*From the Beginning*, Pratt Graphics Center, New York, NY

*Patterns in Contemporary Art*, Laguna Gloria Art Museum, Austin, TX

*1 + 1 = 2*, Bernice Steinbaum Gallery, New York, NY (exhib. cat.); *(traveled)*

*The Decorative Continues*, Pam Adler Gallery, New York, NY

*Women Artists Series*, Mabel Smith Douglass College, Rutgers University, New Brunswick, NJ

*Homer, Sargent, and the American Watercolor Tradition*, Brooklyn Museum, Brooklyn, NY

*Private Art as Public Monument: World's Fairs, Waterfronts, Parks and Plazas*, Rhona Hoffman Gallery, Chicago, IL

*National Women's Art Exposition*, Women's Pavilion, Louisiana World Exposition, New Orleans, LA

*On 42nd Street/Artist's Visions*, Whitney Museum of American Art at Philip Morris, New York, NY (exhib. cat.)

*Of, On, or About Paper III*, USA Today, Arlington, VA (exhib. cat.)

*Sites and Solutions: Recent Public Art*, Freedman Gallery, Albright College, Reading, PA (exhib. cat.); *(traveled)*

*A Celebration of American Women Artists, Part II*, Sidney Janis Gallery, NY (exhib. cat.)

### 1983

*The Architectural Impulse*, Tweed Gallery, Plainfield, NJ

*Art on Paper…since 1960*, Weatherspoon Art Gallery, University of North Carolina, Greensboro, NC (exhib. cat.)

*The Decorative Image*, Bard College, Annandale-on-Hudson, NY

*Printed by Women*, Penn's Landing Museum, Philadelphia, PA (exhib. cat.)

*Walls of the Seventies*, Queensboro Community College, Queens, NY (exhib. cat.)

*New Image/Pattern & Decoration from the Morton G. Neumann Family Collection*, Kalamazoo Institute of Arts, Kalamazoo, MI (exhib. cat.); *(traveled)*

*New Decorative Art*, Berkshire Museum, Pittsfield, MA (exhib. cat.); *(traveled)*

*Back to the U.S.A.*, Lucerne Museum, Lucerne, Switzerland (exhib. cat.); *(traveled)*

*Art on the Rapid Transit*, Theater Place, Buffalo, NY

*New Decorative Works from the Collection of Norma and Bill Roth*, Loch Haven Art Center, Orlando, FL (exhib. cat.); *(traveled)*

*The Artist and the Quilt*, Marion Koogler McNay Art Museum, San Antonio, TX (exhib. cat.); *(traveled)*

*Collectors Gallery XVII*, Marion Koogler McNay Museum, San Antonio, TX

*Art Materialized: Selections from the Fabric Workshop*, New Gallery for Contemporary Art, Cleveland, OH (exhib. cat.); *(traveled)*

### 1982

*A Private Vision: Contemporary Art from the Graham Gund Collection*, Museum of Fine Arts, Boston, MA (exhib. cat.)

*Polychrome Sculpture*, Lever House, New York, NY (exhib. cat.)

*Women's Art/Miles Apart*, Aaron Berman Gallery, New York, NY (exhib. cat.); *(traveled)*

*Painters and Clay*, Garth Clark Gallery, Los Angeles, CA

*Soft as Silk*, Wadsworth Atheneum, Hartford, CT

*Orientalism*, Neuberger Museum, Purchase College at SUNY, Purchase, NY

*Ornamentalism: The New Decorativeness in Architecture and Design*, Hudson River Museum, Yonkers, NY *(traveled)*

### 1981

*Home Work*, Women's Hall of Fame, Seneca Falls, NY (exhib. cat.); *(traveled)*

*The Decorative Image*, McIntosh/Drysdale Gallery, Washington, DC

*Usable Art*, SUNY College at Plattsburgh, Plattsburgh, NY (exhib. cat.); *(traveled)*

*Museum Choice*, Loch Haven Art Center, Orlando, FL

*Retrospective, Women Artists Series*, Douglass College Art Gallery, Rutgers University, New Brunswick, NJ *(traveled)*

*New Dimensions in Drawing*, Aldrich Contemporary Art Museum, Ridgefield, CT (exhib. cat.)

*Woman and Art*, Suzanne Brown Gallery, Scottsdale, AZ (exhib. cat.)

*Collage/Construction/Installation*, First Women's Bank, New York, NY

*Contemporary American Prints and Drawings 1940–80*, National Gallery of Art, Washington, DC (exhib. cat.)

*The New Decorative Movement*, Hodgell Hartman Gallery, Sarasota, FL

*The Pattern Principle*, Ohio University–Lancaster Campus Gallery, Lancaster, OH (exhib. cat.)

*Printmaking in the Eighties*, Sordoni Art Gallery, Wilkes College, Wilkes-Barre, PA

*5 + 5: Artists Introduce Artists*, Department of Cultural Affairs, New York, NY (exhib. cat.)

**1980**

*Pattern Painting/Decorative Art*, Galerie Krinzinger, Innsbruck, Austria (exhib. cat.); *(traveled)*

*Printed Art: A View of Two Decades*, Museum of Modern Art, New York, NY (exhib. cat.)

*Arts on the Line*, Hayden Gallery, M.I.T., Cambridge, MA (exhib. cat.)

*Pattern Painting/Decorative Art*, Galerie Holtmann, Hannover, Germany

*Les Nouveaux Fauves*, Neue Galerie Sammlung Ludwig, Aachen, Germany (exhib. cat.)

*In Celebration of Prints*, Print Club, Philadelphia, PA (exhib. cat.)

*Fabric into Art*, SUNY College at Old Westbury, Old Westbury, NY (exhib. cat.)

*Drawings: The Pluralist Decade*, 39th Venice Biennale, American Pavilion, Venice, Italy (exhib. cat.); *(traveled)*

*Arte Americana Contemporanea*, Civici Musei e Gallerie di Storia e Arte, Udine, Italy (exhib. cat.)

*Painting and Sculpture Today*, Indianapolis Museum of Art, Indianapolis, IN (exhib. cat.)

*Decorative Fabricators*, Institute of Contemporary Art of the Virginia Museum, Richmond, VA (exhib. cat.)

*Decoration*, Atholl McBean Gallery, San Francisco Art Institute, San Francisco, CA

*Artists Who Make Prints*, 26 Federal Plaza, New York, NY

*New Editions in the Decorative Mode*, Barbara Gladstone Gallery, New York, NY

*Aspects of Printmaking in the 70s*, SUNY College at Plattsburgh, Plattsburgh, NY

*Islamic Allusions*, Alternative Museum, New York, NY (exhib. cat.)

*The New York Pattern Show*, Merwin Gallery, Illinois Wesleyan University, Bloomington, IL

**1979**

*Whitney Biennial*, Whitney Museum of American Art, New York, NY (exhib. cat.)

*Patterns Plus*, Dayton Art Institute, Dayton, OH (exhib. cat.)

*Patterning Painting*, Palais des Beaux Arts, Brussels, Belgium (exhib. cat.)

*Persistent Patterns*, Andre Zarre Gallery, New York, NY (exhib. cat.)

*Contemporary Feminist Art*, Haags Gemeentemuseum, The Hague, Netherlands (exhib. cat.); *(traveled)*

*A Day in the Life*, ARC Gallery, Chicago, IL (exhib. cat.)

*The Decorative Impulse*, Institute of Contemporary Art, Philadelphia, PA (exhib. cat.); *(traveled)*

*Material Pleasures*, Institute of Contemporary Art, Philadelphia, PA (exhib. cat.); *(traveled)*

*Patterns*, Albright-Knox Gallery, Buffalo, NY

*Patterned Space*, Art Sources, Jacksonville, FL (exhib. cat.)

*New Directions/New Editions*, Barbara Gladstone Gallery, New York, NY

*Post Card Size Art*, P.S. 1, Long Island City, NY

*Five New York Artists*, Two Plus Gallery, Denver, CO

*Hassam and Speicher Fund Purchase Exhibition*, American Academy of Arts and Letters, New York, NY

*Recent Work by Artists of the Fabric Workshop*, Marian Locks Gallery, Philadelphia, PA

*Two by Fifteen: Contemporary American Prints*, Keystone Junior College, La Plume, PA (exhib. cat.)

**1978**

*Woman Artists '78*, Graduate Center of the City University of New York, NY (exhib. cat.)

*Dissonance and Harmony*, Avery Fisher Hall, New York, NY (exhib. cat.); *(traveled)*

*Collage 1978*, Goddard-Riverside Community Center, New York, NY

*Arabesque*, Contemporary Arts Center, Cincinnati, OH (exhib. cat.)

*New York Now*, Wordworks Inc., San Jose, CA

*Artists' Books U.S.A.*, Washington Project for the Arts, Washington, DC (exhib. cat.); *(traveled)*

*Pattern on Paper*, Gladstone-Villani Gallery, New York, NY

*Decorative Art: Recent Works*, Douglass College Art Gallery, Rutgers University, New Brunswick, NJ (exhib. cat.)

*Pattern and Decoration*, Sewall Gallery, Rice University, Houston, TX

*Perspective '78*, Freedman Gallery, Albright College, Reading, PA

*ISBN: 0:000.0 LCCN: 78-0000*, Franklin Furnace, New York, NY (exhib. cat.)

**1977**

*Pattern, Grid, and System Art*, Lehigh College, Bethlehem, PA (exhib. cat.)

*Recent Paintings*, Mulvane Art Center, Topeka, KS

*Contemporary Issues: Works on Paper by Women*, Women's Building, Los Angeles, CA

*Preparatory Notes — Thinking Drawings*, East Galleries, New York University, New York, NY

*Contemporary Women: Consciousness and Content*, Brooklyn Museum Art School, Brooklyn, NY

*Patterns and Borders*, Ross Graphics, Minneapolis, MN

*Pattern Painting*, P.S. 1, Long Island City, NY

*Strong Works*, Artemesia Gallery, Chicago, IL

*Patterning and Decoration*, Museum of the American Foundation for the Arts, Miami, FL (exhib. cat.); *(traveled)*

*Art on Paper*, Weatherspoon Gallery, University of North Carolina, Greensboro, NC (exhib. cat.)

**1976**

*nycmu*, West Broadway Gallery, New York, NY (exhib. cat.)

*Private Notations: Artists' Sketchbooks*, Philadelphia College of Art, Philadelphia, PA (exhib. cat.)

*Ten Approaches to the Decorative*, Alessandra Gallery, New York, NY

**1975**

*New Drawings*, Women's Inter-art Center, New York, NY

*Women Artists Here and Now*, Ashawagh Hall, Springs, NY

*Color, Light and Image*, Women's Inter-art Center, New York, NY

*American Women Printmakers*, University of Missouri, St. Louis, MO (exhib. cat.)

**1974**

*East Coast Women's Invitational Exhibition*, Museum of the Philadelphia Civic Center, Philadelphia, PA

*Spring Invitational*, A.I.R. Gallery, New York, NY

**1973**

*Women Choose Women,* New York Cultural Center, New York, NY (exhib. cat.); *(traveled)*

*Women Artists Year Three,* Mable Smith Douglass Library, Douglass College, Rutgers University, New Brunswick, NJ (exhib. cat.)

**1972**

*GEDOK American Woman Artist Show,* Kunsthaus, Hamburg, Germany (exhib. cat.); *(traveled)*

*Painting Annual,* Whitney Museum of American Art, New York, NY (exhib. cat.)

*Color Forum,* University of Texas, Austin, TX (exhib. cat.)

*Women in the Arts,* C.W. Post College, Brookville, NY (exhib. cat.)

*Focus on Women,* Kent State University, Kent, OH

*22 American Women Printmakers,* Ridgeway Gallery, Oak Ridge, TN

*Unmanly Art,* Suffolk Museum, Stony Brook, NY (exhib. cat.)

## Public Commissions

**2003**

*Dreaming: The Passage of Time,* U.S. Consulate, U.S. State Department, Istanbul, Turkey

**2002**

*Florida Revisited,* Fairway Office Center, Seavest Inc., West Palm Beach, FL

**2001**

Floor mosaic, Chubu Cultural Center and Pear Museum, Kurayoshi, Japan

**1997**

Floor mosaic, Washington National Airport, Washington, DC

**1994**

*Around the World on the 44th Parallel,* Memorial Library, Minnesota State University, Mankato, MN

**1993**

*The Movies: Fantasies and Spectacles,* Metro's Seventh and Flower Station, Los Angeles, CA

**1992**

Open Space Design Team, Riverside South Corporation, New York, NY

**1991**

*Caribbean Festival Arts,* P.S. 218, New York, NY

**1990**

*Pasadena, the City of Roses,* Plaza las Fuentes, Pasadena, CA

**1989**

*Underwater Landscapes,* Home Savings of America, atrium, Irwindale, CA

*Gardens at Villandry with Angels for Los Angeles* and *Gardens at Villandry and Chenonceaux with Orange Festoons for Los Angeles,* Home Savings of America Tower, Los Angeles, CA

**1987**

*'D' Is for Detroit,* The Detroit People Mover, Financial Station, Detroit, MI

**1985**

*Galla Placidia in Philadelphia* and *Topkapi Pullman,* One Penn Center at Suburban Station, Philadelphia, PA

*New England Decorative Arts,* Harvard Square Subway Station, Cambridge, MA

**1984**

*Homage to Frank Furness,* Wilmington Train Station, Wilmington, DE

Humboldt-Hospital Subway Station, Buffalo, NY

**1983**

*Bay Area Victorian, Bay Area Deco, Bay Area Funk,* International Terminal, San Francisco Airport, San Francisco, CA

## Public Collections

Albright-Knox Art Gallery, Buffalo, NY

Allen Memorial Art Museum, Oberlin, OH

Ball State University Art Gallery, Muncie, IN

Bartlett Center for Visual Arts, Oklahoma State University, Stillwater, OK

Brooklyn Museum, Brooklyn, NY

California Palace of the Legion of Honor, M.H. de Young Memorial Museum, San Francisco, CA

Casa de las Americas, Havana, Cuba

College of Wooster Art Museum, Wooster, OH

Davis Museum & Cultural Center, Wellesley College, Wellesley, MA

Denison Library, Claremont College, Claremont, CA

Frances Lehman Loeb Art Center, Vassar College, Poughkeepsie, NY

Grinnell College Art Gallery, Grinnell, IA

Hawaii Art in Public Places Program, purchased by Hawaii State Foundation on Culture and the Arts

Harvard University, Fogg Art Museum, Cambridge, MA

Hebrew Union College Museum, New York, NY

Indianapolis Museum of Art, Indianapolis, IN

Jersey City Museum, Jersey City, NJ

Jewish Museum, New York, NY

John Michael Kohler Arts Center, Sheboygan, WI

Joslyn Museum, Omaha, NE

Library of Congress, Washington, DC

List Gallery, Swarthmore College, Swarthmore, PA

Los Angeles County Museum of Art, Los Angeles, CA

Ludwig Forum for International Art, Aachen, Germany

MIT List Visual Arts Center, Cambridge, MA

Metropolitan Museum of Art, New York, NY

Mint Museum of Art, Charlotte, NC

Mount Holyoke College Art Museum, South Hadley, MA

Municipal Gallery and Museum of Modern Art, Udine, Italy

Museum of Fine Arts, Santa Fe, NM

Museum of Modern Art, New York, NY

National Academy of Design, New York, NY

National Gallery of Art, Washington, DC

National Museum of Women in the Arts, Washington, DC

New Jersey State Museum, Trenton, NJ

Norton Museum of Art, West Palm Beach, FL

Palmer Museum of Art, Pennsylvania State University, University Park, PA

Ruth Chandler Williamson Gallery, Scripps College, Claremont, CA

Smithsonian American Art Museum, Washington, DC

University Art Gallery, New Mexico State University, Las Cruces, NM

University of Arizona Museum of Art, Tucson, AZ

Weatherspoon Art Museum, University of North Carolina, Greensboro, NC

Whitney Museum of American Art, New York, NY

Yale University Art Museum, New Haven, CT

Jane Voorhees Zimmerli Art Museum, Rutgers University, New Brunswick, NJ

# SELECTED BIBLIOGRAPHY

## PUBLICATIONS EDITED BY THE ARTIST

### 1978

"Women's Traditional Arts/The Politics of Aesthetics" (member, editorial collective). *Heresies* IV (Winter).

"Women Artists Speak on Women Artists" (with May Stevens). *Women's Studies* VI, no. 1.

### 1975/76

*Interviews with Women Artists.* New York: School of Visual Arts, Part I, 1975; Part II, 1976.

### 1973

*Rip-Off File* (with Nancy Spero). New York: Ad Hoc Committee of Women Artists.

## SELECTED STATEMENTS, ARTICLES, BOOKS AND VISUAL PROJECTS BY THE ARTIST

### 2006

"Joyce Kozloff Max Kozloff." In *couplesdiscourse*, Micaela Amateau Amato and Joyce Henri Robinson, 48–49. University Park, PA: Palmer Museum of Art, The Pennsylvania State University.

"Joyce Kozloff (1967)." *From Postwar to Postmodernism. Three decades of Columbia Visual Artists*, 21–22. New York: Columbia University School of the Arts.

### 2005

*Arttable: Changing the Equation: Women's Leadership in the Visual Arts, 1980–2005.* New York: Arttable, Inc.

### 2004

"The Artist's Voice." *NAD Bulletin* (Fall): 5.

### 2003

*Boys' Art.* Introduction by Robert Kushner. New York: D.A.P., Distributed Art Publishers, Inc.

### 2002

"Contributions." *New York City.* Edited by Robert Kahn. New York: The Little Bookroom: 187, 342, 402, 435–6.

### 2001

"Pattern and Decoration" (with Valerie Jaudon and Robert Kushner). In *Patterns: Between Object and Arabesque*, 56–92. Odense, Denmark: Kunsthallen Brandts Klaedefabrik.

"Voices from the American Academy: Joyce Kozloff." *Lincoln Center Theater Review* (Summer): 17.

"Statement." *Beauty without Regret.* Santa Fe: Bellas Artes Gallery: 18.

"When This you see…" *Art Journal* 60 (Summer): 105–7.

"*ARTnews* Retrospective: 25 Years Ago." *ARTnews* 100 (April): 50.

### 1998

"Lurking Below, images by Joyce Kozloff." *Culturefront* 7 (Summer): 98–9.

"Robert Kushner: Gardens of Earthly Delight." *Bookforum* 5 (Spring): 38.

### 1996

"The Kudzu Effect (or the rise of a new academy)." *Public Art Review* 15 (Fall/Winter): 41.

"Meaning from A to Z: A Visual Forum." *M/E/A/N/I/N/G* 16 (May): 59.

### 1993

"Joyce Kozloff." *Generation of Fellows.* Washington, DC: National Endowment for the Arts: 35.

### 1992

"Forum: On Motherhood, Art and Apple Pie." *M/E/A/N/I/N/G* 12 (November). Anthologized in *M/E/A/N/I/N/G*, edited by Mira Schor and Susan Bee, 271–2. Durham, NC: Duke University Press, 2000.

"The Question of Gender in Art." *Tema Celeste* (Autumn): 34–8, 62.

### 1991

"An Homage to the Month of Love/Art for the Feast of St. Valentine." *Interview* (February).

### 1990

*Patterns of Desire.* Introduction by Linda Nochlin. New York: Hudson Hills Press.

### 1989

"On Public Art." *Art Journal* 48 (Winter): 339.

### 1987

"From the Other Side: Public Artists on Public Art." *Art Journal* 46 (Winter): 336–46.

"Like a Dense Curry with Coconut Milk." *American Ceramics* 3 (Summer): 16–23.

### 1986

"Questionnaires." *Heresies* 20 (Fall): 4, 17, 49, 58, 69.

"An Ornamented Joke." *Artforum* 25 (December): 86–9.

### 1983

"Statement." *New Decorative Works.* Orlando: Loch Haven Art Center: 18.

### 1981

"The Cyclotron and the Brooklyn Bridge." *ARTnews* 80 (February): 92.

### 1980

"Statement." *Arts on the Line.* Cambridge, MA: Hayden Gallery, Massachusetts Institute of Technology.

### 1979

"Frida Kahlo at the Neuberger Museum." *Art in America* 77 (May/June): 148.

### 1978

"Frida Kahlo." *Women's Studies* VI, no. 1: 43–59.

"Art Hysterical Notions of Progress and Culture" (with Valerie Jaudon). *Heresies* IV (Winter): 38–42. Anthologized in *Theories and Documents of Contemporary Art*, edited by Kristine Stiles and Peter Selz, 154–64. Berkeley: University of California Press, 1996; and *Feminism-Art-Theory: An Anthology 1968–2000*, 168–97, edited by Hilary Robinson. Malden, MA: Blackwell, 2001.

### 1977

"Thoughts on My Art." *Name Book I,* 63–8. Chicago: N.A.M.E. Gallery.

"Letter." *Women's Caucus for Art Newsletter* (June).

### 1976

"The Women's Movement: Still a 'source of strength' or 'one big bore'?" (with Barbara Zucker). *ARTnews* 75 (April): 48–50.

### 1975

"Joyce Kozloff." *Art: A Woman's Sensibility.* Valencia: California Institute of the Arts: 38.

"Women Artists: What Have They Got and What Do They Want?" *Woman Artists Newsletter* (November).

[Adele Leonard, pseudo.] "Statement." *Artforum* 14 (September): 30.

"Women Artists Here and Now." *Women Artists Newsletter* 1 (September).

### 1974

"Letter to a Young Woman Artist." *Anonymous was a Woman.* Valencia: California Institute of the Arts: 94.

## Selected Books

### 2009

Harmon, Katharine. *CARTOG-RAPHY: Artists + Maps.* Princeton: Princeton Architectural Press.

### 2008

Heartney, Eleanor. *Art & Today.* London: Phaidon Press Inc.

### 2007

Kallendorf, Craig W. *A Companion to the Classical Tradition.* Malden, MA: Blackwell Publishing.

Wiseman, Carter. *A Place for the Arts: The MacDowell Colony, 1907–2007.* Lebanon, NH: University Press of New England.

### 2006

Bloom, Lisa E. *Jewish Identities in American Feminist Art.* New York: Routledge.

Buszek, Maria Elena. *Pin-UP Grrrls. Feminism, Sexuality, Popular Culture.* Durham, NC: Duke University Press.

Love, Barbara J. *Feminists Who Changed America, 1963–1975.* Chicago: University of Illinois Press.

Montmann, Nina, Yilmaz Dziewior, and Galerie für Landschaftskunst. *Mapping a City.* Hamburg: Kunstverein.

Sandler, Irving. *From Avant-Garde to Pluralism: An On-the-Spot History.* Lenox, MA: Hard Press Editions.

### 2005

Heartney, Eleanor. *City Art: New York's Percent for Art Program.* New York: Merrell Publishers.

Richer, Francesca and Matthew Rosenzweig. *No 1: First Works by 362 Artists.* New York: D.A.P., Distributed Art Publishers.

### 2004

Galusha, Emily and Mary Ann Nord. *Clay Talks: Reflections by American Master Ceramists.* Minneapolis: Northern Clay Center.

Taylor, Brandon. *Contemporary Art.* London: Laurence King Publishing.

Walt, Irene. *Art in the Stations/ The Detroit People Mover.* Detroit: Art in the Stations.

### 2003

Harmon, Katharine. *Personal Geographies and Other Maps of the Imagination.* New York: Princeton Architectural Press.

Winter, Robert and David Gebhard. *An Architectural Guidebook to Los Angeles.* Layton, UT: Gibbs Smith.

### 2002

Doss, Erika. *Twentieth-Century Art.* Oxford: Oxford University Press.

Gerace, Gloria. *Urban Surprises: A Guide to Public Art in Los Angeles.* Princeton: Princeton Architectural Press.

Kirkham, Pat. *Women Designers in the USA, 1900–2000: Diversity and Difference.* New York: Bard Graduate Center for Studies in the Visual Arts.

### 2001

Bach, Penny Balkin. *New.Land.Marks.* Washington, DC: Editions Ariel.

Clark, Garth and Tony Cunha. *The Artful Teapot.* New York: Abbeville Press.

Danto, Arthur C. *The Madonna of the Future: Essays in a Pluralistic Art World.* New York: Farrar, Strauss, and Giroux.

Lazzari, Margaret. "Interview: Joyce Kozloff." *The Practical Handbook for the Emerging Artist.* Orlando, FL: Harcourt College Publishers.

Reckitt, Helena and Peggy Phelan. *Art and Feminism.* London: Phaidon Press.

### 2000

Hammond, Harmony. *Lesbian Art in America.* New York: Rizzoli.

Herrera, Hayden. "A Conversation with the Artist." *Modern Art in the USA,* edited by Patricia Hills. Upper Saddle River, NJ: Prentice Hall Inc.

Sassaman, Jane. *The Quilted Garden: Design and Make Nature Inspired by Quilts.* Lafayette, CA: C & T Publishing, Inc.

### 1999

Elert, Nicolet V., editor. *Contemporary Women Artists.* Detroit: St. James Press.

Jones, Amelia. *Performing the Body/Performing the Text.* London: Routledge.

Lyon, Janet. *Manifestoes: Provocations of the Modern.* Ithaca, NY: Cornell University Press.

### 1998

Deepwell, Katy. *Women Artists and Modernism.* Manchester, UK: University of Manchester Press.

Malossi, Giannino, editor. *VOLARE: The Icon of Italy in Global Pop Culture.* New York: The Monacelli Press.

### 1997

Heartney, Eleanor. *Critical Condition.* New York: Cambridge University Press.

Lippard, Lucy R. *The Lure of the Local.* New York: The New Press.

Remer, Abby. *Pioneering Spirits.* Worcester, MA: Davis Publications, Inc.

Schor, Mira. *Wet.* Durham, NC: Duke University Press.

### 1996

Brown, Kathan. *ink, paper, metal, wood.* San Francisco: Chronicle Books.

Cerrito, Joann. *Contemporary Artists.* Detroit: St. James Press.

Herbers, Jill. *Tile.* New York: Artisan Press.

Kurokawa, Shunichi, editor. *New History of World Art* vol. 27. Tokyo: Shogakukan, Inc.

Ratcliff, Carter. *The Fate of a Gesture: Jackson Pollock and Postwar American Art.* New York: Farrar, Strauss, and Giroux.

Sandler, Irving. *Art of the Postmodern Era.* New York: HarperCollins.

### 1995

Fichner-Rathus, Lois. *Understanding Art.* Englewood Cliffs, NJ: Prentice Hall.

Fineberg, Jonathan. *Art Since 1940, Strategies of Being.* Englewood Cliffs, NJ: Prentice Hall.

Herbert, Tony and Kathryn Huggins. *The Decorative Tile.* London: Phaidon.

Lippard, Lucy R. *The Pink Glass Swan.* New York: The New Press.

Taylor, Brandon. *Avant-Garde and After.* New York: Perspectives, Harry N. Abrams, Inc.

**1994**

Broude, Norma and Mary D. Garrard. *The Power of Feminist Art.* New York: Abrams.

Lucie–Smith, Edward. *Race, Sex, and Gender in Contemporary Art.* New York: Abrams.

Mittler, Gene A. *Art in Focus.* Mission Hills, CA: Glencoe Division of Macmillan/McGraw Hill.

**1993**

Cirlot, Lourdes. *Historia Universal de l'Art, Ultimes Tendencies.* Barcelona: Editorial Planeta.

Hammond, Harmony. "A Space of Infinite & Pleasurable Possibilities. Lesbian Self-Representation in Visual Art." *New Feminist Criticism,* edited by Joanna Frueh, Cassandra L. Langer, and Arlene Raven. New York: Haro Press.

Phelan, Peggy. *Unmarked: the Politics of Performance.* London: Routledge.

Westheimer, Dr. Ruth. *The Art of Arousal.* New York: Abbeville.

**1992**

Bach, Penny Balkin. *Public Art in Philadelphia.* Philadelphia: Temple University Press.

Becker, Wolfgang and Gabriele Uelsberg. *Ludwig Forum für Internationale Kunst.* Aachen: Ludwig Forum.

Siegel, Judy. *Mutiny and the Mainstream: Talk That Changed Art, 1975–1990.* New York: Midmarch Arts Press.

**1991**

Schwartz, Joyce Pomeroy. "Public Art." *Encyclopedia of Architecture* 4. New York: John Wiley & Sons.

Stroud, Marion Boulton. *An Industrious Art.* New York: Norton.

Wheeler, Daniel. *Art Since Mid-Century: 1945–Present.* New York: Vendome.

**1990**

Chadwick, Whitney. *Women, Art and Society.* London: Thames and Hudson.

Honnef, Klaus. *Contemporary Art.* Cologne: Benedikt Taschen Verlag.

Rubinstein, Charlotte Streifer. *American Women Sculptors.* Boston: G. K. Hall.

Wilkins, David G., Bernard Schultz and Katheryn M. Linduff. *Art Past, Art Present.* New York: Abrams.

**1989**

Hall, Michael. "Forward in the Aftermath: Public Art Goes Kitsch." *Art in the Public Interest,* edited by Arlene Raven, Cassandra L. Langer, and Joanna Frueh. New York: Da Capo Press.

Jaggar, Alison M. and Susan R. Bordo. *Gender/Body/Knowledge: Feminist Reconstructions of Being and Knowing.* New Brunswick, NJ: Rutgers University Press.

**1988**

Busch, Akiko. *Wallworks.* New York: Bantam.

Cruikshank, Jeffrey L. and Pam Korza. *Going Public.* Amherst, MA: Arts Extension Service, University of Massachusetts and National Endowment for the Arts.

Solomon, Holly and Alexandra Anderson. *Living with Art.* New York: Rizzoli.

**1987**

Bach, Penny Balkin. *Public Art in America '87: Case Studies.* Philadelphia: Fairmount Park Art Association.

Clark, Garth. *American Ceramics 1876 to the Present.* New York: Abbeville.

Heller, Nancy G. *Women Artists: An Illustrated History.* New York: Abbeville.

Lombardi, Pallas. *Arts on the Line: A Public Art Handbook.* Boston: Massachusetts Bay Transportation Authority and Cambridge Arts Council.

**1986**

Arnason, H. H. *History of Modern Art.* New York: Abrams.

Schwartz, Joyce Pomeroy. *Art in the Environment.* Boca Raton: Boca Raton Museum of Art.

**1985**

Castleman, Riva. *American Impressions.* New York: Knopf.

Hunter, Sam and John Jacobus. *Modern Art.* New York: Abrams.

**1984**

Robins, Corinne. *The Pluralist Era.* New York: Harper & Row.

**1982**

Conway, Patricia and Robert Jensen. *Ornamentalism.* New York: Clarkson N. Potter.

Rosen, Nancy. "Public Art: City Amblings." *Ten Years of Public Art 1972–1982.* New York: Public Art Fund.

Rubinstein, Charlotte Streifer. *American Women Artists.* New York: Avon.

**1980**

Carluccio, Luigi, Achile Bonito Oliva, Michael Compton, Marin Kunz, and Harald Szeemann. *La Biennale: arti visive '80.* Venice: La Biennale di Venezia.

Charnas, Suzy McKee. *The Vampire Tapestry.* Albuquerque: Living Batch.

Lucie-Smith, Edward. *Art in the Seventies.* Ithaca, NY: Cornell University Press/Phaidon.

**1979**

Munro, Eleanor. *The Originals.* New York: Simon and Schuster.

**1978**

Ratcliff, Carter. "The New York Art World." Geneva: Skira Annual/Art Aktuell.

**1977**

Lippard, Lucy R. *From the Center.* New York: Dutton.

Wilding, Faith. *By Our Own Hands.* Santa Monica: Double X.

## Catalogues: Solo Exhibitions

**2007**

Lippard, Lucy R. *Voyages.* New York: DC Moore Gallery.

**2006**

Cavallarin, Martina and Barbara Pollack. *Joyce Kozloff; Voyages and Targets.* Venice, Italy: Thetis.

Munro, Eleanor. *Joyce Kozloff: Interior and Exterior Cartographies.* Pittsburgh: Regina Gouger Miller Gallery, Purnell Center for the Arts, Carnegie Mellon University.

**2002**

Hanzal, Carla. *Joyce Kozloff: Topographies.* Virginia Beach, VA: Contemporary Art Center of Virginia.

**2001**

Heartney, Eleanor. *Targets.* New York: DC Moore Gallery.

**1998**

Roth, Moira. *Crossed Purposes: Joyce & Max Kozloff.* Youngstown, OH: The Butler Institute of American Art.

**1985**

Johnston, Patricia, Hayden Herrera, and Thalia Gouma-Peterson. *Joyce Kozloff: Visionary Ornament.* Boston: Boston University.

**1983**

Kardon, Janet. *Investigations 4: Joyce Kozloff.* Philadelphia: Institute of Contemporary Art, University of Pennsylvania.

**1982**

Day, Holliday T. *I-80 Series: Joyce Kozloff.* Omaha: Joslyn Art Museum.

**1981**

White, Robin. *View: Joyce Kozloff.* Oakland: Crown Point Press.

**1979**

Rickey, Carrie and Peg Weiss. *An Interior Decorated.* New York: Tibor de Nagy Gallery.

## Selected Reviews, Interviews, and Articles

### 2008

Adler, Esther. "The Dumb Blonde Theory of Art / Joyce Kozloff." *P.S. 1 Newspaper Special Edition* (February).

Anderson-Spivy, Alexandra. "The Triumph of the Big D." *artnet*, January 9.

Artner, Alan G. "HereThereEverywhere map exhibit finds its place." *Chicago Tribune*, January 24.

Brodsky, Judith K. and Ferris Olin. "Stepping out of the Beaten Path: Reassessing the Feminist Movement." *Signs* 33 (Winter): 337–9.

Cotter, Holland. "Scaling a Minimalist Wall With Bright, Shiny Colors." *New York Times*, January 15.

Decker, Elisa. "Joyce Kozloff." *Art in America* 96 (May): 194.

Fujii, Jocelyn. "Art is in the House." *Hawai'i Westways* (September–October): 19.

Hunter, Sam. "Mapping a Different View." *Smithsonian.com*, April 16.

Johnson, Ken. "Striking When the Spirit Was Hot." *New York Times*, February 15.

Mahoney, J. W. "'Claiming Space' at the Katzen Center, American University." *Art in America* 96 (June/July): 201.

Morse, Marcia. "Map Quest." *Honolulu Weekly*, May 5.

Nadelman, Cynthia. "Pattern and Decoration." *ARTnews* 107 (April): 150.

### 2007

Armstrong, Carol. "'Global Feminisms' WACK!" *Artforum* 45 (May): 360–2.

Baker, Kenneth. "A look back at the Vietnam War gives artists no peace." *San Francisco Chronicle*, February 28.

Cotter, Holland. "Agents of Change." *New York Times*, February 16.

Genocchio, Benjamin. "A Decade of Patterns and Promise." *New York Times*, December 2.

———. "Fresh Eyes on a Colorful Movement." *New York Times*, December 10.

Goodrich, John. "From the Inside Out: Feminist Art Then & Now." *New York Sun*, March 22.

Levin, Gail. "Censorship, Politics and Sexual Imagery in the work of Jewish American Feminist Artists." *Nashim* 14 (December): 63–96.

Lovelace, Carey. "Feminist Group Shows: Girls, Girls, Girls." *Art in America* 95 (June/July): 89–93.

MacAdam, Barbara. "Where the Great Women Artists Are Now." *ARTnews* 106 (February).

Ollman, Leah. "All charted on the maps of our lives." *Los Angeles Times*, July 27.

Pollack, Barbara. "Free Radicals." *Washington Post*, September 22.

Princenthal, Nancy. "Feminism Unbound." *Art in America* 95 (June/July): 142–53.

### 2006

Knoops, Johannes. "Venice Biennale: Five Impressions." *Oculus* (September 19).

Kramer, Jane. "Whose Art is It?" *Public Art Review* (Fall/Winter).

Lanfranco, Monica. "Ascoltando il rantolo della Guerra." *Liberazione*, December 10.

Shaw, Kurt. "Mapping the issues." *Pittsburgh Tribune-Review*, October 8.

Thomas, Mary. "Joyce Kozloff captivates with protest video and map-like works." *Pittsburgh Post-Gazette*, September 21.

### 2005

D'Orsi, Alessandra. "Una Pacifista Americana a Roma." *aprileonline*, Rome, September 29.

Natale, Michele. "Onward boyish soldiers." *News & Observer*, Raleigh, NC, February 20.

Schwartz, Joyce Pomeroy. "Unrealized Public Art." *Public Art Review* 32 (Spring/Summer): 33–5.

Sung, Ellen. "Charting worlds of ideas." *News & Observer*, Raleigh, NC, February 6.

Wharton, Glenn. "Planning to Stay." *Public Art Review* 32 (Spring).

### 2004

Breidenbach, Tom. "Joyce Kozloff." *Artforum* 42 (March): 186.

May, Stephen. "Joyce Kozloff." *ARTnews* 103 (February): 111–2.

Miles, Christopher. "Tracking Patterns." *Art in America* 92 (February): 76–81.

Pozzi, Lucio. "Le carte del Pentagono con i bersagli americani." *Il Giornale dell'Arte* (February).

Princenthal, Nancy. "Joyce Kozloff at DC Moore." *Art in America* 92 (February): 118.

Wei, Lilly. "'Outside/In.'" *ARTnews* 103 (March): 134.

### 2003

Glueck, Grace. "Joyce Kozloff." *New York Times*, December 5.

Irmas, Deborah. "Joyce Kozloff." *Vogue Hommes International* (Spring/Summer), 152–3.

Lovelace, Carey. "Art and Politics I: Feminism at 40." *Art in America* 91 (May): 67–73.

Ollman, Leah. "Seeing the pattern." *Los Angeles Times*, September 21.

Pollack, Barbara. "The Art of War." *Village Voice*, April 2–8.

———. "Joyce Kozloff, 'Boys' Art' and Other Works." *TimeOut New York*, November 20–27.

Press, Joy. "Open Me." *Village Voice*, December 3–9.

Roth, Charlene. "'LAPD' at Rosamund Felsen Gallery." *Artweek* 34 (November): 22.

Rosoff, Patricia. "Owning the Map." *Hartford Advocate*, January 30.

Zorabedian, John. "Exploring the world since September 11." *Middletown Press*, January 26.

### 2002

Budick, Ariella. "Taking It Personally." *Newsday*, August 16.

Cembalest, Robin. "Gender Bender." *ARTnews* 101 (January): 136.

Cocks, Anna Somers. "The Hidden Face." *Guardian*, London, August 9.

Dorsey, Catherine. "Mapping It Out." *Portfolio*, Virginia Beach, VA, March 5.

### 2001

Bjornland, Karen. "Science and art of mapping on exhibit at the Tang Museum." *Daily Gazette*, March 22.

Bonde, Lisbeth. "Monstervaerdigt." *Information*, Odense, Denmark, October 3.

Castello, Silvia. "Joyce Kozloff: Puzzle Erotici." *Elle*, Italy (May): 184.

Castro, Jan. "Joyce Kozloff." *Sculpture* 20 (September): 7.

Dalgaard, Bente. "Kunstnere tor ikke flyve fra USA." *Morgenposten Fyns Stiftstidende*, Odense, Denmark, September 19.

Johnson, Ken. "Joyce Kozloff, Targets." *New York Times*, January 26.

Knippel, Lars Ole. "Afbud fra Trampedach." *Morgenavisen Jyllands-Posten*, Odense, Denmark, September 20.

### 2000

Castello, Silvia. "Joyce Kozloff." *Arte* no. 327 (November): 216.

Colombo, Furio. "L'America dei nuovi talenti." *La Repubblica*, July 24.

Emsden, Maya. "Metro Art." *Casabella* (November): 30–1.

Goldberg, Vicki. "Working Notes: An Interview with Joyce and Max Kozloff." *Art Journal* 59 (Fall): 96–103.

Simon, Jordan. "Art on the Move." *Art & Antiques* 23 (January): 90.

Williamson, Jolie. "Rail system encourages riders' art appreciation." *Tribune-Review*, Pittsburgh, March 12.

**1999**

Duncan, Michael. "Crossed Purposes." *d'Art International* 2, Canada (Spring/Summer): 14–5.

Frank, Peter. "Joyce & Max Kozloff, Odd Gloss, Dave Muller." *LA Weekly*, April 30–May 6: 158.

Frankel, David. "Joyce Kozloff." *Artforum* 38 (September): 169–70.

Ise, Claudine. "The Distinct Worldview of Joyce and Max Kozloff." *Los Angeles Times*, April 26.

Johnson, Tracy. "Maps and Legends." *Los Angeles New Times*, April 1–7.

Koplos, Janet. "Revisiting the Age of Discovery." *Art in America* 87 (July): 86–7.

McMullen, Gary. "Couple Works Together for 'Crossed Purposes'." *The Ledger*, Lakeland, FL, October 15.

Miller, Donald. "Central piece brings message to Butler's midyear show." *Pittsburgh Post-Gazette*, August 18.

Pollack, Barbara. "Peer Reviews." *ARTnews* 96 (January): 99.

Smith, Roberta. "Joyce Kozloff." *New York Times*, March 19.

**1998**

Bambic, Robert. "Joyce and Max Kozloff: Crossed Purposes." *Art Papers* 22 (September/October): 54.

Donohoe, Victoria. "Two artists weave travel observation, comment into Swarthmore show." *Philadelphia Inquirer*, March 11.

Emsden, Maya. "Beware of Metro Monsters." *LA Downtown News*, August 10.

Ratcliff, Carter. "The Politics of Ornamentation." *Art in America* 86 (April): 109.

Sozanski, Edward J. "Husband and wife team up for an exhibition." *Philadelphia Inquirer*, March 27.

**1997**

Melrod, George. "Classic Blends." *Art & Antiques* 20 (May): 29.

Nochlin, Linda. "Top 10 x 12: The Year in Review." *Artforum* 35 (December): 90.

Philip, Hunter Drohojowska. "Keeping His Eye on the Big Picture." *Los Angeles Times*, September 7.

Protzman, Ferdinand. "The New National, Artistic Statements— Artwork Reflects Vibrancy, Diversity of a Nation." *Washington Post*, July 16.

Wiseman, Carter. "Flights and Fancy." *ARTnews* 96 (June): 116–21.

**1996**

Busch, Akiko. "You are Here." *Metropolis* 18 (May): 101–37.

Lyon, Joyce. "Joyce Kozloff: Public Art Works." *Public Art Review* 15 (Fall/Winter): 40.

Raven, Arlene. "Not Just Another Man on a Horse." *On the Issues* 5 (Spring): 39–43.

Trescott, Jacqueline. "Landing First Class Art." *Washington Post*, June 18.

**1995**

Busch, Akiko. "Accessories of Destination: The Recent Work of Joyce Kozloff." *American Ceramics* 21: 26–31.

Giulivi, Ariella. "Passagio a Oriente." *Tema Celeste* Italy, (January/March): 41.

Glueck, Grace. "Nature and More Nature; A Sparkling Cartography." *New York Observer*, May 1.

Ostrow, Saul. "Un ensemble fragmente: le peinture abstraite après le modernisme," *Art Press* 16 (1995): 157–62.

Raven, Arlene. "Overworked? Overwhelmed?" *On the Issues* 4 (Spring): 42–4, 53.

Roth, Charlene. "One Square at a Time; Joyce Kozloff's Tile Murals." *Artweek* 26 (April).

Smith, Roberta. "Joyce Kozloff." *New York Times*, May 12.

Tougas, Joe. "Kozloff's Art Runs Parallel to Love of Maps." *The Free Press*, Mankato, MN, June 30.

**1994**

Danto, Arthur C. "Art." *The Nation*, March 28.

Flanagan, Regina. "That Beauty Problem." *Public Art Review* 11 (Fall/Winter): 39–41.

Kushner, Robert. "Underground Movies in L.A." *Art in America* 82 (December): 37, 39.

Lovelace, Carey. "Yagona in Fiji and Breakfast in Derry." *ARTnews* 9 (November): 141–7.

**1993**

Baker, Kenneth. "A Glimpse of Galleries: The Heat of Enterprise in a Slack Economy." *San Francisco Chronicle*, February 16.

Johnston, P.J. "SF Art Show Takes on the Sexual Politicians." *Tracy Press*, East Bay, February 11.

Jones, Amelia. "The Return of the Feminist Body." *M/E/A/N/I/N/G* 14 (November): 3–6.

Knight, Christopher. "Glossy Journey to the Center of the Earth." *Los Angeles Times*, February 14.

Schwartz, Joyce Pomeroy. "Public Art: A Means to Visual Literacy and Pride of Place." *Aaca*: 4.

Smith, Roberta. "A Remembrance of Whitney Biennials Past." *New York Times*, February 28.

Woodbridge, Sally. "A Tale of Two Civic Centers." *Progressive Architecture* 74 (April): 101–4.

**1992**

Bonetti, David. "Gallery Watch." *San Francisco Examiner*, February 12.

Kapitanoff, Nancy. "Red Line Art." *Los Angeles Times*, August 30.

Larson, Kay. "Riverside South." *New York Magazine*, April 6.

Mahmoudieh, Yasmine. "Plaza las Fuentes." *Keramikos*, Italy (May): 42–50.

Pollack, Barbara. "Joyce Kozloff." *Journal of Contemporary Art* 5 (Fall): 29–35.

Wallach, Amei. "A Vision of Green." *New York Newsday*, March 24: 47, 54–5.

Welzenbach, Michael. "Drysdale's Sexy Duo." *Washington Post*, May 16.

Wilkes, Anastasia. "West Side Art Park." *Art in America* 80 (May): 39, 156.

**1991**

Atkins, Robert. "PerCent for Art." *Village Voice*, November 6–12.

Collins, Glenn. "Deep Down into Subway Go Dracula and His Kind." *New York Times*, September 7.

Crockett, Tobey. "That's Life." *Village View*, Santa Monica, April 5–11.

Fox, Catherine. "Public Art's New Wave." *Atlanta Constitution*, August 4.

Frank, Peter. "Art Pick of the Week." *L.A. Weekly*, April 5–11.

Higuchi, Shoichiro. *Shoten Kenchiku*, Japan (January).

Huneven, Michelle. "Joyce Kozloff." *L.A. Style* (March): 30.

Mark-Walker, Diane. "Joyce Kozloff." *Artweek*, April 4: 15.

McCombs, Dave. "Latest Venue for Underground Art." *Downtown News*, Los Angeles, July 8.

Morgan, Robert C. "Patterns of Desire." *M/E/A/N/I/N/G* 9 (May): 42–3.

Reinhold, Robert. "In Home of Movies, Using Fantasy to Lure Subway Riders." *New York Times*, August 4.

Robinson, Walter and Anastasia Wilkes. "Art for Transit in Los Angeles." *Art in America* 79 (November): 175–6.

Rubinstein, Rafael Meyer. "Patterns of Desire." *Arts Magazine* 65 (May): 112.

Webber, Diane. "Attack of the Killer Artist." *Downtown Express*, September 2.

**1990**

Gomez, Edward M. "Quarreling over Quality." *Time* (Fall): 61–2.

Hess, Elizabeth. "Taboo Suite." *Village Voice*, June 19.

————. "Book of Revelations." *Women's Review of Books*, September.

Huntington, Richard. "'Desire' Takes a Witty Twist on the Erotic." *Buffalo News*, November 11.

Johnson, Ken. "Joyce Kozloff at Lorence-Monk." *Art in America* 78 (December): 171.

Nereim, Anders. "Whose Muse? The Spectacle of Chaos." *Inland Architect* 116 (January/February).

Phelan, Peggy. "Crimes of Passion." *Artforum* 9 (May): 173–7.

Seidel, Miriam. "Philadelphia." *New Art Examiner* (October).

### 1989

Allison, Sue. "Her Infinite Variety." *Life* (June): 68.

DeWolfe, Evelyn. "Home Savings Tower Sits Atop Transit Stop." *Los Angeles Times*, January 22.

Geibel, Victoria. "Clay in Context." *Metropolis* 8 (April): 70–3.

Schwartzman, Allan. "Monumental Trouble." *Elle* (September).

Siegel, Judy. "Joyce Kozloff." *Women Artists News* 14 (Spring/Summer): 3.

Vogel, Carol. "Metaphorical Images of the Garden." *New York Times*, December 28.

Whiteson, Leon. "Home Tower." *Los Angeles Times*, March 19.

### 1988

Carlsen, Peter. "American Craft Museum Design into Art." *ARTnews* 87 (May): 61–2.

Geibel, Victoria. "Architecture & Art: A Fine Romance?" *American Craft* 48 (June/July): 28, 33.

Heartney, Eleanor. "A Necessary Transgression." *New Art Examiner* 16 (November): 20–3.

Jensen, Robert. "Angels in the Architecture." *Metropolitan Home* (May): 100–1, 140.

Kramer, Hilton. "Equitable Building, Craft Museum, Show Gim Crackery of Public Art." *New York Observer*, May 30.

Riddle, Mason. "A Sense of Time, A Sense of Place." *American Ceramics* 6 (Summer): 27–35.

Phillips, Patricia C. "Architectural Art; Affirming the Design Relationship." *Artforum* 27 (October): 148–9.

Schor, Mira. "Representations of the Penis." *M/E/A/N/I/N/G* 4 (November): 3–13.

### 1987

Colby, Joy Hakanson. "A Mural for the Mover." *Detroit News*, July 1.

Donohoe, Victoria. "Pattern Painter Who Evolved into a Public Muralist." *Philadelphia Inquirer*, March 21.

Mathews, Patricia. "Feminist Ornament." *Dialogue* (January): 25.

McDonald, Emily. "Creation of Public Art is Joyce Kozloff's Forte." *Chattanooga Times*, January 16.

Gouma-Peterson, Thalia and Patricia Mathews. "The Feminist Critique of Art History." *Art Bulletin* 69 (September): 326–57.

Gouma-Peterson, Thalia. "Joyce Kozloff: Visionary Ornament." *Ceramics Monthly* 35 (November): 32–6.

Hazard, Patrick D. "Center City Whirl." *Art Matters*, Philadelphia (April): 13.

Miro, Marsha. "Eye Stopping." *Detroit Free Press*, July 30.

Monroe, Linda K. "One Penn Center at Suburban Station." *Buildings* (June).

Pearlman, Chee. "Surface Style." *Industrial Design* (March/April).

Slowinski, Dolores S. "Art in the Stations." *Detroit Focus Quarterly* (Fall): 2, 4.

Webster, Sally. "Pattern and Decoration in the Public Eye." *Art in America* 75 (February): 116–24.

Wolkomir, Richard. "Sculpture in the Subways?" *Smithsonian* 18 (April): 114.

### 1986

Bennett, Steve. "Walls Become Canvas for Tile Artist." *Show*, San Antonio, November 23.

Bonetti, David. "Two Public Spirits." *Boston Phoenix*, March 25.

Chandler, John. "Public Art Programs in New England." *Art New England* 7 (May).

Cullinan, Helen. "The Long, Hard Road to Public Art." *Cleveland Plain Dealer*, October 30.

Doll, Nancy. "Joyce Kozloff: Visionary Ornament." *Art New England* 7 (May).

Goddard, Dan R. "Kozloff Champions Public Art." *Express-News*, San Antonio, November 20.

Harvey, Steve. "Underground Art." *Los Angeles Times*, August 3.

Miro, Marsha. "Fanciful 'D' to Illuminate Transit Station." *Detroit Free Press* (May): 1, 6.

Raether, Keith. "N.M. Influenced Artist's Decorative Works." *Albuquerque Tribune*, August 9.

Siegel, Judy. "Joyce Kozloff: Visionary Ornament." *Women Artists News* (June): 8–9.

Silver, Joanne. "The Right Direction." *Providence Journal Bulletin*, February 28.

Stapen, Nancy. "Joyce Kozloff: Pattern and Decoration." *Sunday Boston Herald*, March 9.

———. "Joyce Kozloff." *Artforum* 24 (Summer): 130.

Taylor, Robert. "Kozloff Show Beguiling, Refreshing." *Boston Sunday Globe*, March 23.

### 1985

Bannon, Anthony. "Buffalo Bits in a Mammoth Mosaic." *Gusto: Buffalo News*, March 10.

Boyer, Christine. "Stately Stations." *American Craft* 45 (June/July): 18–25.

Eliasoph, Philip. "Whitney Tracks the Art of Stamford's Rail Station." *Southern Connecticut Newspapers*, April 21.

Haydon, Harold. "Public Art Takes Novel Approach to Involvement." *Chicago Sun-Times*, January 17.

Hills, Patricia. "The Woman's Movement and the Art Professional." *Art New England* 6 (March): 6, 21.

Indiana, Gary. "The Rest of Everything." *Village Voice*, April 30.

McGill, Douglas C. "Artworks Enhance the Elegance of Region's Restored Train Stations." *New York Times*, July 14.

Perrone, Jeff. "Two Ethnics Sitting Around Talking About Wasp Culture." *Arts Magazine* 59 (March): 78–83.

Raynor, Vivien. "Joyce Kozloff." *New York Times*, April 26.

———. "Beauty at Railroad Stations Explored at the Whitney." *New York Times*, May 26.

### 1984

Garmel, Marion. "Quilts are a Tribute." *Indianapolis News*, September 21.

Giovannini, Joseph. "Decorative Tiling: Taking the Bold Approach." *New York Times*, November 8.

Simon, Peter. "Transit 'Galleries' Filling Up Rapidly." *Buffalo News*, June 25.

### 1983

Ahlander, Leslie Judd. "Artists and Their Unique Messages." *Miami News*, March 4.

Bettelheim, Judith. "Pattern Painting: The New Decorative." *images & issues* 3 (March/April): 32–6.

Busch, Akiko. "By Design." *Metropolis* 2 (March): 24–9.

Giovannini, Joseph. "Embellishing 80s Interiors: The Return of Decoration." *New York Times*, May 12.

Johnson, Patricia C. "Urban Renewal." *Houston Chronicle*, February 6.

Kalil, Susie. "Architectural Fantasies." *Houston Post*, February 6.

Kohen, Helen. "Art." *Miami Herald*, March 4.

Perreault, John. "The Plastic Arts: In Search of a New Romanticism." *Horizons '83* (Summer).

Sozanski, Edward J. "Graffiti as More than Vandalism." *Philadelphia Inquirer*, June 30.

### 1982

Atkins, Robert. "Joyce Kozloff: Works on Paper." *Bay Guardian*, March 24–31.

Catlin, Roger. "Cheerful Decorative Art Brightens Joslyn." *World-Herald*, Omaha, June 20.

Conway, Patricia and Robert Jensen. "Ornamentation." *New York Times Magazine*, November 14: 125.

Levin, Kim. "Joyce Kozloff: Projects and Proposals." *Village Voice*, April 13.

Lubell, Ellen. "Usable Art." *Art Express* (January/February).

Perrone, Jeff. "Sign and Design." *Arts Magazine* 56 (February): 132–9.

Seiberling, Dorothy. "A New Kind of Quilt." *New York Times Magazine*, October 3.

Temin, Christine. "Reconsidering the mundane." *Boston Globe*, January 7.

White, Robin. "Joyce Kozloff ile Soylesi." *Boyut*, Turkey (April): 27–32.

### 1981

Donnell-Kotrozo, Carol. "Women and Art." *Arts Magazine* 55 (March): 11.

Frank, Peter. "Joyce Kozloff and Betty Woodman: A Collaboration." *Art Xpress* (May/June): 77–8.

Glueck, Grace. "Joyce Kozloff and Betty Woodman: A Collaboration." *New York Times*, February 20.

Greenberg, Blue. "Joyce Kozloff: An Interior Decorated." *Fiberarts* 7 (January/February): 89–90.

Lewis, Jo Ann. "Return to Splendor." *Washington Post*, March 14.

Morris, Robert. "American Quartet." *Art in America* 69 (December): 93–101.

Perreault, John. "Usable Art." *Portfolio* 3 (July/August): 60–3.

————. "Homespun." *Soho News*, December 15.

Phillips, Deborah C. "Artist and Printer." *ARTnews* 80 (March): 100–4.

Rose, Thomas. "Kozloff/ Woodman." *Ceramics Monthly* 29 (May): 46.

Welish, Marjorie. "Pattern Painting: A New Flowering of the Decorative?" *Art Criticism* 3: 68–71.

### 1980

Albright, Thomas. "No matter What It's called, It's Decorative." *San Francisco Chronicle*, October 21.

Artner, Alan G. "Material Pleasures." *Chicago Tribune*, February 11.

Atkins, Robert. "Decorative inclinations." *Bay Guardian*, San Francisco, October.

Carboni, Massimo. "Decorazioni." *Segno*, Italy (November/ December): 8–12.

Dallier, Aline. "Pattern Painting." *Opus International* 75 (Winter).

Fleming, Lee. "Joyce Kozloff: An Interior Decorated." *New Art Examiner* 8 (November).

Forgey, Benjamin. "Fine Arts, Handicrafts Draw Closer Together." *Washington Star*, September 5.

Glueck, Grace. "Women Artists '80." *ARTnews* 79 (October): 58–63.

Hammond, Harmony. "Horse Blinders." *Heresies* IX (Summer): 46.

Henry, Gerrit. "In Search of the Ideal." *Print Collector's Newsletter* 10 (July/August).

Kampen, Michael E. "Artist Presents Decoration as Fine Art." *Charlotte Observer*, May 4.

Kologe, Brian R. "Red Line to be Constant Art Gallery." *Christian Science Monitor*, February 15.

Larson, Kay. "For the First Time Women are Leading Not Following." *ARTnews* 79 (October): 64–72.

Lorber, Richard. "Women Artists on Women in Art." *Portfolio* 2 (February/March): 68–73.

Perrone, Jeff. "Every Criticism is Self-Abuse." *Arts Magazine* 54 (June): 110–7.

————. "Seriously, Folks." *Arts Magazine* 55 (December): 104–6.

————. "Ten Best/Ten Worst." *images & issues* (Winter 1980– 81): 22–5.

Ricart, Humbero Soto. "Joyce Kozloff—un interior decorado." *Ahora!*, Dominican Republic, December 8.

Richard, Paul. "Pattern Painting's Decorative Deluge." *Washington Post*, August 19.

Rickey, Carrie. "All Roads Lead to the Venice Biennale." *Village Voice*, June 9.

Robins, Corinne. "Late Decorative: Art, Artifact, and the Ersatz." *Arts Magazine* 55 (September): 150–1.

Russell, John. "70s Art in Public Places—From Anchorage to Atlanta." *New York Times*, July 6.

Sandler, Irving. "Modernism, Revisionism, Pluralism, and Post-Modernism." *Art Journal* 39 (Fall/Winter).

Temin, Christine. "Art Aimed at Fitting to a T." *Boston Sunday Globe*, March 2.

Tompkins, Calvin. "Matisse's Armchair." *New Yorker*, February 25.

Toppman, Lawrence. "This Artist Works with Rooms." *News*, Charlotte, April 17.

### 1979

Ashbery, John. "The Perennial Biennial." *New York Magazine*, March 19: 70.

————. "Decoration Days." *New York Magazine*, July 2: 51–2.

Boudaille, Georges. "Pattern Painting." *Connaissance des Arts* (September 1979): 55–61.

Brown, Richard. "Arabesque." *New Art Examiner* 8 (January).

ffrench-frazier, Nina. "New York Letter." *Art International* 23 (December): 44–5.

Friedman, Jon R. "Joyce Kozloff." *Arts Magazine* 54 (November): 11.

Hartranft-Temple, Ann. "Kozloff Ceramics, Silks Feature in Everson Show." *Syracuse Herald-American*, November 4.

Henry, Gerrit. "Joyce Kozloff." *ARTnews* 79 (November): 186.

Hughes, Robert. "Roundup at the Whitney Corral." *Time* (February): 73.

Kuspit, Donald B. "Betraying the Feminist Intention: The Case Against Feminist Decorative Art." *Arts Magazine* 54 (November): 126.

Larson, Kay. "Imperialism with a Grain of Salt." *Village Voice*, September 17.

Lawson, Thomas. "Joyce Kozloff." *Flash Art* 12 (October/November).

————. "Painting in New York: An Illustrated Guide." *Flash Art* 12 (October/November): 4–11.

Lubell, Ellen. "Lush Complexities and Visual Indulgences." *Soho Weekly News*, February 15.

McDonald, Robert. "The Sensual Side of Experience." *Artweek*, November 24.

Miller, Elise. "A Really Big Show of Really Big Decorative Art." *San Diego Magazine* (November): 140.

Muchnic, Suzanne. "From Flamboyant to Deliberate." *Los Angeles Times*, November 30.

Perreault, John. "The New Decorativeness." *Portfolio* 1 (June/July): 46–50.

————. "Pattern-eine Einfuhrung." *Du*, Switzerland, (June).

————. "A Room with a Coup." *Soho Weekly News*, September 13: 47.

Perrone, Jeff. "Joyce Kozloff." *Artforum* 18 (November): 78–80.

————. "The Decorative Impulse." *Artforum* 18 (November): 80–1.

Pinto, Holly. "Art." *New York Magazine*, September 17.

Rickey, Carrie. "Decoration, Ornament, Pattern, and Utility." *Flash Art* 12 (June/July): 19–23.

————. "Art of Whole Cloth." *Art in America* 67 (November): 72–83.

Saunders, Wade. "Art, Inc.—The Whitney's 1979 Biennial." *Art in America* 67 (May/June): 96–9.

Siegel, Judy. "Decoration Day at Artists Talk on Art." *Women Artists News* (March).

Strickler, Madeleine and Dominik Keller. "Atelierbesuche." *Du*, Switzerland (June).

Szeeman, Harald. "Zurick und hin zur 'Wurde des Dekorativen.'" *Du*, Switzerland (June).

**1978**

Alinovi, Francesca. "New York: L'Arte Dev'Essere Decorativa." *Bolaffi Arte*, Italy (April): 16–9.

Bourdon, David. "Joyce Kozloff." *Du*, Switzerland (April).

Brown, Ellen. "CAC's Decorative 'Arabesque Show' Lifts the Spirit." *Cincinnati Post*, October 14.

Cardozo, Judith Lopes. "Joyce Kozloff." *Artforum* 16 (January): 69–70.

ffrench-frazier, Nina. "Joyce Kozloff." *ARTnews* 77 (January): 150.

Findsen, Owen. "Color and Pattern Bloom in New Art." *Cincinnati Enquirer*, October 8.

Frank, Peter. "Joyce Kozloff." *Womanart* (Spring): 34.

Goldin, Amy. "Pattern & Print." *Print Collector's Newsletter* (March/April): 10–3.

Heilbrunn, Jean. "Interview with Joyce Kozloff." *detroit artists monthly* (May): 18–9.

Perrone, Jeff. "Pattern on Paper." *Artforum* 16 (December): 61–3.

Rickey, Carrie. "Joyce Kozloff." *Arts* (January): 2.

Turner, Norman. "Joyce Kozloff." *Arts Magazine* 52 (January): 28–9.

**1977**

Applebroog, Ida. "The 'I am Heathcliffe,' says Catherine, Syndrome," *Heresies* 1 (May): 121.

Chafee, Katharine. "Mixing Feminism and Art." *Straight Creek Journal*, Denver, September 29.

Crossley, Mimi. "Joyce Kozloff: Paintings." *Houston Post*, May 6.

Kingsley, April. "Joyce Kozloff." *Village Voice*, November 17.

————. "Opulent Optimism." *Village Voice*, November 28.

Moser, Charlotte. "Colors, Patterns A Real Knockout at Kozloff Show." *Houston Chronicle*, May 5.

Perreault, John. "Visual Yoga." *Soho Weekly News*, November 10.

————. "Issues in Pattern Painting." *Artforum* 16 (November): 32–6.

Ratcliff, Carter. "New York Letter." *Art International* 21 (December): 67.

Raynor, Vivien. "Joyce Kozloff." *New York Times*, November 4.

Watson, Jenny. "New York Women Artists: Their Work and Feminism." *LIP*, Australia: 75–7.

**1976**

Alloway, Lawrence. "Women's Art in the '70s." *Art in America* 64 (May/June): 64–72.

Askey, Ruth. "Four L.A. Artists Open Women's Building." *Artweek*, February 21.

Bourdon, David. "Joyce Kozloff." *Village Voice*, May 3.

Brumer, Miriam. "Joyce Kozloff." *Artists Review Art* 2 (April).

Goldberg, Lenore. "Is Painting One of the Decorative Arts?" *Women Artists Newsletter* (May).

Leoff, Eve. "Conversation with Joyce Kozloff." *57th Street Review* (March): 17–20.

Masheck, Joseph. "The Carpet Paradigm: Critical Prolegomena to a Theory of Flatness." *Arts Magazine* 51 (September): 82–109.

Panagopoulos, Berta Kitsiki. "Joyce Kozloff." *ZYTOE*, Greece (September/October), 106.

Perreault, John. "Joyce Kozloff." *Soho Weekly News*, April 22.

Perrone, Jeff. "Approaching the Decorative." *Artforum* 15 (December): 26–30.

Ratcliff, Carter. "New York Letter." *Art International* 20 (Summer): 53–4.

Robins, Corinne. "Joyce Kozloff." *Arts Magazine* 50 (June): 5.

Sargent-Wooster, Ann. "Joyce Kozloff." *ARTnews* 75 (Summer): 178.

Siegel, Judy. "Catalogs & Publications." *Women Artists Newsletter* 2 (Summer).

————. "Talk About Decoration." *Women Artists Newsletter* 2 (November): 4.

Stofflet-Santiago, Mary. "Contemporary Issues: Works on Paper by Women." *Visual Dialog* (Spring).

**1975**

Bell, Jane. "Joyce Kozloff." *Arts Magazine* 45 (February): 5.

Burkhart, Dorothy. "A Conversation with Joyce Kozloff." *Artweek*, December 20.

Foote, Nancy. "Joyce Kozloff at de Nagy." *Art in America* 63 (May/June): 88–9.

Heinemann, Susan. "Joyce Kozloff." *Artforum* 13 (March): 60–3.

Miller, Donald. "Three-Woman Art Show at Kingpitcher." *Pittsburgh Post-Gazette*, May 13.

Siegel, Judy. "Joyce Kozloff in Conversation with Judy Siegel." *Visual Dialog* 1 (Winter): 7–10.

**1974**

Kramer, Hilton. "Joyce Kozloff." *New York Times*, December 14.

Rose, Barbara. "The News is Paper." *Vogue* (December): 209.

**1973**

Henry, Gerrit. "Joyce Kozloff." *ARTnews* 72 (May): 86.

Masheck, Joseph. "Joyce Kozloff." *Artforum* 12 (September): 76–7.

Mellow, James. "Joyce Kozloff." *New York Times*, April 21.

**1972**

Kingsley, April. "Joyce Kozloff." *ARTnews* 71 (January): 18.

**1971**

Genauer, Emily. "Joyce Kozloff." *New York Post*, December 18.

Henry, Gerrit. "Joyce Kozloff." *Art International* 15 (January): 42.

**1970**

Canaday, John. "Joyce Kozloff." *New York Times*, November 7.

Campbell, Lawrence. "Joyce Kozloff." *ARTnews* 69 (November): 22.

Domingo, Willis. "Joyce Kozloff." *Arts Magazine* 45 (November): 61–2.

Glueck, Grace. "Yanking The Rug From Under." *New York Times*, January 25.

# INDEX OF WORKS BY THE ARTIST

Agrigento, 44

American History
    *The Age of Discovery*, 86–7
    *Going Global*, 92–3
    *(North) American History:*
        *Popular Uprisings*, 88
    *Nuking the Japs*, 91
    *Sing-along American*
        *History: White Bread*, 89
    *Sing-along American*
        *History: Cowboys and*
        *Indians*, 17, 89
    *Sing-along American*
        *History: War and Race*,
        90
    *21st Century Crusades*, 91
    *Wars in Old Europe*, 90

Around the World on the
    44th Parallel, 31

Bodies of Water, 51

Boys' Art
    *#2: Nagasaki*, 16, 74–75
    *#7: British Fleet, Falkland*
        *Islands*, 35, 76–7
    *#16: Aztec Military Map*, 78
    *#17: Norwegian Fjords*, 79

Buffalo Dance, 29

La Conquista, 67

Dark and Light Continents,
    jacket, 23, 80–1

Pornament is Crime #13:
    Riding Roughshod Through
    the Heavens, 12

Galla Placidia in
    Philadelphia, 49

Hidden Chambers, 29

Imperial Cities, 32

An Interior Decorated, 30, 48

Knowledge
    *#1: Labrador, Iceland,*
        *Greenland, Scandinavia*
        *and the British Isles,*
        *16th Century*, 60
    *#4: The New World, 1541*, 60
    *#6: The New World, 1546,*
        26

*#10: Japan, 1570*, 52
*#14: South America, 1585*, 61
*#21: Japan and Ezo, 1661*, 52
*#26: New York and New*
    *Jersey, 1777*, 61
*#28: The Near East, 1154*, 62
*#41: China, 1470*, 10, 63
*#49: The World, 1581*, 26
*#70: Cape of Good Hope,*
    *1578*, 63
*#73: 1st Century A.D.*, 13, 65
*#74: 1561*, 13
*#75: 1290*, 26
*#76: 1602*, 64
*#77: 1564*, 14
*#78: 1154*, 58, 66

Los Angeles Becoming Mexico
    Becoming Los Angeles, 51

a maze, 47

Mekong and memory, 33

New England Decorative Arts,
    31

pilaster, longing, pilaster, 47

Rocking the Cradle, 36, 84–5

Silk Route, 34

Spheres of Influence, 2–3,
    82–3

Striped Cathedral, 47

Targets, 6, 15, 20, 27–28, 53,
    69–73

tent-roof-floor-carpet, 45

Three Facades, 45

Tondi
    *the days and hours*
        *and moments of our*
        *lives*, 103–5
    *Helium on the Moon*, 40
    *Helium on the Moon II*, 41
    *the moments and hours*
        *and days of our lives*,
        22, 102
    *Now/Later*, 106–7
    *Now, Voyager*, 21
    *Now, Voyager II*, 21
    *Revolver*, 42, 110–1
    *Whether Weather, #1; 4;*
        *6–14*, 108–9

Topkapi Pullman, 49

Voyages (hangings)
    *Carnevale V*, 38
    *Carnevale VI*, 53
    *Kaho'olawe I*, 95
    *Kaho'olawe II*, 55, 95

Voyages (Masks)
    *#1: Sicilie*, 97
    *#2: Veglia*, 96
    *#5: Lemnos*, 18
    *#9: Rhodi*, 97
    *#10: Isle des Larrons*, 97
    *#12: Venetian War Fleet on*
        *the Way to*
        *Constantinople*, 36
    *#13: Sardaigne*, 96
    *#16: Malluco*, 99
    *#18: Sooloo archipelago*, 96
    *#21: Pohnpei*, 100
    *#22: Maria Bay*, 97
    *#37: Sumatra with G.I.*
        *Joes*, 18
    *#41: Lesbos*, 98
    *#47: Lop Buri Siam*, 96
    *#49: I. Balij*, 96
    *# 50: Island of*
        *Newfoundland*, 96
    *#51: Riviere du Menam*, 97
    *#53: Iava*, 97, 101
    *#54: Espiritu Santu*, 97
    *#55: Galapagos Islands*, 18
    *#57: Feejee Islands*, 97
    *#58: Cape Verde to Cape*
        *Rosso*, 97

Voyages+Targets, Thetis,
    S.p.A., Arsenale, Venice, 19,
    20, 37, 38, 94

Untitled (floor mosaic:
    Chubu Cultural Center,
    Kurayoshi, Japan), 56

## Notes on Contributors

**NANCY PRINCENTHAL** is a frequent contributor to *Art in America,* where she is a senior editor. She has written for many other publications as well, including *The New York Times, The Village Voice, Artforum, ARTnews,* and *Parkett.* A frequent lecturer, she has taught at Princeton University, Yale University, the Center for Curatorial Studies at Bard, New York University, and Montclair State University. Books to which she has contributed include monographs on Alfredo Jaar, Doris Salcedo, and Robert Mangold. Princenthal is a coauthor of *After the Revolution: Women Who Transformed Contemporary Art* (2007).

**PHILLIP EARENFIGHT** is director of The Trout Gallery and associate professor of art history at Dickinson College. He has organized numerous exhibitions and published on a wide range of topics. Recent books and editorial projects include *Captive Imagery: Assimilation and Resistance at Fort Marion* (2009); *A Kiowa's Odyssey: A Sketchbook from Fort Marion* (2007); and *Within the Landscape: Essays on Nineteenth-Century American Art and Culture* (with Nancy Siegel, 2005). In addition to curatorial work, he researches and publishes regularly on art and architecture in late medieval Italy.

## Photo Credits